Zi...

The ...
America...

The Artist in America

THE
ARTIST
IN AMERICA

Contemporary Printmakers

BY

CARL ZIGROSSER

HACKER ART BOOKS
NEW YORK, N.Y. 1978

Introduction

"AT this time, at the end of the day," relates Giorgio Vasari in his autobiography, "I often went to see the Cardinal Farnese dine in the evening. He was always entertained by the conversation of Molza, Annibale Caro, M. Gandolfo, M. Claudio Tolomei, M. Giovio, and other gallants and men of letters of whom his court was always full. One evening they were talking of Giovio's museum and of his gallery of portraits of illustrious men with appropriate inscriptions. In the course of the conversation M. Giovio said that in addition to his museum and eulogies he would dearly like to have a treatise upon all the famous artists from Cimabue to our own day. In developing this he showed great knowledge and judgment about our arts, though it is true that, taking the matter as a whole, he lost sight of details and often confused the names of artists, their birthplaces and works. When Giovio had done, the cardinal turned to me and said: 'What say you, Giorgio, would not this be a fine work?' 'Admirable,' I answered, 'if Giovio is assisted by someone of the profession to put things straight for him. I say this because in his admirable remarks he has confused many things.' Urged by Giovio, Caro, Tolomei, and others, the cardinal replied: 'You might make him a list of all the artists and their works in chronological order, and your arts

v

will thus receive an additional benefit from you.' I promised to do my best, and very gladly, although I knew it was beyond my powers. Accordingly I set to work to look up my notes and papers, which I had made as a pastime from my early youth and because of my regard for artists. Selecting what I thought suitable, I took it to Giovio. After praising freely what I had done he said: 'I wish you would undertake this task, Giorgio, and elaborate this, as I see you can do it admirably. I do not feel equal to it, as I do not know the technicalities or many of the particulars, as you do. Besides, mine would more resemble a treatise like Pliny's.' "

Thus Vasari described how he happened to write his *Lives of the Eminent Painters, Sculptors, and Architects.* In truth they do not resemble a treatise like Pliny's — that is to say, schematic art criticism; they are in the main a racy and vivid record of the artists of his day. It is as such that they have enduring value. He wrote about many of the artists from personal knowledge and contact, and he interpreted them in the spirit of his time. Although I am no Vasari, I too have " my notes and papers, which I had made as a pastime from my early youth and because of my regard for artists." I have always been impressed by the importance of contemporary documentation and its service not only to succeeding generations but to the present generation as well.

This book, then, is the story of twenty-four American artists, the story of their lives projected against their background. Twenty-four artists as printmakers, since it is as printmakers that I know them. There are some twenty thousand artists in the country, each striving in his or her own way to create pictures, with divergent incentives and with varying degrees of success. No one person could possibly know them all. Of the many I have known I have selected twenty-four, partly by chance, partly by design, chiefly because I have known them best. I have tried to draw faithful and just and convincing portraits, often using their own words, and in most cases

with knowledge and experience based upon lifelong friendship. Interpretation rather than criticism has been my aim. I have tried to picture them as functioning artists, setting forth what they are striving for and have accomplished, what they had to struggle against and overcome not only in themselves but in their environment. In undertaking this biographer's task, I have attempted with all the sympathy and understanding at my command to bring to light the spirit, the whole character, the enduring drive, rather than the surface view.

A rounded portrait is not easy to achieve. Each contact with the subject of the portrait may be likened to a view illuminated by a flashlight. Somebody else sees the subject from a different angle and thus gets a different impression. A number of different angles or views gives roundness and body to the portrait. Successive flashlight views from one point may add more detail to one's impression but seldom another angle. But one can get other angles by observing the subject in action with other people, or in situations which reveal new facets, or by collecting and synthesizing other people's reactions to the subject. In this way the biographer's personal equation may be discounted and the lines of a more objective and rounded portrait emerge. To this should be added the subject's own revelations, which have the advantage, as Mark Twain once pointed out in referring to the difference between the bug and the entomologist, that at least the bug knows his subject from the inside. Furthermore the artist's own words, if uttered in good faith, throw light on his aim and intentions. The evaluation of this ultimate goal is the beginning of objective criticism: first, what did the artist attempt to do, and, second, to what extent did he succeed? Only after these points have been established can there be any attempt to judge whether the aim and the effort were worth while. As long as he struggles along the thorny and treacherous road to creation, the artist should be given the benefit of the doubt.

INTRODUCTION

The artists I have chosen are not necessarily the most important in the country. Some of them undoubtedly are, but if I had selected them by that one criterion, I should have had to include many more than I have. I chose them because, as I have said, I was better acquainted with them and their work. But if they are not the only significant printmakers in the country, each of them is at least different. Each of them is typical in his or her own way of some one achievement or creative emphasis. The group may, I think, be considered a cross-section of the American printmakers now in their prime, of what might loosely be called the generation between two great world wars (1914–41). This period is perhaps the most exciting and important in our art history, for during it has occurred the transition of American art, at least as far as the graphic arts are concerned, from provincialism to the beginnings of a national school. The age-levels are, I believe, fairly and typically distributed. The oldest of the group, Stieglitz, was born in 1864; the youngest, Castellón, was born in 1914. The largest number, however, were born in the '90's (ten of them). The '80's come next with six, the 1900's with five, and the '70's with three.

They may be classified in many ways, not categorically to fit arbitrary pigeonholes, but imaginatively in terms of dominant or crystallizing idea. One might, for example, say that for Rockwell Kent art was an act of will, for Raphael Soyer an act of compassion, for Arms an act of worship, for Sternberg a passionate idea, for Mahonri Young the pleasure principle. Again one can see how various essences can be translated into art: the Courtier turned artist as in Jasper Plum, the Architect in Arms, the Seer in Stieglitz, the Wild Bird in Landacre, the Objective Recorder in Cook, the Missouri Senator in Benton, the County-Store Philosopher in Lankes. Art happens in all kinds of places; to cite but three examples: close to the soil as with Wickey, in middle-class circumstances as with Spruance, in the best families as with Biddle. Cotton can be transformed into art

through Mauzey; art can be the Flower of New Orleans as in Durieux, or an exemplar of New England Virtues as in Nason. Art can begin with technique as in Ganso, and can quickly lead beyond Realism as in Castellón.

The recital of these artists' beginnings is instructive. It presents a picture of art instruction that was haphazard and of art standards that were unstable and often unsound. As they grew up nearly all of them had a struggle of some sort to find their way. One need but read George Biddle's story to see how an art student with ample educational opportunities had to flounder about in order to find himself. When this perplexity, this lack of sound counsel, was complicated by poverty and the necessity of earning a living, as it was with Lankes, Gág, Ganso, or Soyer, the handicap became even more acute. Many of the artists had to unlearn much of what they learned in school. The standard of art instruction today is much higher than it was thirty or even twenty years ago, largely because many of the important artists have themselves turned to instruction. Fifteen of the twenty-four artists have taught or are teaching at the present time: Wickey, Spruance, Biddle, Soyer, Sternberg, Benton, Ganso, Lankes, Plum, Arms, Kuniyoshi, Dehn, Durieux, and Mahonri Young. Their activity has had beneficial consequences in sparing a younger generation some of their own mistakes and much pointless effort. Indeed, I believe that the fertilizing influence of this generation now in its prime has been one of the most important factors in the growth of the American school of art all over the country. It is significant that many of this generation studied or traveled abroad, chiefly in Paris: Benton, Biddle, Spruance, Castellón, Ganso, Stieglitz, Marin, Plum, Arms, Kuniyoshi, Dehn, Dwight, Mahonri Young. Gág, Landacre, and Soyer received stimulus from European art while in this country, and a sojourn in Mexico has influenced Cook and Durieux. The researches of modern art, chiefly a European discovery, into diverse modes of expression, are thus sifted through

to become a stimulus and inspiration to a younger generation of American artists.

The lack of opportunity that had such heart-rending implications in the story of Ganso, Lankes, or Mauzey was on the way to being alleviated when the present war came. It was getting easier to be an artist. Not only were there more and better art schools, but there were a few more scholarships and other financial aids for students. The chief of the latter were the National Youth Administration and the W.P.A. Art Projects. It is to be hoped that the Art Project, which began as a relief measure, will continue in what was after all its fundamental contribution — an investment in creative talent. In the course of my travels over the country I had occasion to visit many of the state art projects and to examine the work of the artists working there. Time and time again I have watched the progress of a particular artist as evidenced by the sequence of his prints over a period of time. His early prints would be halting and derivative; after six months' or a year's time he would find his own distinctive style, and from then on continue as a full-fledged master. If he had not had the opportunity for trial and experiment, guaranteed by the modest stipend of the project, he would never have found himself as an artist and might even have been driven into some other profession. The Art Projects made mistakes of policy and administration, and, likewise, many of the recipients of relief were not of a temperament and capacity to benefit by the aid given. On the other hand, there have been and are intelligent and conscientious administrators, and young artists who have profited enormously by their opportunities. If but one out of every ten artists is helped toward self-expression at a time when that aid counts for most, then the idea may be considered constructive. If, in addition, one considers the achievements of the projects in the development of new techniques such as silk screen, carbograph, and color aquatint and color lithography, and in the dissemination of technical skill throughout the country, often

in regions where none existed before, then the whole idea can be accounted as more than justified. The fact of fundamental importance is that a precedent has been established. For the first time in its history, the government, theoretically the symbol of the people as a whole, has acknowledged that it has a stake in the welfare of its artists. Since private patronage has been a dwindling influence, the degree to which government patronage has been bestowed and continues to be bestowed is a measure of the hold that art has gained on the public consciousness.

Although the educational opportunities have increased slightly, the economic status of the artist was and is precarious. Very, very few artists make a living solely from their art. Many have turned to teaching to help out, and most of the rest have depended upon illustration or commercial work. Two of our group, Wanda Gág and Rockwell Kent, are well-known authors as well as artists. There seem, however, to be some compensations for their insecure economic position. Art, like farming, may not be a lucrative profession, but it is on the whole a pleasant way of life. Most artists have broad cultural interests in music, literature, and the other arts, and display good taste in their homes and their dress. They may have to pinch and save, but they seem to get as much if not more out of life than people with ten times their income. They manage to travel extensively. They have an appreciation of beauty that enables them somehow to make a work of art out of their own life. They are more or less their own masters and are not tied down to regular hours or to any one place.

By their interests and activities the artists belong to the professional section of the middle class. They have free and easy ways and are less bound by prejudice and convention than most of their class. Indeed, in many respects their sympathies transcend the middle class and extend into the groups of the very rich and the very poor. Their developed imagination, trained as it is to participate in all

experience, their own personal encounters with poverty and privation, and their response to things of culture which under the present scheme are equivalent to objects of luxury, all tend to give them a broadly sympathetic and disinterested view. Artists — and this includes practitioners in related arts — tend to be free of class interest and to yield allegiance, imaginatively, to humanity as a whole. On the practical side, it is hard for them to work together or organize. Many of them are strongly individualized, lone wolves as it were. This individualism, carried over into expression, tends to enhance the variety and richness of the American pattern in art.

This book, the first volume of a projected two-volume study of contemporary graphic art in America, was made possible through a grant from the John Simon Guggenheim Memorial Foundation. The second volume will be a regional survey of American printmaking during the last thirty years, ending with America's entry into the second World War, an event of far-reaching consequences which marks the end of a particular epoch. In this first volume the emphasis is on the human side. The life stories of a score or so of typical American artists are set down with an account of their struggle and accomplishment. This work, in which so often the artist speaks for himself, may perhaps have some value as a primary source for the art of our time. It has been said there is no single approach — there are many approaches to the creative problem. The reader, confronted with a number of such typical examples, will thus be able to make a synthesis in his own mind of what it means to be an artist. It is to be hoped that these "close-ups" or character sketches will not only throw some light on the nature of the creative process in general, but also give a picture of how the artist affects and is in turn affected by his environment. From this delineation of background and this summation of varied achievements, each dramatizing, as it were, some ruling passion or passions, might possibly emerge a composite portrait of the American printmaker of our time.

This work is the fruit of a Guggenheim Fellowship, and my grateful thanks to the John Simon Guggenheim Memorial Foundation are acknowledged herewith. I also wish to thank the following galleries for assistance generously rendered: An American Place, American Artists Group, Associated American Artists, Harlow Keppel and Co., Kennedy and Co., The Kraushaar Gallery, and The Weyhe Gallery. The studies of Kent, Kuniyoshi, and Stieglitz have appeared in periodicals in slightly modified form, and are here reprinted by kind permission of The Print Collector's Quarterly, The London Studio, Parnassus, New Democracy, and Twice a Year. For permission to quote certain copyright material I am indebted to Harcourt, Brace and Co., Little, Brown and Co., The Magazine of Art, Robert McBride and Co., and Simon and Schuster. Above all I wish to thank the artists themselves, who have in a very real sense co-operated in this work.

Carl Zigrosser

Philadelphia Museum of Art

August 1942

Contents

Illustrations

The illustrations in this volume are arranged in groups of four — a portrait of the artist followed by three typical works. In each case the groups of pictures are inserted immediately following the page reference given below.

xvii

ILLUSTRATIONS

ILLUSTRATIONS

xix

ILLUSTRATIONS

ILLUSTRATIONS

> *Owing to circumstances beyond control, it was impossible to reproduce any of the work of* Jasper Plum. *Most of the reproductions of prints were made from proofs in the Philadelphia Museum of Art.*

The Artist in America

JOHN MARIN

JOHN MARIN dramatizes in his own life the transition between two creative impulses. He bridges the gap between the old and the new order. He began as an etcher in the Whistler tradition and ends as one of the very greatest of modern artists. He has made distinguished contributions to both fields, and by that very fact personifies the change that has taken place in American art within one generation. There is no doubt whatsoever as to the importance and authority of his contribution. He is and has been acclaimed a great artist: he is one of the few American artists who have achieved national and even international fame.

He is as racy and American a character as Thoreau and Whitman. He was born in Rutherford, New Jersey, in 1870. In some whimsical autobiographical notes he records: "Early childhood spent making scrawls of rabbits and things (my most industrious period). Then the usual public schooling, where as usual was soundly flogged for doing the unusual, drawing more rabbits on slate." After high school and several years at Stevens Institute: "One year business, not much chance at the gamebag. Believe I was fired." After four years in architects' offices he went for two years to the Pennsylvania Academy

3

of Fine Arts: "Could draw all the rabbits I wanted to, therefore didn't draw many. While there, shot at and captured prize for some sketches." Later: "One year at Art Students League, New York. Saw Kenyon Cox. Two years blank. Four years abroad." It was there that he first started to etch. "Since then I have taken up Fishing and Hunting and with some spare time knocked out a few watercolors for which in former years I had had a leaning." Such is his mock-serious account of his life. In the autumn of 1936 the Museum of Modern Art in New York held a great retrospective exhibition of the watercolors, oils, and etchings which he had knocked out in his spare time.

He started to etch in Paris in 1905 when he was thirty-five years old. He was busy painting in oils also and one of his paintings of this period was purchased for the Luxembourg. After half a dozen experimental plates, he found his stride with the *Pont Neuf*. The next two years were the most productive of his career on copper — 1906 with thirty-three, and 1907 with twenty-seven etchings. He set about to record the picturesque landmarks, the quaint nooks and corners of the French capital, with brief excursions to Amsterdam and such provincial cities as Laon and Meaux (*Near Quai d'Ivry, Bal Bullier, La Rue Mouffetard, Cour Dragon, Bridge Canal Amsterdam*). In 1907 he did the same for Venice, all the favorite spots and views and *Ponte Ghetto, Clock Tower of Sta Maria Zobenigo* as well. He was working under the spell and inspiration of Whistler. But he laid the great expatriate's impressionism over a slightly more architectonic core. The vignetting and feeling for *mise en scène* are there, and bravura line and sense of movement (even then Marin had a nervous idiomatic line). But, as the French critic Charles Saunier wrote, he knew how to draw an architectural monument. His architectural training served him in good stead. But the Whistler influence was felt in many other ways. There is a flavor of it in his letters, as in the following to his print publisher, Albert Roullier:

4

"These personalities (etchings) were put down at places in Paris and Venice during my wanderings about, of things that appealed and impressed me to such an extent that something had to be said, things that were seen in passage, and of an impression deeply felt. The hour demanded them to be stamped and to be done in a manner easiest seen and easiest understood. So the needle was picked up and these etchings made. One might call an etching a written impression of tone, more or less in the spirit of a veil to soften, as does nature's veil soften, her harshness of line. And sometimes when one would lift the covering from beauty of outline to reveal a part, to do so — boldly here and tenderly there. Of my own manner of expression only this can be said: If I have appealed to you and have held your sympathy, then I am understood, and that is all I desire."

In 1908 he etched only a few plates but they were more ambitious and bigger in size, *Notre Dame*, *L'Opéra*, and *La Madeleine*, and they are accounted among the finest of his architectural phase. They were straightforward and brilliant renderings with just enough of a personal slant to consolidate his reputation as one of the ablest of the young architectural etchers. But in the next year something untoward happened: a ferment began to work. The artist seemed to be developing at the expense of the architect. Such etchings as *Cathedral near the Old Market, Rouen, Cloister of St. Maclou, Notre Dame from the Quai Celestins* — each one a masterpiece — are not just picturesque recordings of the draftsman's needle: they have the color and atmosphere, the potent design, the meaning and vitality that stem only from the artist. In one plate, *Rouen Cathedral*, the ferment burst forth with inspired exuberance. Restraint and verisimilitude were cast to the winds: one spire was transformed into a passionate tumultuous ecstasy of soaring. The emphasis was not upon the letter but on the spirit: the impressionist has turned expressionist. The year 1910 saw four more etchings. In *Chartres* he tried again to be a good little boy architecturally. It was his swan song. The two of

5

Frauenkirche, Nuremberg, and the *Pflanzbadgasse Strassbourg,* became more and more dynamic and abstract. His dealers and his public, bewildered by this new development, would have none of it. Henceforth his print production was experimental and sporadic and limited in numbers. He no longer could count on any immediate market.

In 1911 he returned to America, never to leave it again. His friend Arthur Carles had introduced him in Paris to the photographer Edouard Steichen, who in turn had introduced him to Alfred Stieglitz. This was the beginning of a long and fruitful friendship, for it was Stieglitz who for many years enabled Marin to work freely with no thought for the morrow. When Marin returned to New York he soon became part of that vortex of art and discovery over which Stieglitz presided at the Photo-Secession Gallery, 291 Fifth Avenue, familiarly known as "291." Here he discovered the works of many modern artists from Cézanne onwards, of which he somehow had not been aware in Paris. But simultaneously he was doing a little exploration and creation of his own. He became excited by the skyscrapers and bridges of New York and during the years 1911–13 made many watercolors and a dozen etchings to express his feeling about them. It might be illuminating to quote his own interpretation: "Shall we consider the life of a great city as confined simply to the people and animals on its streets and in its buildings? Are the buildings themselves dead? We have been told somewhere that a work of art is a thing alive. You cannot create a work of art unless the things you behold respond to something within you. Therefore if these buildings move me, they too must be alive. It is this 'moving of me' that I try to express, so that I may recall the spell I have been under and behold the expression of the different emotions that have been called into being. How am I to express what I feel so that its expression will bring me back under the spell? Shall I copy facts photographically?

6

JOHN MARIN

" I see great forces at work; great movements; the large buildings
and the small buildings; the warring of the great and the small;
influences of one mass on another greater or smaller mass. Feelings
are aroused which give me the desire to express the reaction of these
'pull forces,' those influences which play with one another; the
great masses pulling smaller masses, each subject in some degree to
the other's power.

" In life all things come under the magnetic influence of other
things; the bigger assert themselves strongly, the smaller not so
much, but still they assert themselves, and though hidden they
strive to be seen, and in so doing change their bent and direction.

" While these powers are at work pushing, pulling, sideways,
downwards, upwards, I can hear the sound of their strife, and there
is great music being played.

" And so I try to express graphically what a great city is doing.
Within the frames there must be a balance, a controlling of these
warring, pushing, pulling forces. This is what I am trying to realize.
But we are all human."

Among the etchings are seven studies of *Brooklyn Bridge* and four
of the *Woolworth Building*. In one of the bridges there is a veritable
mosaic of construction with exciting receding planes and aerial
pyrotechnics; in another the precariousness is accentuated: high
above the river it swings and oscillates pendulously. In one the
building struts haughtily above its fellows; in another it sways and
bends in a beautifully rhythmic and titanic dance. He has made
these things alive for us as well as for himself. The best of them are
among the most important prints of their time. The succeeding years
brought their tiny quotas of etching. In 1915 he produced the
Brooklyn Bridge from Brooklyn within an etched border, one of his
most characteristic plates. During the same and the two following
years he was occupied with abstractions of grain elevators, most of
them experimental. In 1921 came the famous *Downtown New York,*

7

sometimes known as *Park Row*. He made two ventures into line engraving on copper, *Woolworth Building from the River* and *Downtown Synthesis*, to which in the printing he added flat areas of tone, differing with each print, a kind of monotype effect. In 1925 he etched the *River Movement,* in which he carried abstraction to the limit. A most moving and æsthetically satisfying synthesis ensues from his inspired elimination of all but essentials. In 1930–1 he took his final fling at New York, and in 1932–3 he made his last etchings, two versions of *Sailboat.* One of them in particular, the 1932 version, is a thing of beauty and one of his most successful prints. It is to be regretted that in these later years there seemed to be no incentive for him to produce on copper. The print world is the loser thereby even though his major energies did go into the creation of superb watercolors.

Marin in his life work has exemplified two theories of expression or emotional appeal. The first may be called the associative method. The aim is to copy or portray as faithfully and vividly as possible a building or object on the assumption that the sight of the object will release all feelings of wonder, reverence, glory, or delight that have been associated with it. Its magic is literal and literary. The other, or what might be called the æsthetic method, aims to work — somewhat like music — more directly on the spectator's emotion, through the exigencies and emotive power of the medium itself. Lines, shapes, thrusts, color, have an emotional power inherent in them. These elements, more important for the moment than verisimilitude, are assembled and arranged for a desired effect by the artist, completely indifferent to how many liberties in regard to distortion, abstraction, or emphasis he has taken with his subject matter. Both methods have their limitations. With the associative the emotion, being indirect and secondary, is apt to be less strong or vivid. The handicap of the æsthetic theory is that relatively few people know the language of art; the number is very considerably less than of those who know

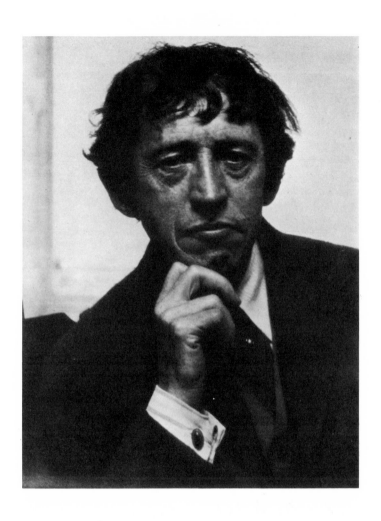

PORTRAIT OF JOHN MARIN

PHOTOGRAPH BY STIEGLITZ

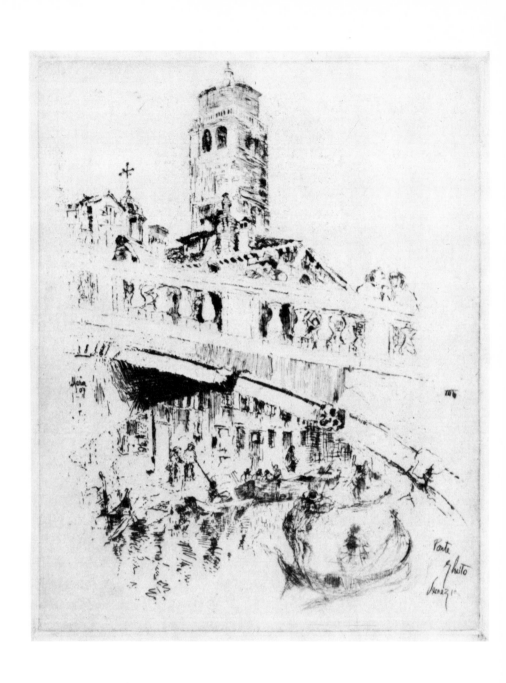

JOHN MARIN: PONTE GHETTO, VENICE

ETCHING

9 X 7 INCHES

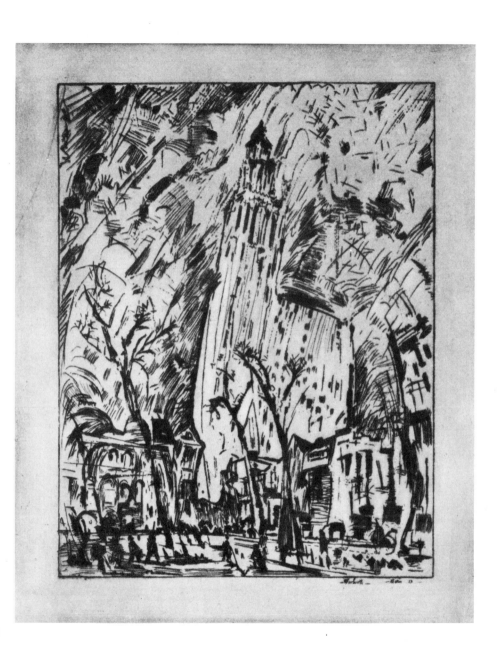

JOHN MARIN: WOOLWORTH BUILDING

ETCHING

12⅞ X 10⅜ INCHES

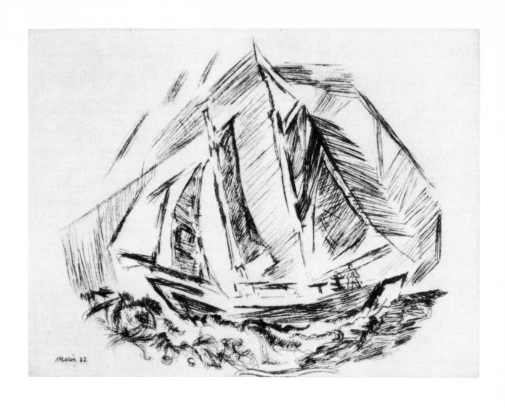

JOHN MARIN: SAIL BOAT

ETCHING

6⅞ x 9¼ INCHES

the language of music, for example. Furthermore very few know the language in its pure state. The taste of most people has been debased by popular dialects. There are other differences between the two: the first method generally employs a compositional scheme that is static, a projection of phenomena on a flat plane, the objects are dead; whereas in the other the composition is more dynamic, there is greater depth of focus (to borrow a phrase from the camera world), a greater illusion of a third dimension, more emphasis on the interplay of lines and planes within that third dimension, the buildings are more alive, as Marin says. Since the new order is the more misunderstood of the two, it might be well to elaborate on it somewhat. Marin himself has contributed some enlightening notes written in an idiomatic staccato style so richly the equivalent of his spoken word.

"The worker in parts, to create a whole, must have his parts, arrange his parts, his parts separate, his parts so placed that they are mobile (and though they don't interchange, you must feel that they can); have his lines of connection, his life arteries of connection. And there will be focusing points, focusing on, well, spots of eye arrest. And these spots sort of framed within themselves. Yes, there will be big parts and small parts and they will work together, they will all have the feel, that of possible motion. There will be the big quiet forms. There will be all sorts of movement and rhythm beats, one-two-three, two-two-three, three-one-one, all sorts, all seen and expressed in color weights. . . .

"The glorious thing is that we cannot do, elementally do, other than our ancestors did. That is, that a round conveys to all who see it a similar definite, a triangle a similar definite, solids of certain forms similar definites, that a line — what I am driving at is that a round remains, a triangle remains, a line remains and always was. So that the worker of today, as of old, picks up each of these things with recognition. . . .

9

"And that this my picture must not make one feel that it bursts its boundaries. The framing cannot remedy. That would be a delusion, and I would have it that nothing must cut my picture off from its finalities. And too, I am not to be destructive within. I can have things that clash. I can have a jolly good fight going on. There is always a fight going on where there are living things. But I must be able to control this fight at will with a Blessed Equilibrium.

"Speaking of destruction, again, I feel that I am not to destroy this flat working surface (that focus plane of expression) that exists for all workers in all mediums. That on my flat plane I can superimpose, build up onto, can poke holes into; but, by George, I am not to convey the feel that it's bent out of its own individual flatness. . . .

"Seems to me the true artist must perforce go from time to time to the elemental big forms — Sky, Sea, Mountain, Plain — and those things pertaining thereto, to sort of re-true himself up, to recharge the battery. For these big forms have everything. But to express these, you have to love these; to be a part of these in sympathy. One doesn't get very far without this love, this love to enfold too the relatively little things that grow on the mountain's back. Which if you don't recognize you don't recognize the mountain."

Some of the differences between static and dynamic composition can be illustrated in Marin's etching *Sailboat*. His is dynamic in that he attempts to portray movement in space, a flux that is never resolved. The Futurists attempted unsuccessfully to capture this elusive motion by a formula. Marin succeeds by suggestiveness, by indirection, by re-creating the principle of motion through the intensity of his vision and his intuitive knowledge of form. It is much the same quest that is described in Walt Whitman's moving lines:

Metre or wit the best, or choice conceit to wield in perfect rhyme,
　　delight of singers;

JOHN MARIN

These, these, O Sea, all these I'd gladly barter
Would you the undulation of one wave, its trick to me transfer,
Or breathe one breath of yours upon my verse,
And leave its odor there.

Much must be sacrificed, as Whitman suggests, much of the traditional and conventional forms, literal representation, in order to capture this dynamic quality; an entirely new unity of structure must be created. This Marin has done. The wind blows, the boat is moving, the waves are dancing. The illusion is complete; the scene becomes alive by the power and intensity of his creative imagination. Furthermore, in this print the artist has stripped away all extraneous detail and set down, in the white heat of his intuition, only the very essence of things. It may take some time for the observer to catch up when the artist has penetrated so far into the core of expression. But the adventure is worth the time and effort of imagination expended. Therefore when the layman looks at the etching for the first time and sees in it only a meaningless bunch of scrawls, he should remember that there is more to the picture than appears at first glance. It is not the scrawl of an incompetent; it not a picture that the layman's five-year-old child could do better; it is the mature and imaginative work of a distinguished and technically equipped artist. It took the artist thirty-five years to arrive at his perfection of expression; the spectator cannot expect to master it in thirty-five seconds.

Another significant point about Marin is the immediacy and intensity of his creative reactions. So seemingly free and spontaneous are they that superficially one might label them pure impulse or whimsy, did not one know the long gestation of impression, the winnowing and ordering, the concentration on formal design — the laborious upbuilding of potential that precedes the lightning flash.

11

The abstraction of essentials is the hardest kind of work. With Marin it means the instantaneous focusing of all energies, physical, emotional, and mental, on one single point.

One gathers from the quotations given above that Marin has a unique flavor as a person as well as as an artist. His letters, chiefly to his friend Stieglitz, reveal the man. They are written in a lively and pungent style, quite without artifice or self-consciousness. He writes as he would talk. His punctuation and spacing are his very own and cannot be reproduced in type. The letters abound in vivid descriptions of country life and types in New York State and Pennsylvania, and especially of the seacoast of Maine. His penetration in character is amazing. A kind of Yankee *Spoon River Anthology* could be assembled from his letters. There is many a chuckle of humor in them too. There is a bit of the homely philosopher in him — sayings as shrewd and common-sensical as Will Rogers's. There is a great hatred of sham, and a contempt for the " discussionists." Above all, there shines through him the quality of the seer. Somehow one is reminded of Thoreau in this respect. Whence Marin acquired this quality, I do not know, but he has that easy intuitive grasp of the profundities of existence that comes only from some inner discipline. His detached and half-humorous observation of his own moods betokens the self-knowledge of a mature and integrated personality — never a morbid introspection but an appraisal abounding in sanity and health. There is a trace of the mystic in his persistent penetration into essentials and in his insight into the creative process. The artist and the mystic are somewhat akin — but with this important qualification: that one speaks of real creation and a genuine mystical attitude, not mysticism in its pseudo or vulgar sense. Your true mystic has clarity and is eminently practical. He does not go beating about the bush and dragging in a lot of non-essentials. He makes straight for his goal, union with the absolute, or whatever it may be. He concentrates his efforts not on facts or formulas, of which there are a

multitude, but on insight and vital principles which are unique. So it is with the true artist and so it is with Marin. He has developed into an artist of creative stature. Like the true mystic, he does not flaunt his accolade. He is a human being like the rest of us, with all the human traits, an American with many facets and unexpected depths. It is hard to give the flavor of the whole man, as hard as it is to define life itself. Perhaps the only solution is a paradox. One is reminded of Henry McBride's epigram: " Marin was born old and has remained young."

ADOLF DEHN

THE *feel* of things and places — the tragicomic antics of that curious creature, Man — filtering through the imagination like strains of music heard over water — how to capture all this on paper — how to manipulate lines and tones with cunning and art in order to build up that something, capable of evoking in others those same moods of sweet or bitter mystery! It seems an easy thing to do: to cast a spell of poignancy over simple evanescent things. But it isn't. It's a life job. Hemingway and Sherwood Anderson have done it with words; Adolf Dehn has done it with lines.

Dehn is an American. His grandparents were German — pioneers in Minnesota. From his mother he inherited his sociability and feeling for art and culture; from his father, his independence and love for nature. His father is a trapper and fisherman, a keen-eyed and vigorous man, a backwoodsman, who loves his freedom. He knows the lakes and the woods as a book. Above all he knows animals, their ways, their habits, their nature. This word "nature" is constantly on his lips: "It was in the nature of the fish to do that," or "You have to know the nature of the beast before you can trap him." Dehn used to help his father, and as he tended his lines, he looked

about him at trees and water, at reflections in water, at skies ever changing. Something was happening to him; he was absorbing something during those days and nights spent on Minnesota lakes, something that deeply affected his art in later years.

He was born in 1895 at Waterville, Minnesota, not so far from the Main Street where Sinclair Lewis was born. A typical American background. And typically American was young Dehn's reaction to it. He aspired vaguely to Old World culture. He went to art school in Minneapolis from 1914 to 1917. He won a scholarship in 1917 to go to the Art Students League in New York. So far so good. He continued to live in New York. He existed somehow, tending furnaces, painting furniture, being night watchman for an electric burglar patrol. But starving in New York was not so different from starving in Minneapolis. Why not starve in Europe? You could do it so much more elegantly there. And those were the days when a dollar would go far.

In 1921 he went to Europe. The American's urge toward culture, the easy life of the cafés and boulevards, the bohemian's paradise! He was by way of becoming an expatriate – on a shoe-string. He drew incessantly, eagerly drinking in the modes and manners of people who really knew how to live. He drew and drew, and his line became sensitive and free. He made caricatures that appeared in *Vanity Fair* and other magazines, caricatures that subordinated human beings to flowing curves and spirals. His drawings became witty, elegant, and sophisticated. He met people, got to know artists and writers and actors and dancers. George Grosz said to him: " You will do things in America which haven't been done, which need to be done, which only you can do – as far at least as I know America." He made some etchings. "Whether the etchings are good or not," he wrote, " I don't know. People like them. Bill Bullitt, for instance, said about the *Au Sacre du Printemps:* 'Pascin never dreamed of doing anything so good.' Well that's tommyrot of course, but I like

15

to hear it." He became intimate with the capitals of Europe — Vienna, Berlin, Paris, London. He absorbed experience and lived life to the full. What incomparable illustrations he could make for *The Sun Also Rises*!

Dehn was not quite so carefree as most of the expatriates. And, of course, he did do some work instead of just sitting at a café and talking about life. But it was a precarious living. Often he did not know where his next meal would come from. He sold occasional drawings, and with them and a few commissions and sales to magazines he eked out a meager existence. It was a glamorous life just the same. His letters, scrawled over with sketches, were compounded of exuberant descriptions and worries about money. In 1922 he wrote from Vienna: " I expect to go to Berlin permanently around Xmas, for it is very alive. It's really fine for me. About the only reason I've been here so long is that the aforesaid ' by-path ' has wound around in this direction, but it, too, will wind Berlin-wards, it seems. Germany is cheaper than Austria, too. It is very costly here now. I have had to cut out one damn luxury after another so that I'm almost down to my American basis. Disgusting isn't it? My expenditures are limited to $30.00 per month.

" I was in the country this summer near Bad Gastein and also at Bregenz am Bodensee. My head is dizzy with delightful memories of the mountains, and the quiet days lying on a rock by a mountain stream, doing nothing but breathing and sleeping. I shan't regret this year with its lack of work, that is, if I can do some real work now; for speaking of this thing they call Happiness, I've come closer to it here than I ever did in America."

In 1923 he writes: " In the meantime of course, my broken state does not deter me from being gloriously happy. I may not be able to eat Wiener Schnitzel any more, but sunshine of spring is here — and I have a Florentine Panama hat to wear out in it — a beautiful person is here to love, and there is more power in my little right hand than

16

PORTRAIT OF ADOLF DEHN

PHOTOGRAPH BY ELIZABETH TIMBERMAN

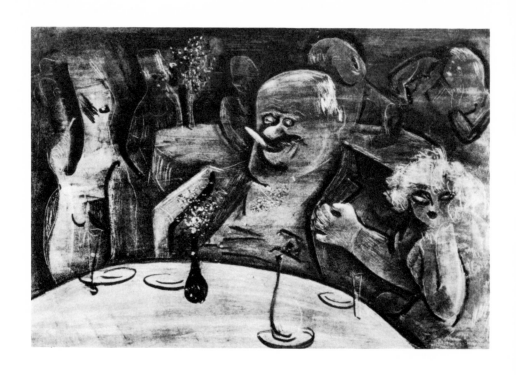

ADOLF DEHN: ALL FOR A PIECE OF MEAT

LITHOGRAPH

8 x 11⅝ INCHES

ADOLF DEHN: NORTH COUNTRY

LITHOGRAPH

9½ x 13¾ INCHES

ADOLF DEHN: GARDEN OF THE GODS

LITHOGRAPH

13½ x 16½ INCHES

there ever was before. Yes, I got wildly rash and took my last $100.00, and fled to wonderful Italy for a month with Norman Matson. Italy was always a dream, but now that the dream has been realized, she again becomes one. I was disillusioned. Italy is more glorious than I expected. The weather, the people, the wine, the olive oil, the oranges, the picturesque lovely children, the radiant girls with splendid legs, Giotto, Byzantine mosaics, St. Peter's, the Sistine Chapel, Venice — all in their respective ways charmed me. Oh yes, one disappointment — not nearly so dirty as I expected. Not one bedbug did I see, and only 2 cockroaches. But then I was there the ideal month. Assisi was the high point — 4 days of a life-time — Giotto stands out in my memory nearly as clearly as Agatina, the daughter of the landlady — what a creature she was. No doubt you'll see drawings of her some time. Exotic and haunting! To be full of the wine of the country, at midnight high up on the hill overlooking Assisi, the Church of San Francesco, and with Perugia's lights across the valley, is a memory of Italy and my nearness to God's Universe which I shall not forget."

So Dehn lived and loved and loafed and worked for years on end. " My attitude to life," he once wrote, " is rather sensuous — and sensual too — and only after I have filled myself with sensuous experiences can I go about working. Putting it simply: when I am fed up, I work. I am crazy about life and want to have as much out of it as I can. Take away my work and I lose interest in life, yet the work comes after my living life, or rather out of it." About the year 1927 his personal style emerged; he now had become a full-fledged master. In the spring of 1929, before the debacle of the autumn, he returned to America and announced that he was here to stay. Although he did go back to Europe, the visits were relatively brief. " I realize more than ever," he writes, " that I want to and need to live in America — that Europe is good for an Ausflug in the summer! So *that* for you and McBride and other hundred percenters! " The

center of gravity was now in America. The expatriate had returned. Henceforth American subjects appear with increasing frequency. He brought to the American scene a sharpened sensibility, an urbane sophistication, and a technical instrument at once sensitive and flexible. It was as a citizen of the world, with a sense of universalizing experience, that he now looked at the soil and lakes of Minnesota, the sand-dunes of Martha's Vineyard, the metropolis of New York, or the impressive heights of the Rockies.

Two great themes run through his whole work — landscape and caricature. Dehn can render — more successfully than anyone else I know — atmosphere and the subtler moods of nature. The envelopments of fog and mist with their strange and unreal accents, dusk, evening, night, with all their subtle half-lights and shadows, the quivering heat of a summer day as well as the sadness of an autumn evening, snow on trees and mountains, light on trees, sunlight, electric light, the mood of a summer shower at night on a city square, the splendor of a sunset sky, moods of winter, summer, spring, autumn — all these he has immortalized on stone. He invokes moods and impressions: he is the *impressionist* par excellence — the Debussy of the lithograph. His works are far from being formless or without structure: they have a subjective structure and a unity of their own. They have a feeling of space, a feeling of thematic design, and above all a feeling of atmosphere. They are finely tuned like a quartet or musical ensemble: each detail is tuned to play its part in creating the total impression. As in music so in his work, too, there is harmony, dissonance, rhythm, tonal color. His landscape themes are everywhere — in the city streets as well as in the mountains or the plains; a city park serves as well as a forest. He does not work directly from nature but builds up from his notes. For all their local accents or specific titles, his pictures are themes of universal significance — a snow scene is, for example, not of one place but valid everywhere. His approach is akin to that of Chinese painters — ac-

cording to the Six Canons of Hsieh Ho — a *feeling into* a scene, using a landscape to express a mood. His affinity to Chinese art is apparently instinctive, for he has denied that he ever studied it very much. He has been influenced, he said, by Boardman Robinson and later by Pascin and Grosz.

Just as Dehn has feelings about nature, so he has a feeling about people. City life, people resting in parks, women and babies, nursemaids and children, monks and nuns, the oldest profession, singers, clowns, dancers, lecturers, farmers, people seated in cafés, gestures of the theater or night club, men and women ever manifesting their gender — all these unfold themselves in kaleidoscopic succession. There is something Gothic in his sense of the grotesque, but there is something baroque in the way he subordinates these satiric forms to swelling lines and curves. He is one of the most powerful satirists in America. " Social criticism and caricature," he writes, " I like to do that sort of drawing, although I feel the words, social criticism, are too serious. Preposterous things are about me; I comment on them, that's all." He may claim that he is detached and above the battle, but there are times when he has revealed his feelings. Once he wrote from Karlsbad: " No, Carl, I am not exactly taking the cure in this god-damned place full of creeping cringing robbers and lackeys. I really can't think of a more disgusting place than this — full of fat toads and jaundiced ladies trying to get back youth and beauty and health. Sometime I hope to present you with a lithograph which will tell you more than my words can about this place! " His satire is seldom kindly; on the contrary it is savage and ruthless. Its motivation is, I am sure, complex — not one incentive but several. Sometimes it is a sheer delight in the incongruous, as in the opera scenes, the nun subjects, *Native of Woodstock, Sex Appeal,* or *Music,* or a sense of tragic irony as in *Clowns, Three Songsters, We Speak English,* or *Jazz Baby,* or sometimes an *arrière-pensée,* based in part on social valuations, as in *All for a Piece of Meat, Entr'acte, The*

Aristocrat, Beethoven's Ninth Symphony, We Nordics, or *Hypochondriacs at Karlsbad.* In some of the subjects the satiric intention is subordinated to a feeling for gesture, a sense of movement in *Four End Girls* or *At the Palace,* or to the vivid realization of a spectacle such as *Cabaret* or *Floradora Girls* or *Black Birds.* The subjects dealing with the Negroes are, in my opinion, among the least successful of his caricatures.

Adolf Dehn made his first lithographs in 1920, a half dozen before he went to Europe. There was a bit of Bellows and Robinson in them; they were rather melodramatic: one of some derelicts rooting around in ash cans, another of *The Mothers of the Revolution,* several of nuns. In 1922 he made six lithographs, mostly transfers, rather mannered and consciously clever. In 1926 he made a series of seven etchings culminating in the *Consumptive Girl,* a haunting picture of death in life, and *Au Sacre du Printemps,* a most amusing park scene. In 1927 he was fumbling around for a formula to express landscape in a series of lithographs based on motives in the province of Savoy. They were still experimental, empty, straining for cleverness. Suddenly in the same year he struck his stride in a series, mostly of Brittany subjects, *Quai at Douarnenez, Harbor at Douarnenez, Church in the Valley of the Chevreuse,* and the immortal *Listening to Beethoven's Ninth Symphony.* The cleverness faded away when the stone took on substance, color, power. The pictures clicked, were in tune. The following year, 1928, was a triumphantly productive one, with a total of about seventy-five lithographs, including such masterpieces as *Along the Seine at Night, Place Chatelet Summer Night, Sunday Evening in the Bois, Landscape at La Varenne, Entr'acte, Jazz Baby, All for a Piece of Meat, Lohengrin, We Speak English, Clowns,* and others. He had formed a perfect working alliance with the printer Desjobert in Paris, and the two overcame all technical difficulties in the way of free spontaneous expression. The winter of 1929–30 found him in Berlin working with the printer

Schultz of the firm of Birkholz, whom he had trained to become an equally efficient ally. Among the seventy-odd lithographs which he made there, are many fine prints, such as a group of winter scenes from the Bavarian Alps, *Snow, Winter Landscape, Snow Landscape, Black Forest*, figure pieces such as *Die Walküre, Sex Appeal, Old Rooster, Four End Girls*, and a group of American subjects such as *Filling Station, New York Night*, and *Fur Coat*. In the winter of 1931–2 he again worked with Desjobert and created, among others, such prints as *Gladys at the Clam House, Cabaret, Loge, Impasse, Along the Italian Border, Central Park, Summer Day Central Park*, and a large group of Minnesota subjects, *Autumn in Minnesota, Minnesota Sunset, Summer Day at Waterville, Minnesota Landscape*, and *Minneapolis Grain Elevators*. The production during the years 1933–9 was not very great owing to economic reasons, but nevertheless, in conjunction with the printer George Miller in New York, he produced such outstanding lithographs as *Waves, Road to Gayhead, Swans, Art Lovers, Central Park at Night, North Country, R.F.D., Great God Pan, Siegfried, Tristan and Isolde*, and *Contacting Pablo Picasso*. For several years he has spent his summers at Colorado Springs, where temptation in the form of stones and an able printer, Barrett, were at hand. From this happy conjunction have come some of his most distinguished prints, *Garden of the Gods, Spanish Peaks, Lake Tarryall, Man from Orizaba, Swinging at the Savoy, Big Hearted Girl, Americans All*. They are subtle and vigorous and colorful in the full maturity of his style. His renderings of the Rockies are particularly impressive, for he has managed to convey a sense of scale, while suggesting both solidity and atmosphere, in a way that few printmakers have ever accomplished. Dehn has produced in all about three hundred lithographs, an impressive showing in both quality and quantity. During the past five years his interest has been centered chiefly in watercolor. With his innate artistry and sense of style, he has forged rapidly ahead in the new medium.

Today he stands in the foremost rank of American watercolorists.

Technically Dehn is one of the ablest lithographers alive. He has achieved complete freedom and spontaneity on stone. Only those who have faced the blank expanse of stone and felt its inhibiting emptiness can truly appreciate what this means. He works on stone as if it were a sheet of paper. He has no one approach. He works with pen or crayon, with point or flat edge, with wash and spatter and rubbed tones, he rubs and picks and scratches and scrapes, he spatters with toothbrush, shoebrush, whatever is at hand. He caresses or attacks the stone according to his mood. Sometimes he does a thing over and over again. He is not methodical; he works by intuition, feeling, and mood. These moods cannot always be assumed or controlled at will. There are times, months and years, when his inspiration lies fallow, or when his feelings are otherwise engaged (in " by-paths " as he has called them) and he cannot produce. He is an uneven artist; not all of his things come off. This natural tendency is accentuated by the inevitable hazards of lithography: there's many a slip between first conception and final proof. He will be filled with the power of a big idea or creative streak, and under its spell produce grand things. Gradually its force diminishes, and he does nothing or tries to recapture the spell, making up in cleverness and formula what is lacking in inspiration. This thinning-out process goes on, to his own and his friends' alarm, until all of a sudden the fury is on him, and he produces one masterpiece after another, and digs into that creative research which is the compulsory obligation of every artist of integrity. He has what is called the artistic temperament. In working out a particular problem, he does not start with a rigid conception in mind: he has an intuition about a subject, he feels his way into it. He lets the picture, as elusive as life, grow before his eyes; he doesn't know the ultimate end, but he knows when it comes to life, when it clicks or is in tune. He works for days and nights at a time when the spell is on him. He often draws all night by

preference instead of by day. For all his vast knowledge of the possibilities of the stone, he knows little of the mechanical craft of printing. He has been fortunate in having four superb printers, Desjobert, Schultz, Miller, and Barrett, who have been able to meet and overcome the exacting demands that Dehn makes upon the resources of the medium.

As a man, Dehn is a genial, urbane, sophisticated man of the world. He is good company when in the mood; he talks pleasantly and entertainingly. He can be at ease with people, meeting them with a tone of banter and good-fellowship. But he can be moody, a bit secretive perhaps, indirect, cajoling, subjective in his reactions at times. He can scratch when he is in a teasing mood. But he has mellowed with the years. There used to be an undercurrent of bitterness which was natural considering the lack of security throughout so much of his life. He started out to cultivate the field of caricature in black and white, never very popular in America. Until he took up watercolor he had had very little popular recognition. Even so, it has been the landscapes that have been popular. He maintains that his satiric work is of equal, if not paramount, importance. Thus there are two themes dominant in his work — nature and human nature. Upon those two themes he has played variations with equal facility, invention, and style all his life.

JOHN TAYLOR ARMS

ARCHITECTURE flowers into art with John Taylor Arms. Architecture in its ideal sense is a union of science and art, engineering and æsthetics. When the builder becomes preoccupied with beauty, when he ceases constructing on his own or his client's part and depicts the glory of edifices already existing, when he fabricates not with building materials but with pencil and etching needle on paper, then the architect has turned artist. So it was with John Taylor Arms.

He was born at Washington, D. C., in 1887. His father wanted him to study law, but he was inclined much more toward art. While he was attending Princeton he took a decisive step. He realized that his heart was not in the legal profession; what he wanted to do above all was to draw as he always had done since his eighth year. After consulting with his dean, he transferred to the Massachusetts Institute of Technology and in due course graduated in 1912 with the degree of M.S. He had decided to take up architecture because he had to earn his own living, and he reasoned that architecture would combine art with business. He was to learn later that almost the one thing an architect never does is to draw. He spent several years with the firm of Carrère and Hastings, and worked on the plans of the

PORTRAIT OF JOHN TAYLOR ARMS

PHOTOGRAPH BY JULEY

JOHN TAYLOR ARMS: LACE IN STONE

ETCHING

$14\frac{1}{8}$ X $11\frac{1}{8}$ INCHES

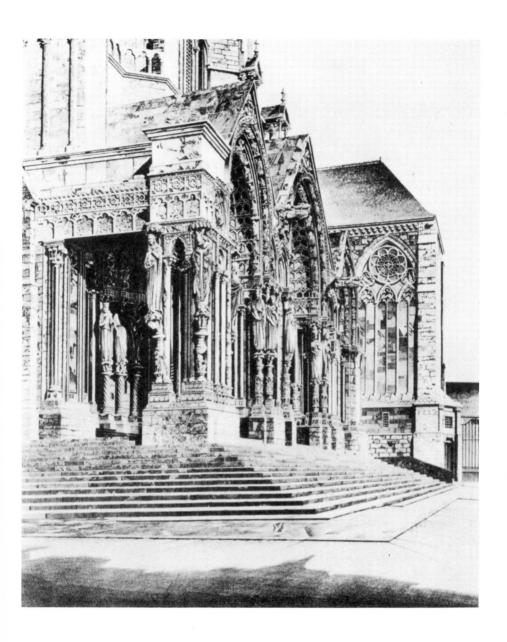

JOHN TAYLOR ARMS: IN MEMORIAM, CHARTRES

ETCHING

14⅝ X 12 INCHES

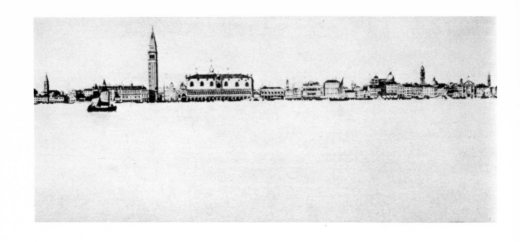

JOHN TAYLOR ARMS: LA BELLA VENEZIA

ETCHING

$7\frac{1}{8}$ x $16\frac{3}{8}$ INCHES

Frick house and the Pulitzer Fountain. He became a partner in the architectural firm of Clark and Arms. In 1913 he bought his first etching, a Benares subject by Lumsden, which he saw in a shop window. His wife bought him a little etching kit for twelve dollars as a Christmas present. He took up etching as a hobby and reveled in it. Then came the war, and Arms joined the navy. After the war — for he had undergone considerable soul-searching in the meantime — he withdrew from the architectural partnership and decided to devote himself entirely to the practice of the graphic arts. At last he was doing what he had always wanted to do, to draw.

"I have always believed," as he explained in an autobiographical note, "in a vocabulary, no matter what the medium of expression, and since I etched my first plate in 1914 (a copy of an etching by Jongkind) I have consistently and earnestly striven to develop one. It is all very well to say 'express yourself,' but no expression that is inadequate or unintelligible to the average man, or that is unable to quicken and inspire his mind to some degree, seems to me wholly worth while. The great artist does not dwell alone in his ivory tower, communing with his own spirit and those choice few who may understand and value him; he goes out into the highways and byways of life, meets his fellow men and, through the medium of his art, shares with them his gift and the spiritual uplift attendant upon its manifestation. . . . So, in my own small way, I have tried to master a vocabulary that would be intelligible to all. I did not try to 'express myself' until I had acquired the means of expression. In the early days, prior to 1915, there were many copies of the work of great men, copies made that I might acquaint myself with the means whereby they achieved certain specific technical results. And always through the twenty-one years since the publication of my first plate, the little *Sunlight and Shadow* of 1915, there have been the daily, hourly experiments with acids, needles, grounds, scrapers, burnishers, and all the other tools of the etcher's craft, carried on

through elation and inspiration, headache and heartache, with a view to enriching a vocabulary designed to express what I felt and thought. I am still stumbling and faltering, but I have learned a lot about acids and grounds since 1915, and can say my say on the copper with greater facility and clarity than I could then."

Arms has made considerably over three hundred prints since his first published etching in 1915. Some of them fall naturally in series, such as the Gables series of 1915–16, the Maine Landscapes of 1920. In 1919–25 he executed a number of aquatints of ships and other decorative subjects in color or monochrome in an effort to revive the vogue and technique of the early English aquatinters. A dozen Gargoyles were made between 1920 and 1924, and a thirteenth in 1929. A portfolio of Princeton etchings was brought out in 1925. In 1923 he launched upon an ambitious plan of recording the great churches of Europe, beginning with a Spanish series in 1923, a French series in 1924, an Italian series in 1925, and an English series in 1937.

This bare recital of subject matter conveys little idea of his steady growth in technique and conception. His earliest prints are no better and no worse than the work of any number of architectural etchers. The subject matter was chosen from the point of view of picturesqueness, the pretty, the quaint, the obvious view; the treatment emphasized a conventional technique, the charm of the etched line, the tricks of printing that impress with ease. Gradually there came about a reaction against the picturesque in favor of a profounder quest, a search for the essence, the soul of the edifice, as it were, that intangible something that Meryon, for example, has captured in his greatest plates. With it came a change of technique. No longer was line to display its wayward or bravura style. Every resource of technique was directed to one end only: to interpret most faithfully, most minutely the building before him, to render accurately the local color of every stone, to register every tonal value of light and dark,

26

of shadow within shadow. Such a quest is the very opposite of impressionism. He sought to recapture what he calls the Gothic Spirit, not by intuitive suggestion but by the faithful re-creation of some Gothic masterpiece, in the hope that people will experience the same spiritual uplift from his picture that they might feel while contemplating the original structure. He thus may be said to employ the associative method of emotional appeal: a Gothic cathedral inspires feelings of religious awe and ecstasy; these feelings are stored in the memory and can be tapped on occasion when a proper associative stimulus is offered. Unfortunately the method has some disadvantages. In the first place it is difficult to catch up with nature just by imitation. In the second place, since experience is not communicable, the emotive effect of the simulacrum is considerably lessened if a person has not had the original experience. One of the feelings, however, which his etchings very properly inspire, is that of wonder at his amazing skill and patience in transferring such minute detail to copper. That the artist is not unaware of the difficulties in the creation of works of art is indicated by another quotation from his autobiographical note of 1937:

"It is true that I have always been deeply, absorbingly interested in technical expression. My process of reasoning has been simple. The greatest etchers have been great technicians. I wanted, and still desperately want, to be a great etcher, though I know now I never shall be. Spiritual conception and power of imagination cannot be acquired, technique can. Since technical skill is part of the repertory of a master, even if a lesser part, and since anyone willing to make the sacrifice can acquire it, I have burned many a quart of midnight oil in the effort to gain this much. When I ask myself if the spiritual (the thought, the spirit, the motivating impulse) has kept pace with the technical in my work, I cannot answer. I know I feel intensely, deeply, and I know I ache to express my feelings on copper. I know, too, that I am in command of a fairly adequate vocabulary. Granted

27

these two, the results should always be what I would have them. But they rarely are. Somewhere between the impulse I experience when I face the Cathedral of Chartres and the proof from the plate I have etched to express that impulse, something, I do not know what, has gone wrong. Either the feeling is not intense enough, or the imagination lacks the power necessary to create a masterpiece, or my hand does not possess the skill to interpret that which is within me. I cannot tell. In a very few instances out of the three hundred and eight plates my scribbled catalogue records, the print has come from the copper exactly as I visualized it. If, then, I have done anything good, anything that will endure, the following prints are good and enduring: *The Gothic Spirit, From the Ponte Vecchio, Arch of the Conca Perugia, Lace in Stone, Gothic Glory, Basilica of the Madeleine Vézelay, The Enchanted Doorway, Shadows of Venice, La Bella Venezia, Palazzo dell' Angelo, Venetian Filigree, Sunlight on Stone, Caudebec-en-Caux, A Breton Calvary, Study in Stone Cathedral of Orense, Puerta del Obispo Zamora, Stone Tapestry, Miniature, La Colegiata Toro, Venetian Mirror,* and *Louviers Lace.*" To this list he has added by word of mouth at least two other plates made since 1937: *Aspiration* and *In Memoriam Chartres Cathedral.*

John Taylor Arms has carried architectural etching just about as far as it can go. The genre of architectural draftsmanship, the romantic cult of the old building or church, has been rich in fulfillment since its inception somewhat over a hundred years ago by Pugin, Malton, Girtin, Prout, and Boys in England and by the artists of the monumental *Voyages pittoresques et romantiques dans l'ancienne France,* Bonington, Isabey, Cicéri, and the like in France. Almost everything that can be said has been said on the subject, and all the changes rung — the architectural, the romantic, the sentimental, the picturesque, the literal. Arms, like Griggs, whom he in many ways resembles, approaches the subject with a sense of worship, with medieval nostalgia. And with incomparable zeal for faith-

28

ful reproduction. His technical meticulousness is incredible. As Alfred Stieglitz once put it: "His things are so dead, they are almost alive." The precision of his draftsmanship again demands superlatives: it once called forth Fitz Roy Carrington's astounded exclamation: "For God's sake, John, don't you ever make a mistake, get drunk or something!" If his compositions occasionally leave something to be desired in the matter of design (for he seldom takes liberties with his material), this lack is compensated for by the superhuman range of his tonal values. He has carried verisimilitude as far as it will go. He has laid all his cards on the table; he has staked his all to one end — and it is a lofty end. He will always be remembered for his achievement, which is tangible and definite, and for the whole-hearted dedication of his life to one purpose.

There has been a consistent development in his career. He has learned much and profited by experience. He is one of those complex natures who mature slowly and by accretion, and whose acquired tastes eventually become broad and sound. He has refined his own work till it has been purged of all the early dross. He has grown steadily in appreciation of art, and become more tolerant of the work of other artists whose work differs fundamentally from his own. Indeed, he now is unique among artists for the catholicity of his taste. He supports no rigid definition of art and favors no exclusively single approach: "I may neither understand nor agree with my fellow worker in the common field, but I demand for him the right to worship at his own particular shrine in his own particular way, and to allow me to do the same. And if the warm sunlight falling on the weathered stone of Gothic arches and bathing the soaring towers of a mighty cathedral, made up of infinite beautiful detail welded into one single beautiful whole, leads me to the attempt to re-create the scene on plate and paper, I ask only that my friend who, with sincerity of inspiration and purpose, etches social revolution, landscape or seascape, tenements or palaces or gas-tanks, portraits or machinery

or abstractions, accord me the same respect and toleration that most freely I extend to him." As an artist, as a public and private figure, he has made a tremendous contribution to the cause of print-making. Under his presidency the Society of American Etchers has grown in dignity and influence. The American Committee on Engraving, virtually created by him, has done much to exhibit prints on a national and international scale. His association with the print section of the National Academy Shows and the New York World's Fair Exhibition has made them more truly representative of print-making in the United States. There is an amusing tale of how he literally sat on an artist's doorstep till he consented to exhibit at the Academy, and a long continued story of how he patiently ignored rebuff after rebuff and finally won over certain prominent artists, thereby assuaging the resentment caused by the Academy's policy of long ago. By his example he has inculcated higher standards of tolerance and fair play among his fellow artists. He has consistently worked to maintain the dignity of his profession as printmaker, and has given freely of his time and money for that purpose. He has brought about a wider appreciation of prints among the general public. Not the least of these ways has been his public demonstrations of how to make an etching. These lectures, which he started making as long ago as 1919, are truly amazing performances. In the space of an hour or two he will demonstrate to his audience the entire process of etching from bare copper to finished proof, talking every second of the time even while drawing with his right or left hand and performing the most intricate operations, giving a running history of the art, the flavor of its great practitioners, its purpose and spirit, and the key to its intelligent appreciation. It is a dramatic performance of a rare kind, with local color, instruction, humor, and a dramatic element of suspense that keeps even the most informed listener on the edge of his seat until the demonstration is brought to a triumphant close.

He is not sparing of words. In fact he admits he is prolix and verbose. It is his nature. Just as he sets down every detail in his etchings, so he must fill in to the limit with words. Either his eloquence requires no effort at all, or else he has a prodigious fund of energy. He will write a whole-page letter where two sentences would suffice. He can talk for two hours or more without stopping, pouring forth a torrent of oration and peroration, of lengthy periods, apt phrases, synonyms and clichés, and graphic illustrations. There is quite a bit of the preacher in him: the unctuous tone, the emotional fervor are there, and also the purple passages. He can wax mighty evangelical about art in place of the customary topic of salvation. No doubt for him they are one and the same thing. The emotional prolixity is a little harder to understand. When he lectures about prints, they mean everything in the world to him: they are his life, his love, and his work. At the end of an hour and a half one wonders how any human being can love so much and so many different things. His verbal prolixity sometimes places him, I think, in an equivocal position emotionally. He is modest, and has said that his own work is as nothing. No doubt he means it — up to a certain point; deep down all of us have a fair idea of our limitations. But how can a man in his position and with his own tangible achievements write: " For twenty-one years I have visualized a plate of perfect beauty and, in my own way and according to the dictates of my own impulses, I have striven to achieve it. I gave up hope, a long while ago, of ever etching a perfect plate, and concentrated upon attaining one perfect passage. Now this seems vain, and perhaps it is no exaggeration to say that, before I finally put aside needle and acid, I pray that I may etch one perfect single line." I suspect that Arms had for the moment dramatized himself in the role of the preacher or evangelist of art in whom such extreme modesty was a becoming virtue. But what is behind the façade of so superhuman a character? What is the private

life of a great public orator? What did Henry Ward Beecher or William Jennings Bryan say to his wife at the breakfast table? A fascinating speculation always.

John Taylor Arms in the home circle is an engaging figure. There is the background of the comfortable and hospitable farm at Fairfield, Connecticut. There is Mrs. Arms, who deserves much credit for her share in his development as man and artist. There are the children, now grown up, and a procession of young people, friends, and house guests. There is much good-natured fun and chaffing of the man who answers to the name of Old Buzzard, and at times a judicious appraisal of the various shades of purple passages ranging from light mauve to deep purple. And the quiet talks in the studio with all its etching paraphernalia and the prints of Bone, Dürer, Griggs, Heintzelman, Higgins, and Rembrandt hanging on the walls, the friendly appraisals of artists, the unaffected and intelligent love for prints of many kinds. An endearing and human picture of a man not always possessed of pentecostal powers.

There are two aspects of his public career: his vocation as an artist and his activity on behalf of art and the common weal. Such seem to be the two roles by which he wishes to be remembered. On the one hand there is his art, his dream and interpretation of Gothic beauty, Gloria Ecclesiæ Antiquæ. Simultaneously there is his zeal for prints in general, his routine as a lecturer and writer and editor, and as a member of committees and societies (the number of societies to which he belongs is quite overwhelming). He is sociable by nature, and wants to be known and loved by his fellow artists. To a notable degree he has achieved both his ambitions, and the world is a better place by reason of it. John Taylor Arms is an architect — a builder who is erecting, print by print, an edifice of Gothic beauty, and who with equal patience is building up, detail by detail, his own legend as a public benefactor.

PORTRAIT OF WANDA GÁG

PHOTOGRAPH BY ROBERT JANSSEN

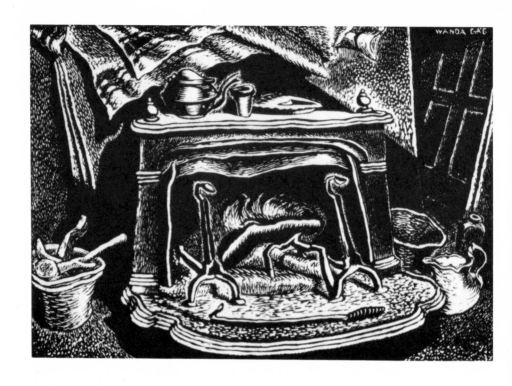

WANDA GÁG: THE FRANKLIN STOVE

WOOD-ENGRAVING

5 X 7 INCHES

WANDA GÁG: SIESTA

LITHOGRAPH

10 X 12 INCHES

WANDA GÁG: PLOUGHED FIELDS

LITHOGRAPH

8¾ x 11¼ INCHES

WANDA GÁG

"MOTHER Nature, Human Nature, the Unguessable! What does anyone know about their possible reactions? I for one am continually surprised at mine, and it is only in the calm and more uneventful parts of my life that I find myself presumptuous enough to think I know how I will respond to this or that." In these words Wanda Gág suggests the flux and turmoil, the dynamic quality of her life and work. She is an enigmatic person, a taut equilibrium of many conflicting forces, caution and abandon, logical cerebration and jungle temperament, feminine sensibility and masculine ruthlessness, genuine humility and expansive egotism. All these volcanoes are concealed under a deceptively childlike exterior, trim youthful figure, innocent face set in a shapely head with bangs of inky black hair. Yet keen observers have noticed more: Stieglitz, for example, has spoken of her expressive hands — expressive, not beautiful — of the curious nervous mouth, of the dark burning eyes. And Wanda Gág herself in a moment of frank appraisal has written: "Round eyes and turned-up nose notwithstanding, I'm an austere lady — one who, although managing often to reach the greatest heights of ecstasy in creating pictures, yet realizes that even this ecstasy may

only be a pet illusion or drug. I live in a state of constant humility because of the instability of flesh and blood and a sense of cosmic futility. Every once in a while someone is surprised at finding something grim or somber in my pictures, although my frisky lines and somewhat humorous slant are all that can actually be seen on the surface."

Wanda Gág is a native American and has never once been outside the country. She was born in 1893 in New Ulm, Minnesota, of Bohemian parentage, the eldest of seven children. Her idealistic father painted and decorated houses, even an occasional mural in a church, with moderate financial success. On Sundays he painted pictures for himself. "My mother," Wanda Gág recounts in her early recollections, "my sisters and brother, and even the half-peasant uncles and aunts 'down at Grandma's' had the æsthetic urge in some form or other — and I spent my earliest years in the serene belief that painting and drawing, like eating and sleeping, belonged to the universal and inevitable things of life." She was, however, to learn otherwise. Her father, after a long illness brought on by working in damp, unheated churches, died when she was fifteen, leaving to his family the house in which they lived and about a thousand dollars of insurance money. Wanda helped her mother, who was herself ailing, with the housework, and earned a dollar now and then making place cards and writing and illustrating stories for the children's section of the *Minneapolis Journal*. She has a vivid recollection of that experience:

"There followed years of struggle for us all. To me it was a jumble of housework, hungry children, endless woodchopping, 'drawing fits,' and adolescent sentimental moods — and a yearning for oysters and butter. We determined that the title of the house should be kept clear and that we were never to get into debt. The insurance money was made to stretch over six years, so even with occasional donations, and eight dollars a month which the county allowed us for groceries,

there was rarely enough food. Our meals were often pitiful — in retrospect, amusingly so. For instance there was the famous ' Dingle supper.' Dingle was a baker who sold us stale sugar rolls very cheap. A dime bought enough of these for a scanty supper, the sugar coating serving as a substitute for molasses — butter and jelly were to us the rarest luxuries. We ate Dingle rolls and nothing else. It was a task to divide the food fairly between us, until we thought of putting it on the basis of a game of chance. After making seven equal divisions (Mother always took a smaller share with the excuse that she was not growing any more), one of us numbered the portions mentally. Each child chose a number at random, and received the portion which that number represented. As there was no finding fault with one's own choice, everybody had to be satisfied. It might be supposed that the one who did the numbering could juggle the portions to her advantage, but no one thought of questioning her integrity. There is no way in which I can describe our extreme sense of honor in this matter, swearing on the Bible being a pale oath by comparison.

" Among the donations we rejoiced in were other people's castoff clothes. I often went blocks out of my way to avoid meeting the person whose contribution I happened to be wearing. We soon learned to remodel them beyond recognition, and became so expert that we were criticized for ' dressing swell.' I could not stop drawing and reading, and was made to feel guilty for that. ' Wanda could find something better to do than sit in the yard and read and draw all the time.' We were finally completely crushed by these criticisms, and regained our self-respect only when we were safely assembled in our funny tall house, where we drew, sang, and played games among ourselves. I think this self-sufficiency, in spite of our poverty, nettled some of the inhabitants of New Ulm.

" After a year and a half at home I came, not without tears and fumbling, to an important conclusion. Things were looking hopeless,

and it seemed to me that whether we were to swim and come out Gágs, or sink and stay in a small town forever, depended on a plunge — a high school education for us all. To have planned this for the rest and sacrificed myself to the noble cause would have been preposterous enough in the eyes of the natives; but brazenly to include myself was nothing short of selfish; and it was, in a way. I was eager to help the family, to be sure, but how much of me did they really need — all? How much did I belong to myself? To what extent had I the right to ignore myself — not the physical part that walked around and worked, but that fiery thing inside that was always trying to get out and which made me draw so furiously? That was something to be considered, too. Hadn't Papa told me? His last conscious words had been in regard to this very thing. 'Wanda,' he had said faintly and with that utter-artist look in his eyes, 'what Papa has left undone, you'll have to do.' And I nodded my head, speechless with the sudden realization that he was dying and overwhelmed with the poignant drama of what was happening to me. Now then, was not this a justification of my course? It was more than that — a rich legacy, a coat of mail, something to fight the world with! A defiance flashed into birth within me, 'I must go to school again!' Mother was willing if I could see a way to do it. A few discerning people saw my point of view and even offered to help me. And so I went to high school, earning more than my way by drawing and writing stories as before, and giving many a day besides to household duties. After graduating I taught country school for a year. The autumn after that, my oldest sister was ready to teach — which was fortunate, for in the meantime I had won a scholarship and was sent away to art school."

In 1913 she went to St. Paul to attend the St. Paul Art School, and for the next four years she studied there and at the Minneapolis Art Institute, interrupted at times by the necessity of earning a living. Her mother died and she became titular head of a family of six

orphans. Herschel V. Jones, editor and owner of the *Minneapolis Journal,* became interested in her work and contributed material financial aid toward her schooling. Among her fellow pupils at art school were Adolf Dehn, Arnold Blanch, Lucile Blanch, John B. Flannagan, Lloyd Moylan, Elizabeth Olds, and Harry Gottlieb, all of whom were to become nationally known. It is interesting to speculate why such a distinguished group came together at one time in Minnesota. It was not that the art school was so extraordinary or so far in advance of its time. It was a good school — above the average — but its ideal did not extend beyond Whistler (the impact of the Armory Show of 1913 had not yet penetrated the West). For example, in drawing there was no idea of *form,* three-dimensional realizations, spatiality; there was only a two-dimensional concept of pattern and contour drawing with flat shading. All of these artists had to work out their personal style much later. Miss Gág, however, remembers with gratitude several of her teachers. Owing to the pressing need for making a living immediately, she specialized in illustration rather than in pure art. Her work, as she herself admits, was superficial and trickily clever. There must, however, have been something more than that to her work, because she won a scholarship in a national competition for the Art Students League in New York. Dehn also had won one, the first time that two scholarships had been awarded from the Minneapolis art school in one year.

In 1917, therefore, she came to New York for a year's study at the League. New York she found was an even tougher nut to crack than Minneapolis or St. Paul. She was desperately poor, in urgent need not only to support herself but to send a little money to her family back home. For some years she was just one of many art students, earning a precarious living, painting lampshades, making fashion drawings, trying to get commercial work, making batiks, and so on. Gradually she became a little more successful, brought her sisters and brother to New York one by one, and saved up a little money.

In 1923 she made a decision which was to have a great influence on her development. She gave up all her commercial work and went to live in a tiny shack, first in Connecticut and later in New Jersey. It was there that she really became an artist in her own right. One of the factors which aided in clarifying her decision to " go native," as she called it, was the reading of Thoreau's *Walden* and Hamsun's *Growth of the Soil.* Another, and more important perhaps, was the pressure of certain innate drives for self-expression which had been stifled by her commercial work. " During my years of fashion draw-ing," she said, " my whole sense of the body was perverted. I lost all fundamental feeling for it and I dare not draw it until I have pulled myself out of this perversion." She set out patiently and la-boriously to build up a new æsthetic — her own — a personal vision and style. For years she ignored the figure entirely and made elabo-rate form studies of trees and plants and rocks, exercising and de-veloping a three-dimensional sense, a feeling for form and spatiality. They were fragmentary studies and not in any sense works of art; that would come later. Then there were certain vague intuitions that she was striving to realize and could not explain — something about making the empty spaces count as positively as the concrete spaces, projecting a sense of the potentialities and pregnancy of those empty spaces, of all the things that might happen there, and the interplay of what might be called positive and negative forms. Akin to this was the idea of the layers or aura, as it were, of natural forms, that press out into the surrounding atmosphere; a scheme of vast and complex relations between all objects, a cosmic equilibrium of forces, all the planes and lines and points thrusting out their forces and being held back by other planes; each object sending out its aura-like ripples until it meets another aura. She was to continue her exciting exploration of spatiality for many years to come. In 1926 she wrote in a letter:

" Just now I am wrangling with the hills. In looking at a peaceful,

rolling hillside, one would never guess that it could be composed of such a disturbing collection of planes. The trouble is that each integrant part insists on living a perspective life all its own, although it knows darn well it will have to conform to the big mass in the long run. It's the very devil to reconcile all these seemingly conflicting fragments to the big forms of the entire hill. I am determined once and for all to get at the bottom of the principle which governs all this. It's the same thing I encountered in the squashes last fall. I thought I caught a glimpse of it then, and seemed on the verge of grasping it. But I see now, I was far from it."

And later: " I am out on the hills every day, now, in pursuit of the Hill-Form Principle. He is still elusive though ubiquitous. As I scurry or plod along, I find here a foot-print and there a bit of fur. I daresay I'll never see him in his entirety — but, as in the case of the dinosaur, will have to construct him in my imagination from such fragments as I can gather from time to time. Then, as you point out, whether it will be accurate or not will not be of so much importance as long as it's built up solidly, and as long as I believe in it sincerely and with sufficient intensity. Yesterday while trying to catch the Beast by means of a sandpaper drawing, I had an exhilarating struggle. I was literally limp at the end of it, but came out of it with what I think is a solid drawing."

These were days of plain living and high thinking, always skirting on the edge of poverty. She made experiments in the graphic processes, linoleum cuts and, since she could not afford lithograph equipment, sandpaper lithographs (it is possible to make by proper manipulation a small number of prints from a lithographic crayon drawing on sandpaper, instead of on stone or metal, an interesting though limited technique). Later she made wood-engravings, lithographs on zinc and stone, and a few etchings and drypoints. Along with these of course were innumerable drawings, some of which appeared in advanced magazines such as *Folio,* the *New Masses, Broom,* as

well as watercolors and some painting in oil. Thus in the course of much travail was precipitated the characteristic expression, the personal style that we now associate with the name of Wanda Gág.

One of the elements of this personal style is her feeling for dynamic composition. Her design is never static: it is always the balanced resultant of opposed or conflicting forces. "A still life," said she, "is never *still* for me, it is solidified energy." In looking at her pictures, the eye participates in an exciting æsthetic drama of interplay of centripetal and centrifugal forces, driving deep into space as well as ranging this way and that. Sometimes the eye, in following the lines of force, almost escapes from the confines of the picture, yet never is quite allowed to do so; the rebellious lines are always kept in by all sorts of ingenious and amusing devices. Her sense of form approximates that of music. "There is something so flowing, so clear about the pattern of great music."

Another element is, as we have seen, a passionate awareness of space relations. She builds up every dimension of an architectonic unit in her mind before making a picture; and when she has mastered it, she sets it down with every resource of tactility at her command. This thorough digestion of subject matter has always been a principle with her. In her art-school days she used to have big arguments with her instructors, who would not believe her when she said she had planned a drawing without blocking it out. She sometimes would sit for half an hour before the blank sheet of paper. In front of a landscape, for instance, she might walk around it in imagination, over every part of it, to get the feel of it before she would draw at all. I remember once, while watching her draw a bit of landscape I knew very well, she asked me what was beyond a certain knob or hill; it did not show in the drawing but she wanted to know what the contours were. Such absorption and transmutation of material are possible only with great intensity of effort.

How to measure or describe such intensity? It can only be sug-

gested by such words as fury, the tense abandon of sex passion, the eruption of a volcano, the release of a bolt of lightning. It is incredible what dæmonic energies seem to be locked up in her frail frame. All her life she has been subject to what she calls " drawing fits." During these periods of rapt dedication she ignores, as much as is physically possible, the call of food or sleep, and wishes not only that she was not a woman but also that she was not a human being at all. During the inevitable fallow periods there are always the worry and anxiety — will the drawing fits ever come back again? Her whole life has been a succession of attitudes and moods, some of which were imperious and brooked no resistance, others over which she exercised some measure of choice or control. But once she yielded to a mood, she did so absolutely and unreservedly. She is a baffling combination of practicality and impracticality. She is practical because efficient in whatever she does, impractical because she is dedicated not to worldly success but to a guiding voice, like Socrates' Dæmon, within her. Her integrity is absolute.

Wanda Gág's subject matter has a folk-tale or universal quality. She has a deep feeling for landscape, for animals, for hills and trees and flowers, for the perennial march of the seasons. Her letters are filled with minute and penetrating observations of nature. But she has also rendered the city, its buildings and streets, in a very individual way. And then there are the still lifes and interiors, a lamp, a chair, a pattern of shadows on a wall. As models she uses her own surroundings, her family, or herself. People have spoken of her preference for dilapidated buildings, homey things, cats or a " tired bed." She had no special preferences, she said, she had always been more or less surrounded by such things, and she merèly drew what was around her. In this sense of interior or stay-at-home adventure, in this penetrating appraisal of things at hand, in this practical acceptance and use of surroundings, is she not more nearly at the core of woman's unique contribution, in so far as woman is differentiated

from humanity in general? Rockwell Kent once said to her: "You draw everything around you just as it comes, and make it interesting, whereas I must first idealize or dramatize it." Of course, she dramatizes her material in a way, also. I remember watching her make some drawings at the Paramount Theatre. The spots in the interior which interested her most were just those which were most lacking in rhyme, reason, or purpose. These she endeavored to draw as a discipline to her organizing powers.

An organizing faculty such as hers makes use of a certain amount of distortion for design or emphasis. The question of distortion is always a stumbling-block for the layman or literalist. They always forget that a work of art is not a factual transcript of nature but a play, obeying conventions of its own, in which the acting parts, in this case lines and planes and symbols of objects, are heightened or distorted for emotional and dramatic effect. Wanda Gág has written an analysis of two of her own lithographs which is worth repeating for the insight it gives into an artist's motives and creative processes.

"*Siesta* shows a family of cats basking in the warmth of an early autumn fire. I am always amused at the natural tendency of cats to fit themselves into and over all sorts of places and spaces — and from an artistic point of view I am interested in the interrelation of forms resulting from this. I felt the room as a space in which cylinders (stove, wood), cubes (box, bench), flat surfaces (floor, walls), and the more pliable forms of the cats all had their place. Since I wanted a mood of calm and comfort, I used a simple composition of familiar objects grouped around a nucleus of light, and arranged so that the eye could travel easily from one to the other. Technically I was interested in bringing out the delicacy rather than the forcefulness of the lithographic medium, so I built up this drawing by the use of many fine lines.

"When, after many years, I returned to Minnesota and again saw the front room Down at Grandma's, it seemed to me epitome of

Parlor — a staid, rather cold place, the clean, dustless repository of objects too 'artistic' to be sullied by use. That, at least, is how it impressed me objectively. Subjectively a host of childhood associations crowded themselves into the scene, softened its lines, and gave it a life of its own. Out in the kitchen sat my solid peasant forbears — here in the parlor was this baroque display, their naïve acceptance of mid-Victorian 'beauty.' It was amusing but touching too, and so when I began to draw, a wave of tender tolerant mirth flowed through me and over my paper. That, I suppose, is why the picture came out as it did: the Grand Rapids dresser atilt with gaiety, the lamp like a clumsy gosling poising its ridiculous wings for flight, and the two little pitchers swaying and saying, 'Let's dance.' Technically I tried to get all the richness possible out of the lithographic medium. An old-fashioned parlor, arranged mainly for show rather than use, has something theatrical about it; and to portray this, I used a strong black-and-white design — an almost spotlight effect — to bring out the rococo pattern against the rich black shadows."

I have quoted at great length from Wanda Gág's writing because she is unusually articulate for an artist. There is precision and definiteness in whatever she does. She writes with genuine distinction of style; indeed, she writes so well that one is forced to the conclusion that she is as great a writer as she is an artist. In 1928 she published a story, *Millions of Cats,* written and illustrated by herself, which has become a veritable children's classic, for it has all the memorable quality of a folk-tale. This was followed by *Snippy and Snappy, The Funny Thing, A B C Bunny, Gone is Gone,* and her own translation of *Tales from Grimm.* The recent publication of *Growing Pains,* the diary of her adolescent and Minnesota art-school years, reveals still another facet of her creative personality. She has kept a diary since her fifteenth year, and judging by the portion that has been revealed by publication, it is one of the most extraordinary human documents ever written. In its entirety, which no one outside herself has ever

43

seen and probably ever will, it is no less than a complete and all-around projection of one woman's life with the utmost candor and self-analysis of motives. As far as is humanly possible she is frank with herself. I once asked her why she wrote a diary. She had no other reason than that she "must" — a force as compelling as her "drawing fits." During the last decade she has devoted the major portion of her time to writing at the expense of art expression. Her creative energy apparently is channeled in the two fields of art and literature. It remains to be seen which will constitute her major interest.

She has to date made a little less than a hundred prints. Some of them are tentative and experimental, but some of them rank with the finest things of our time. She has worked out for herself a characteristic technical language; she builds up her compositions by means of short nervous strokes that indicate and reveal contour and lines of force: flicks or jabs of the graver on wood, dots and tiny strokes with crayon or tusche on stone. Among the most notable of her prints are, in wood-engraving, *Franklin Stove, Spinning Wheel, Christmas at Tumble Timbers, Cats at Window;* of lithographs on zinc or stone, *Easter Morning, El Station, Spinning Wheel, Spring in the Garden, Lamplight, Stone Crusher, Grandma's Parlor, Backyard Corner, The Forge, Snowy Fields, Spring on the Hillside, Winter Garden, Ploughed Fields, Fairy Tale, Siesta, Abandoned Quarry, Macy's Stairway.*

Wanda Gág is an original, in no sense a derivative artist. A great designer in space, she works with the common experiences of humanity in everyday things. A conscious creator, she transmits to her work her personal sense of vitality and drama. She is spiritually humble, never resting on her oars but ever struggling toward greater perfection and the final secret. In spite of vast differences of background, there is a certain kinship between her work and the poetry of Emily Dickinson, the same passionate intensity and tingling form.

ROCKWELL KENT

AT the beginning of the first book illustrated by Rockwell Kent is a drawing of a heroic man striding beside an obelisk, and underneath is written the legend: "Vaster is Man than his Work." This proverb sounds the keynote of Rockwell Kent as a man and as an artist. With most artists, the work is greater than the man. Not so with Kent. Art is but one facet of his total expression. He is not only an artist; he is also a writer, an explorer and adventurer, a farmer, a sailor, a builder and craftsman with tools, a great illustrator, a former magazine editor, a lecturer and magnetic speaker, a great friend and lover, and, above all, a man. Like the great figures of the Renaissance, he is a man of many accomplishments and even greater potentialities. He might have been a great lawyer through his ability to think quickly and concentrate and deliver his powers at a given moment. He might have been a great business man through his executive ability and his practical grasp of essentials. He might have been and may still become a great leader of men through his personal magnetism, his adherence to principles, and his unquenchable physical vitality.

Whatever he undertakes he carries through to the utmost with

mind, body, and soul, whether it be playing tennis, baking biscuits, or discussing philosophy. I have seen him, with an axe, shinny up a tree, fifty feet high, which had jammed against another in falling, chop away the obstructing limbs, and jump to safety as the tree crashed down. I have seen him the life of the party in wit and animation among the most sophisticated people of the metropolis. He is equally at home in a box at the opera or on a dog sled in Greenland. It is a cardinal part of his philosophy to be equal to any situation, whether it be outdrinking the hardest drinker, driving a car at eighty miles an hour, dancing with a pretty girl, or engaging in a controversy with a railroad. I have never seen a man whose powers were so completely under control and at the service of the will. I wonder through what arduous self-discipline he achieved such mastery over himself. Perhaps it was because from youth onwards he has never allowed any challenge to his will to remain unanswered. I remember his telling once how on the island of Monhegan he came upon a cleft or chasm, quite wide and terribly deep. It was just barely possible to jump across — a fifty-fifty chance. Somehow the challenge came to him to jump it. He examined it closely; he was afraid, yet that fear spurred him on to renewed determination, and he finally jumped it. He could never have faced himself again if he had flinched from that challenge. The truly brave man is the one who is afraid and does things in spite of it.

In an autobiographical fragment Kent has shown how his life was shaped by a series of just such challenges. " Probably for no better reason than that I was born in Westchester County, which has practically no sea coast, I wanted more than anything in the world to live on the ocean; so I went to Monhegan Island. Because I had never done any work with my hands I was most impressed by the strength and potential power of people who did work with their hands. Seeing fishermen at work on an element that was terrible to me, I felt my own inferiority and the necessity to restore my self-respect by learn-

ing how to work. So I became in course of time a laborer and earned my two dollars a day by heavy work. I was intelligent and learned to use tools. I built my own house. I became a carpenter. I had a chance to work at lobstering. It was winter work, getting up before daylight, going down to the harbor in oilskins that were stiff as sheet iron from the cold, rowing out to the dory moorings, chopping the ice off the gunwale of the dory and, with another man, rowing out to sea just as the first light of morning appeared.

"Those were days of hard work, with all the excitement of a new and dangerous vocation. I liked the cold. It was stimulating. It became an obsession to me. Have I said I liked it? I question that. It may be that I hated it so that I got a kind of exaltation from the effect of overcoming it. I liked the thrill of working to keep warm when it was cold, of building a hot fire out of wood that I had cut myself to warm that little house that I had built myself against the bitter cold of the Maine winter. I have never been quite sure that the most profound incentive of my whole life has not been overcoming that lazy slothful sensuous being that I maybe am. I suspect that I get up early in the morning because I want to lie in bed, that I exercise because I want to sleep, that I work because I am essentially lazy, that I want to accomplish something because I have profoundly a contempt for accomplishment."

Kent may be said to live an ideal life — an exemplar of the all-around man. He lives on his beautiful Adirondack farm in a beautiful house that he built himself, surrounded by beautiful pictures and furniture and a fine library of the world's great literature. He has his pedigreed stock, his polo ponies, his tennis court, and his swimming-pool. Music means much to him — Bach, Mozart, Beethoven, Wagner, and folk-song. There is ensemble playing, piano and strings, with his children and their musician friends, in which he takes part with his voice and flute. In such an environment he, the perfect host, receives his friends — Stefansson, Peter Freuchen, Thomas Cleland,

47

Louis Untermeyer, Lewis Milestone, Donald Ogden Stewart, and a host of others. He enlivens any gathering with his innate charm, his quick wit and dramatic expressiveness. What grand times have been celebrated there — music, brilliant talk, good-fellowship, picnics, revelry at the bar, punctuated by moments of philosophic ecstasy under the stars! He lives a full and rich life, completely adjusted to the amenities of culture and civilization. Yet he can give it all up and live excitedly and dangerously in a Stone Age environment for years at a time, live in hardship and austerity and enjoy it. Yet he can give most generously of his time and energy and money in support of those radical causes which he holds dear. I have known Kent in poverty and in affluence. His attitude toward life has not changed. To a greater extent than most human beings, life does not happen to him: he happens to life.

A perfect flowering of the extravert attitude! But there is more to him than that: he is extravert *plus*. There is a mystic strain in him — in those moods in which the world and all its ways fade into nothingness in the presence of intuitions of more cosmic significance. Because he attempted to translate some of these intuitions into the visual arts (not always effectively to the world at large, since mysticism implies kindred experience to be fully appreciated) he has been accused of being an imitator of William Blake. That he is a great admirer of Blake he does not deny (who wouldn't be?), but his mysticism is no mere imitation: it is part of his life. It has always astonished me that his mystical pictures are as popular as they are, for I am sure that they are understood by very few. Mysticism is so alien to the general temper of the age, so remote from everyday experience, that to most people his pictures must appear to be meaningless poses. But every one of those figures which people in their superficiality label Blake is in reality Kent himself. He has lived those figures, he has taken their poses and gestures, he has felt all their muscular tensions, he has put himself in their place. In Dante's

48

ROCKWELL KENT: SELF PORTRAIT

LITHOGRAPH

13⅜ x 9¼ INCHES

ROCKWELL KENT: NORTHERN NIGHT

WOOD-ENGRAVING

5½ x 8¼ INCHES

ROCKWELL KENT: MAST-HEAD

WOOD-ENGRAVING

8 x 5½ INCHES

ROCKWELL KENT: NIGHTMARE

LITHOGRAPH

10¾ x 8 INCHES

memorable words: "*Chi pinge figura, si non può esser lei, non la può porre.*" (Who paints a figure, if he cannot be it, cannot draw it.)

There is in him also an idealizing tendency, especially in relation to human beings. His imagination sometimes overshadows reality. People to him are not always what they really are but what he conceives them to be. This trait naturally prevents him from being a great portrait-painter. His few portraits fall in such categories as a "Portrait of a Son of His" or a "Portrait of a Friend of His." And this tendency sometimes gets him into difficulties in his personal relations. Some of his friends have not been content to remain themselves, but have for the time being adopted his estimate of them. They have played up to it and heightened its effect. Things went on beautifully till at some crisis they reverted to themselves with disillusioning and disastrous results. Nevertheless it was a beautiful and noble tribute he paid to them as friends; it is a pity that they could not live up to it.

For all his masculine traits of initiative and power — the glorified he-man that he is — there are an astonishing number of feminine traits in him also: tenderness, sensibility, and at times a measure of irrational vindictiveness. He has always had a horror of destroying life needlessly. There is none of the sportsman killer in him. He has gone through all his adventures without protective firearms. I wonder if his masculine assertiveness, his pride in maleness, is not to a certain extent a deliberate overbalancing of the feminine side of his nature. It is especially in his relations with women, however, that his feminine traits serve him. His tenderness, his deep intuitions of womanly feeling, his innate understanding of womanly nature, together with his power of idealization and sentiment, his ability to snatch the moment and make it beautiful, his masterly control of his own great powers, which he dedicates to the service of his beloved — all these combine to make him the great lover.

49

In one respect his extravert attitude is very evident — in his impatience with weakness, sickness, and the neurotic temperament in general. Enjoying superb health and vitality, he cannot understand a state of sickness. Having disciplined his faculties to the control of will, he cannot tolerate vacillation or irresolution. The knots and tangles of man's ego arouse in him not pity but disgust. So, too, in spite of his sentimental regard for the state of childhood, he does not really understand children, their incompleteness and appealing weakness. He is at his best associated with maturity in the fullness of its powers. He is a yea-sayer to life. He has tasted life and found it exciting. His expression, whether in life or in art, is a triumph of will and health and vitality.

"Everywhere that I have been," writes Kent, "I have had enthusiasms and excitements. I have had the excitements of certain little risks that I have run, the enthusiasm of being where nature was immense, where skies were clear at night, where lands were virginal. I have stood in spots where I have known that I was the first white man who had ever seen that country, that I was the supreme consciousness that came to it. I have liked the thought that maybe there was no existence but in consciousness, and that I was in a sense the creator of that place. And because I have been alone so much and have been moved by what I have seen, I have had to paint it and write about it. And by virtue of that need to paint and write I am an artist."

It is strange, in view of his claim that his art is exclusively derived from life, that he has not carried over into his expression certain qualities that are very conspicuous in his personal life, such as a certain warmth and personal magnetism that are manifest in his contacts with men and women, a certain interest and psychological insight into purely human affairs. There is no doubt that he has the knack of immediately establishing essential relations with his fellow man of the most varied types, and that he is a born leader among

men. It is possible that in spite of his sociability — "hail fellow well met" — there is an essential loneliness in his soul that must find expression in his pictures of man as insignificant before the stupendous forces of nature. Indeed, he once said: "That these pictures may convey to those who see them some of the elation of self-forgetfulness is all that they are meant to do." If one can reconcile such seeming opposites as extraversion and introversion, mysticism and a practical way of life, adaptability to both primitive and sophisticated existence, loneliness and sociability, one can perhaps arrive at the secret of his psyche.

Rockwell Kent was born in Tarrytown Heights, New York, in 1882. He studied architecture at Columbia, and then with the encouragement of Professor Ware took up the study of art under William M. Chase at the Shinnecock Hills School, with Robert Henri and Kenneth Hayes Miller at the Independent School of Art, and finally became an apprentice to Abbott Thayer at Dublin, New Hampshire. He thus has had an unusually long and thorough training in his craft. In addition, his later experiences as a carpenter and builder, and his familiarity with tools, served him in good stead when he came to take up the graphic processes. He is a beautiful craftsman. His wood blocks are marvels of beautiful cutting, every line deliberate and under perfect control. The tones and lines of his lithographs are solidly built up, subtle, full of color. His studio is a picture of an efficient workshop, neat, orderly, everything in its place. His handwriting, the fruit of his architectural training, is beautiful and precise. Nothing vague or accidental about him, nothing at loose ends. His expression is definite, clear, and deliberate. Misty tonalities are not to his taste, nor vagueness, suggestiveness, the dramas of the unconscious. His is a highly objectified art, clean, athletic, sometimes almost austere and cold. He either records adventures concretely, or deals in ideas and feelings about ideas. He may be said to be an intellectual artist in the sense that Rivera or Hogarth or Dürer is in-

tellectual, and in contradistinction to artists of the emotional-creative type such as Orozco, Dehn, or Rembrandt.

It is quite obvious that Kent does not work in the French tradition that is current today. It is this fact (when it is not envy or malice) that is the basis of most of the criticism that is leveled against him. His art is not based on impressionism or pure decoration or æsthetic spatiality as is the School of Paris. It stems from another — possibly more Nordic — tradition; it is romantic, symbolic, or documentary in character. Man is the hero of most of his pictures, where with other artists it may be apples, Kansas, or a studio nude. He stands almost alone in his use of symbolism among the artists of today. What other artist has produced such wood-engravings as *Over the Ultimate, Twilight of Man, Masthead, Starlight?* They are symbolic representations of certain intuitions about the destiny of man and the meaning of existence. Take for example *Masthead;* this is what it seems to say: Man, in his struggle to capture ultimate reality, to penetrate into the mystery of the dark night of the universe and discover the reason of his own existence — Man in all this struggle has climbed as far as he possibly can, he has come to the very end of his resources. He has discovered that he cannot fly at will into the universal, but is bound down to earth by the limitation of his senses. It is a tragic but at the same time a heroic conception — akin in mood to Bertrand Russell's "A Freeman's Worship." Consider again the mood of wonder in *Man at Mast* or *Starlight,* of terror in *The End,* or *Nightmare,* or the dynamic vitality and exultation of *Pinnacle.* Such are the overtones that his prints evoke.

His first important wood-engraving, *Bluebird,* was made about 1919. Since then he has made about a hundred and twenty-five wood-engravings and lithographs in almost equal proportions. His prints are distinguished for their balance of black and white masses, their beautiful draftsmanship, their precision of execution, their con-

trolled clarity of form and tonal values, and their largeness of conception. His design is orderly and composed with that sense of rightness and order that is natural in an architect's approach to the universe. Such an achievement is not spontaneous, but deliberate: I have seen sheet after sheet of studies in preparation for a print — individual details to be perfected, the totality of the composition to be harmonized, the particular to be abstracted into the universal. Of course not all of his works are equally deeply felt or perfectly executed (he has made pot-boilers and is the first to admit it), but such prints as *Twilight of Man, Masthead, Over the Ultimate, The End, Forest Pool, Lovers, Man at Mast, Starlight* (technically interesting, also, for its building up of a body solely from arms and legs), *Northern Night, Homeport,* and *Fair Wind* represent a definite contribution to American wood-engraving. Some of his later engravings, especially the last three mentioned above, are interesting for their increased suggestion of color: he has broken up some of his black masses into various textures of semitones. He has recently made a chiaroscuro wood-engraving in two colors, *Night Flight.* Notable among the lithographs are the superb *Pinnacle,* the *Roof Tree,* the *Self-Portrait* ("*Das Ding an Sich,*" he calls it; a frank and honest appraisal, the topography of a head without any adornments or extenuations), the *Nude* (in two colors), *Sermilik Fjord* (in three colors) *Mala* (a masterpiece of vivid and grotesque characterization), *Young Greenland Woman,* and the psychologically impressive *Nightmare.* In many of the lithographs, particularly the Greenland series, the impulse is not so much symbolic as documentary. Throughout his life there run these two strains — symbolic imagination and romantic realism.

Rockwell Kent is a positive force. He has put his impress on many fields of American life, and particularly on the graphic arts, in wood-engraving and lithograph, in illustration and book-making, in book-

53

plates and advertising design. He is one of the most widely known artists in the United States, and one of the most misunderstood. That he has a secure place in the roster of American artists is certain. Which of his many talents will be singled out for memorable distinction, time alone will tell.

RAPHAEL SOYER

Who can make a poem of the depths of weariness
bringing meaning to those never in the depths?
Those who order what they please
when they choose to have it —
can they understand the many down under
who come home to their wives and children at night
and night after night as yet too brave and unbroken
to say " I ache all over "?

THIS poem of Carl Sandberg's suggests a mood and temper appropriate to the life and work of Raphael Soyer — the tone of gentle compassion that is so much a part of his inner motivation, and more than a faint suggestion of his own experience in life. His is a voice of the nameless multitude, the downtrodden and underprivileged, the immigrant aspiring to freedom and a full life, and floundering in, oh, what a mockery of it. But it turned out for him as it did for Mary Antin: " In the Dover Street Ghetto I was shackled with a hundred chains of disadvantage, but with one free hand I planted little seeds, right there in the mud of shame, that blossomed into the honied rose of freedom."

Raphael Soyer was born in Tombov in 1899 and did not come to

America until he was twelve years old. His twin brother, Moses, has drawn an attractive picture of their early life in Russia and the United States: " Even before we came to America we knew a great deal about it. Our favorite books were *Tom Sawyer, Uncle Tom's Cabin,* and *Hiawatha,* and among the heroes of our childhood George Washington and Abraham Lincoln led all the rest. On week-ends and holidays our mother would cover the large round dining-room table with a shiny oilcloth, on which in barbaric red and green was pictured Brooklyn Bridge (*Brooklynski Most*) spanning the East River and joining the 'glass' skyscrapers of Manhattan with the slums of Brooklyn. Raphael, Isaac, and I loved this table cover. We would spend hours at a time studying it. Often in our fancy we would be transported into this magic city. Our father, too, spoke to us about America, about its vastness, its riches, and its democracy. 'Who knows,' he would say wistfully, 'perhaps you too might one day be citizens of this great Republic and contribute your talents and strength to its growth.' Our father is truly a remarkable man. Self-taught and self-made, in the real American sense of the phrase, he toiled hard all his life, and has never deviated from the ideals he set for himself in his youth. At seventy, presenting the appearance of a Rembrandtesque scholar, he is still full of life, tolerant to youth and vitally interested in world affairs. An author and teacher of modern Hebrew literature and history, he is esteemed by his contemporaries and literally idolized by his many pupils.

" We inherited our artistic tendency from both our father and our mother. Our father had an innate talent for drawing. In his rare moments of leisure he would draw for us, in a primitive yet strangely alive way, people, birds, or animals. He was especially adept at horses. He could draw them in many attitudes with a fine eye for character distinction. Our mother, too, had a sense for the artistic. We used to love to watch her embroider on towels and table spreads, illustrations of Russian fairy tales, in vivid, bright color schemes. I

56

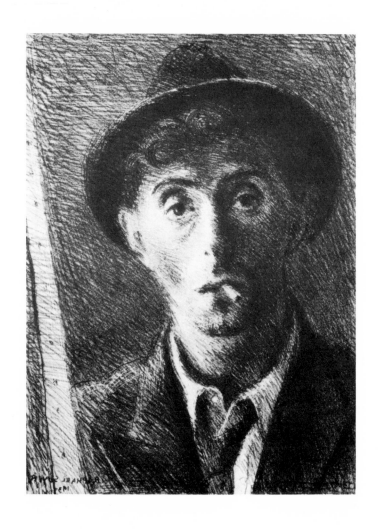

RAPHAEL SOYER: SELF PORTRAIT

LITHOGRAPH

13¼ x 9¾ INCHES

RAPHAEL SOYER: THE MODEL

LITHOGRAPH

16¼ X 12 INCHES

RAPHAEL SOYER: BACK STAGE

LITHOGRAPH

$16\frac{1}{4}$ x $11\frac{1}{2}$ INCHES

RAPHAEL SOYER: THE MISSION

LITHOGRAPH

$12\frac{1}{4}$ x $17\frac{3}{4}$ INCHES

remember one in particular, that of a young Cossack on a beautiful white steed, bidding farewell to his weeping mother. She was quiet, more critical than our father, by nature the more hesitant. Encouraged by our parents, we drew and painted constantly. The walls of our living-room were always decorated with our childish efforts.

" One fine day, in the year 1912 to be exact, our father suddenly received a curt communication from the Governor of our district to leave Russia, the land of his birth, immediately and forever. After selling what household goods he possessed and after many touching farewells, our father, at the head of his large family, set forth for America, the land of his dreams and of limitless opportunities, to begin life anew. We children saw no tragedy in all this. To us it was a glorious adventure.

" We settled in the lower East Bronx, our father went to work and we to school. We had a difficult time at first. Shy, self-effacing and ill at ease, we could not adjust ourselves for a long time. Unlike our two younger sisters, who quickly acquired the American ways of habit and speech, we clung sullenly to our Russian, much to the sorrow of our poor parents. Like most European children, we were better educated than the American children of corresponding age. Especially Raphael and I, since we were the oldest, and also because some of the high-school and college students in our town, grateful to our father for his help with their examinations and theses, would reciprocate by coaching Raphael and me in their favorite subjects. . . . Thus we knew quite a bit of French, German, and Hebrew in addition to our native Russian. We completed grammar school in two years and entered high school. Here, too, we were maladjusted and unhappy. We were happy only in the badly lighted and ill-ventilated back room in our apartment which our mother had allocated to us. Here we did our lessons, posed for one another, and painted and drew our sisters and parents, our little brother, and the children of our neighbors.

57

"Some years went by. Things were not going well with us. Our father, though he worked very hard, could hardly provide for his large family. Mother was losing her youth rapidly and often looked sad and worried. Finally things came to such a pass that Raphael and I decided to quit high school and go to work. It was a sad blow to our parents, for it meant the end of perhaps their fondest dream, that of sending their children through college. Yet the circumstances were such that they could do nothing but acquiesce, sadly and quietly. We also decided to take up art seriously."

In 1916 they went to work and studied art bit by bit on the side. Raphael got a job distributing newspapers and also worked in a clothing factory as errand boy. Meanwhile he was groping toward art. The twins discovered the National Academy of Design School and attended off and on. One Sunday Moses visited the Ferrer Center, to which Henri and Bellows would come to give criticism to young art students. Henri criticized severely one of Moses's drawings for its academic and superficial cleverness and contrasted it with a drawing by Daumier in a copy of the *Liberator* which he happened to have at hand. This criticism made a great impression on Moses: "Elatedly I described to my brothers the encounter with Robert Henri. I must have succeeded in transmitting to them some of my enthusiasm for Henri's ideas, the meaning and importance of which I felt rather than understood, for they listened eagerly and were greatly impressed. We pored long and studiously over the copy of the *Liberator* which I brought home. In addition to the Daumier drawing, it also contained drawings and etchings by Sloan, Henri, Minor, and Luks. We fell in love with their work. What impressed us most was the up-to-dateness, the contemporary spirit of the content of the pictures. These artists dealt with everyday, common people and with their humble, hard lives at home and in the shops. There were also pictures of strikes, police brutality, of child labor and so forth. We also liked the frank, biased attitude of the artists.

58

They were not afraid to moralize. They were kind to the poor and dealt cruelly with the rich. That night the light burned late in our room."

After this incident the Academy and its routine became distasteful to them. They had already decided beforehand that it would be advisable for them to go to different art schools, for people had already commented on how closely the work of the twins had resembled each other's. Moses decided to attend the art school of the Educational Alliance and later went to Europe. Raphael, in his shy, fumbling way, did not know where to turn. He had read some articles by Guy Pène du Bois and went to him for advice, liked him, and finally studied with him when he had saved up enough money to attend the Art Students League. Slowly, patiently, but persistently, he laid the foundations of his art. Daumier, Degas, Rembrandt, Brueghel, and Goya were his inspiration; his subject matter was the only life he knew, the city streets and parks, interiors — and people. And always the pressure of earning a living somehow by odd jobs or factory work. Around 1926 he sent a painting to the Salons of America show, which attracted the attention of Alexander Brook. Brook sold it for him and introduced him to the circle of the Whitney Studio Club. This contact was momentous, for not only did the modest young artist make the acquaintance of many of his brilliant contemporaries at the sketch class, but he also sold, through the energetic promotion of Brook, a number of paintings, including several to the Whitney Club (which eventually became the Whitney Museum). Encouraged by this success, in 1928 he rented his first studio and has depended solely on his art for a livelihood ever since. In 1929 he had his first show, at the Daniel Gallery. Since then his success has been slow and steady, adequate to his modest needs, never spectacular, for nothing about him is ever spectacular.

In 1930 Raphael made his first lithograph, and in the next ten years made about fifty. His brother Moses has made very few, al-

59

though such stones as *Washing* and *Two Figures* have a pleasing, almost classic quality, somewhat akin to that of Puvis de Chavannes. His other brother, Isaac, has made about a dozen on the Federal Art Project (*Letter, Waitress, Laundress, Nickel for a Shine*). Raphael has also made perhaps ten etchings, but he seems to feel more free on stone than on copper. His early lithographs were transfers, mostly street scenes, with little of that vibrant quality which is associated with his painting. Around the end of 1933 and the beginning of 1934 he began to work directly on stone and elaborate the caressing vibrato touch which is his great charm. This was the period of the *Self-Portraits*, large and small, *Girl at Table, Conversation.* 1935 was a banner year, with *Two Girls, Back-Stage, The Model, The Mission*, and *Bowery Nocturne*. Likewise, *Girl at Window, Sylvia* of 1937, *Spring* of 1938, and *Protected* of 1939 rank high in his published work. There is a strangely moving quality in his prints as there is in his painting; his drawings, too, have the feel of a personal style, crayon studies of figures and nudes, pen drawings as gently evocative of a period and type as a Watteau. Two kinds of subject matter have been his chief preoccupation in later years. One has been the portrayal of the downtrodden and disinherited, the types that people his *Mission* and *Bowery Nocturne*. There is nothing sweet or sentimental in his approach: he views them with godlike compassion, with pity for human frailty, and with understanding of the forces that have engulfed them. He might well have chronicled, as did Henry Elsasser:

> Today I saw a Rembrandt in the flesh
> Sitting upon a bench in Union Square. . . .

His other theme has been Woman. He has caught and fixed, more completely than anyone else, a certain type of young womanhood peculiar to the big city in the '30's. One sees her in the subway or on the street, at concerts and meetings. A working girl, not a

debutante, sometimes sturdy, sometimes with a wistful charm, always self-reliant, never the automaton of the mass, always with some spark of individuality glowing within her. Soyer places her sometimes on Fourteenth Street or Union Square, sometimes in a dance studio at rehearsal, more often in the intimacy of the home or the artist's studio. The conception grew out of his friends or his sisters' friends. He became acquainted, for example, with some of the younger modern dancers like Jane Dudley, and watched them at rehearsal. He finds their poses in action or at rest interesting and significant. In all his work there is a feeling of gentle rapport, an imaginative feeling with and into his subject. There seldom is anything posed or artificial in his pictures. Like Degas, he aims to give a fleeting transcript of life, to catch the spontaneity and casualness of a moment of time. By his innate sympathy and sensitive approach he makes his characters live. They are real; they move and breathe and feel. He portrays them in the intimacy of a homely and instinctive gesture. The scene is filled with the silence of a transfixed moment. The setting, too, is bathed in a soft vibration of atmosphere, full of half-lights and shadows, an intimate presence that makes the room as alive as the characters in it.

Like a true artist, he transmutes his experience into visions of tender and lasting beauty. No need for him to travel far; he portrays what is at hand, the familiar scenes, his relatives, his friends, and even the outcast who has come for shelter to his studio. There is a similarity about the three brothers in spite of their efforts to be different. These immigrants from a foreign land have contributed to the melting-pot, have given richly of their store of feeling and compassion, of their skill and sensitiveness to beauty. The father's prophecy regarding his sons has come true: they are citizens of this great Republic and they contribute their talents and strength to its growth.

61

HARRY STERNBERG

H<small>ARRY</small> S<small>TERNBERG</small> — the embodiment of a passionate idea. In his expression he unites two forces seldom contained in one artist: namely, intellect and strong feeling. The fact that he is consciously striving to interpret conditions of today makes this union imperative: the intelligence to grasp the essentials, and the feeling to weld them into cogent forms. And it is a colossal, almost superhuman task that he has undertaken — not only to see clearly himself but also to make others see clearly. Behold a man who has a vision of a new and better society, a vision attained by privation and suffering and hard thinking, and he is burning to tell us our shortcomings as well as holding the promise of a new way of life. What are his qualifications and to what extent has he succeeded in his chosen purpose?

Harry Sternberg was born in 1904 of Austro-Hungarian parents. "We were extremely poor," he said, " I was born in the lower East Side of New York City. Father was determined that I should not have to repeat his hard struggle, and he sacrificed much to send me through high school. He had the traditional European respect for the learned professions, and offered to do anything in the world for me if I would become a doctor. Both parents hated and distrusted

my picture-making. Due to this and my sympathy with his hard battle to support his family, I always worked to pay my own way at least, and to contribute to family support if possible." He went to work at odd jobs, as a timekeeper in construction work, as secretary to Professor Ralph Pomeroy of the General Theological Seminary (who had a strong influence on him), as a designer of electrical fixtures; and he studied art in his spare time and at night. He went to the Art Students League and worked with Bridgman, Morgan, and Wickey.

In 1927 he took up etching. After a year of technical experimentation with line etching, soft ground, aquatint, and drypoint, he began producing his well-known series. "In contrast to spasmodic and unplanned production," he says, "I believe in organized and planned handling of a subject. Production in series enables the artist to extract the essence from his subject." He made a number of series, such as a Circus group, Streets and Subways of New York, Railroads, Construction, Principles (concerned with social criticisms of human relationships and possibly inspired by Goya's Proverbios). Finally the series of thirteen etchings and aquatints of *Musical Instruments*, which took a year to produce and which consists of imaginative representations of the essential qualities of such instruments as the trumpet, the oboe, the violin, the kettledrums, the cymbals, and so forth. Some of this early work is crude, but most of it is technically accomplished and rendered with a freedom and vigor rare in contemporary graphic art. Few artists have his ability to portray the human figure at rest or in action or flying through space. He often makes use of circles and ovals and trapezoids as the compositional frame in place of the conventional square or rectangle. His draftsmanship is rugged and powerful. His is a masculine art, worshiping vigor and power rather than the beauty that comes of sweetness. His life and work are built upon a superabundant vitality. Over six feet tall and strong in proportion, he often bellows and thrashes

63

around in real life like the proverbial bull in the china shop. Needless to say, tact is not one of his virtues, but neither is hyprocisy one of his vices. Everything comes straight from the shoulder. There is a tendency in him toward the melodramatic which sometimes comes perilously close to affectation in life and art, were it not redeemed by a dash of skepticism. He can be raucous, he can be arrogant and superior, he can set out deliberately to shock and antagonize — again both in life and in art — but he can also be humble and receptive, he can be stimulating and fructifying, he can laugh and drink and dance. He can have the woes of the world on his head, but he can also enjoy life. He gives out his strength, and his exuberant virility is beyond question.

The range of his expression is varied — things of imagination, nudes in a landscape, a dream, or a series of fantasies, satiric and critical of our civilization. In realistic vein he creates vivid, tumultuous pictures of the life around him, the streets of New York, the subway, locomotives, airplanes, building construction, the seamy aspect of the East Side. Many an artist, given his early background of galling poverty and hardship, would be unable to face the bitter memories and would choose the easiest way, the escape from reality. Sternberg, however, is tough-minded about it and chooses to exorcize the memories by externalizing them through his art. The whole experience has nevertheless given an edge to his social consciousness.

In 1933 he was appointed instructor in etching, lithography, and composition at the Art Students League, a position he has held to this day. Not only has he made the course dynamic and vital to all his students, but, what is more unusual, he has shown a respect for their potentialities and an inspired insight in drawing them out. Like Wickey he has the faculty of kindling emotional response in his students, and he employs the sound pedagogical method of treating technique not as an end in itself but as an inseparable part

PORTRAIT OF HARRY STERNBERG

PHOTOGRAPH BY BRUCE EDWARD

HARRY STERNBERG: HARP

AQUATINT

10⅞ x 6⅞ INCHES

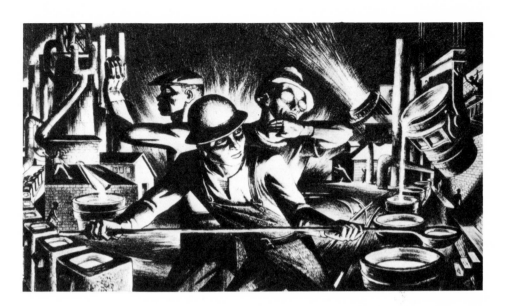

HARRY STERNBERG: STEEL

LITHOGRAPH

11¾ X 20¾ INCHES

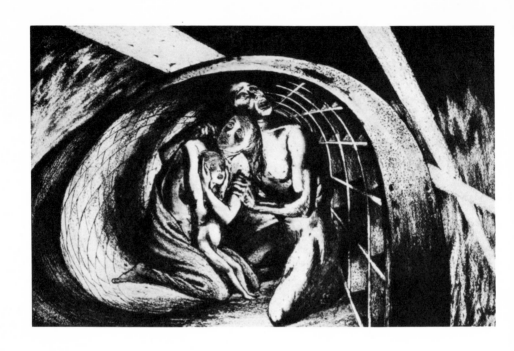

HARRY STERNBERG: HOLY FAMILY

AQUATINT

13¾ x 21⅞ INCHES

of content and aim. He makes his students conscious of what they want to say as well as how they will say it.

The Guggenheim Foundation awarded him a fellowship during the summer of 1936 for an intensive study of the coal and steel industry. During all these previous years there had crystallized in him certain political and social convictions, initiated by his early experience with injustice and exploitation, and disciplined by a thorough study of Marxian economics. He now planned an epic study of the major industries and agriculture of the United States, to be made from the workers' point of view, and covering such units as steel, coal, transportation, automobiles, wheat, corn, livestock, lumbering, and cotton. He would live with the workers, share their work, and gain insight into their daily lives. But he would also make a record of the technological background.

In common with many Americans, Sternberg is tremendously interested in the machine. He is excited by its dynamic forms, by the myriad-shaped tools and forces by which the ingenious mind of man has set itself to harness nature. He has the professional technologist's regard for accuracy of representation. This preoccupation with the relation between man and machine is foreshadowed in such early prints as the circular *Construction* and the series *Dance of the Machines*. He is thus concerned not only with the machine but with its implications. Circumstances beyond his control have prevented him from carrying the study beyond coal and steel, and it is to these two that he has devoted his spare time for the last few years. In addition to innumerable notes and drawings, he made a number of oils and about a score of lithographs and aquatints, notably *Coal Mine Seventh Level, Coal Miner and Wife,* the large *Drilling,* the large *Steel, Steel Town, Blast Furnace,* and *Blast Furnace at Night.* In portraying a way of life so remote from the ken of the average man as steel and coal, the artist labors under a certain disadvantage

65

in that very few people can really know how successfully he has achieved his aim. An artist who seeks to master a given subject has, as it were, to pass through three stages. First he must familiarize himself with every detail of the subject, have all its externals accurately at his fingertips; this might be called the step of mastering the material. In the second he probes deeper into significance for his own edification and that of his peers; in the last stage he so shapes his material that it becomes of compelling interest to the world at large. First he gathers experience, then he shares it with others who have also had a little experience, and finally he so dynamically transmutes his experience that it can become a primary experience to others. As far as one can see, Sternberg is at present in the second stage. We await the series that will tell the whole story of Coal and Steel. Meanwhile we can supplement his pictures with a description he has made of his experiences in a coal town.

"I came over the top of a mountain after driving through miles of the fine green hills and farmlands of Pennsylvania, and stopped by a cemetery to look down on my first mining town. Deep in the valley, surrounded on all sides by huge man-made hills of accumulated grey coal wash, sprawled a litter of wooden shacks thickly studded with projecting church spires. The grey clum banks, the skeleton mine shaft tipples and the crazy wooden shacks were full of rich form for picture-making. The subtle ranges of blue, green, and brown-greys were splendid color for painting. The streets were picturesque, raggedly lined with houses tilted and twisted at interesting angles, each with its little box of an outhouse. Here then would be characters to do. I was so excited by the richness of the surface material that only after I had lived with the miners for weeks did I begin to really see and draw a mining town.

"At first the saloons and churches seemed uninteresting. Oddly enough the earth beneath the churches is not mined out; they therefore retain dull true perpendiculars. But when I began to notice that

66

there were two or three saloons on every block and about as many churches, Gothic, Romanesque, Greek Orthodox, all expensive well-kept structures, architecturally pulling the eye up and away from the decay around their bases to the empty sky above, they began to take on a new artistic significance.

"The miners, their wives, and kids were fine romantic stuff to draw. Faces with strange deep blue marks pitted in the skin, men with fingers missing, with stumps of arms and legs, women with gaunt tired faces, thin barefooted children in overalls. Grand stuff to draw and paint. But then I realized that bare feet and patched overalls meant no money for decent clothes. The interesting lines in the women's faces were worn with patient stoical waiting for their men to come home from the pits. Something more had to be got into the deep-socketed eyes, the sunken cheeks, the lips drawn back from the teeth, when short gasping breath tells of silicosis and the dread miners' asthma caused by coal dust in the lungs.

"It is fun to be dropped, literally, on an open platform hung on a cable a thousand feet down into the earth in complete darkness where only the head lamps show a rushing blur of the timbers of the shaft. I walked through miles of unlighted gangways propped with heavy timbering cut from tree trunks. I crawled in the narrow slippery chutes called 'man ways' that are driven up at a forty-five degree angle from the gangways into the veins of coal. These passages are three or four feet square, and the huge weight of the mountain of earth above is supported only by the engineering skill in timbering of the miners. I watched the men working in the breasts, huge domed chambers cut out in the coal veins, digging holes with eight-foot heavy iron hand drills, tamping in the dynamite, setting the time fuses, and shooting the blasts. Everywhere was beauty Rembrandtesque, black and white, abstract patterns of tunnel shapes, a thousand cubistic forms in the walls of black blasted coal. The sure slow movements of the miners were breath-takingly stir-

67

ring. It seemed all there, ready made, waiting for canvas and brush to record. Later I came to see that there was richer material for pictures that lay beneath the surface drama.

"For this work, which next to steel-making is occupationally the most dangerous, wages are paid that force the men to a shamefully low standard of living. Somehow all of this had to be expressed in my pictures. To have rendered only the surface drama and beauty of design and color would have invalidated all the months of living and working in coal, and I might have better remained in my studio and done 'pure' abstractions. Here, magnified as though seen through a high-powered microscope, and so dramatically emphasized that simple truths seem like melodramatic extremes, lies a clear cross-section of our society."

Sternberg is thus attempting a new orientation in art, a transvaluation of all values. He embraces it with all the ardor of conversion. He is forthright and intolerant, as befits exuberant masculinity. In this over-emphasis, this tendency to "melodramatic extremes," lies a danger to himself as an artist — free expression coagulating into doctrinaire channels. He once said that emotion was the dominant factor in his art, and that he had to force up the intellectual aspect. Yet his later work has been criticized for being too intellectual, as tending to lose itself in still-born tokens. He is not unaware of this danger himself; and that is perhaps his greatest safeguard.

Other themes besides coal and steel have engaged his interest in the last year or two. He has taken up with enthusiasm the silk screen or serigraph medium. He not only practices it himself but also teaches it in his classes and has written an excellent textbook on it. He was one of the first artists to see the implications, both social and æsthetic, of the new medium, and has made prints in both spheres (*Workers, Steel Mills, Coming of Night, Tulips, The Mirror*). The great World War has likewise inspired him to make three monumental aquatints. Of unusually large size and of expressionistic in-

68

tensity, they are among the most impressive reactions to the horrors of totalitarian war that have been made in this country (*Men and War, Women and War, Holy Family*).

Sternberg is vigorously critical of much of the art of today. He sees in most of it a great emptiness; it is an art of escape which evades the chief obligation of the creator today, to interpret the forces that are shaping the world's destiny. All modern artists save a few are blind to their responsibilities; he at least is aware of the problem. He is still searching for a mode of expression, a frame of reference, a living and intelligible symbology that will synthesize what he feels and thinks about man and society. The dilemma of the radical social artist is this: either he must work with obvious and self-evident symbols appealing to the lowest common denominator, or he has to forge new symbols, the meanings of which are not generally accepted. He is understood either too well or not at all. Nevertheless Sternberg's continual emphasis on the importance of expression and its intensification is a wholesome trend. "It cannot be too often repeated," he has said, "that great art consists in saying something important and saying it as well as it can be said. Little minds will think little thoughts and feel little emotions. Out of this will come little pictures, with little emotion and less plastic organization. When a man grows big enough to think brilliantly and feel deeply, and interlocks with this a complete mastery of his medium, then he is a great artist."

HARRY WICKEY

HARRY WICKEY stems from the soil, the soil of the Midwest, whence, as some of our critics assert, the characteristic expression of American art arises. Here, then, is an American artist — a real one, without benefit of ballyhoo — typical both in his background and in his aspirations. He is robust, vigorous, enthusiastic, resourceful; he is at once boastful and modest; he is intensely individualistic, somewhat of a lone wolf; he believes in getting things done and doing them to the best of his ability — all typical American qualities. He is the rough diamond, not flashy but pure. He works hard for whatever he gets. He is not endowed with an instinctive sense of style, as was Toulouse-Lautrec. His role is more that of Cézanne, who labored all his life with dogged persistence.

Harry Wickey was born in 1892 in Stryker, a small town in the northwestern part of Ohio. He lived there until he was eighteen. His background was rugged and vigorous. "My grandparents," he has written, "on both my father's and my mother's sides were pioneers in that part of the state, and cleared farms for themselves. They were of French and Scotch and Welsh extraction. I still remember my grandfather Besançon, a noble man, deeply religious in

70

a non-sectarian sense, who never refused anyone food, bed, or even money. Many a time the children slept on the couch while a peddler slept in their bed. It was the custom in those days to put the children to work early, and both my father and my mother shared in the farm work when they were very young. This tradition was still in vogue when I was a boy. I have been told by friends in Stryker that I started earning my living as soon as I was able to walk. This is of course an exaggeration, but the spirit of it is true. At the age of nine I inherited the agency for a laundry from my elder brother, who had run it into bankruptcy. My father furnished me with the capital to square all accounts and put me into business. I gathered laundry all over our little town, and as people liked me, I was well on the way to success when a friend introduced me to a delicious confection in the form of a cream puff. I was on that very day introduced to a bankruptcy which took place about six months later. One morning with assets at zero and liabilities at eight dollars, my father came into my bed-room, and after delivering a short but blistering lecture, removed me from the agency and sold it to a friend of mine. This friend had traveled with me in my hey-day, and as his appetites were similar to mine, he reached his Waterloo much quicker than I did.

"Having shown my father that I had no business ability, I was advised to try a hoe, and my next job was in the sugar-beet fields thinning and topping beets. This job was a tough assignment because my fellow workers in the fields were imported from Bohemia for that very purpose, and I had to hold up my end. I stuck it out for the entire season, getting up at four in the morning and working till sundown. By the next summer I had graduated to a road-building job which I held for two years. During the winter months while I was going to school, I delivered groceries for a general store and used up a great deal of wrapping paper making drawings. In the evenings I counted eggs in the back room, and during rest periods refreshed myself with three or four bananas that I rolled around in

the brown-sugar bin to make them tasty. During these efforts at economic independence I found time to play ball and go swimming in the summer and get in skating during the winter."

Such was his routine until he finished school. There was a crisis in his life when he was seven. He attended a revivalist meeting and learned that those who swore were doomed to hell fire. Now, his father was a stern man much given to vigorous profanity, but Harry felt that God would be very unjust to condemn a man like his father to everlasting punishment. His aunt read him a tract by Robert Ingersoll and cured his worries. At the age of eighteen he knew that he would rather draw than do anything else in the world. He decided to go to art school in Detroit. His uncle had a good job with the L.S. and M.S. Railroad in Detroit and promised him a job in the railroad yards. He continues his narrative: " I accepted his offer and started working as a car checker in the yards. I had the night shift and worked from 6.00 p.m. to 6.00 a.m. for $45 per month. I held this job about a year, and would have held it longer but for an experience I had. I stumbled over a dead man lying by the tracks one dismal rainy night and quit the next day. My next job was for a seed company, making boxes. I hammered the nails in so energetically and whistled so loudly while I was doing it that the office force across the street was disturbed and my services were dispensed with. Immediately upon my arrival in Detroit in 1911, I entered art school and studied half days. I wanted to become an illustrator. John P. Wicker, owner of the school, tolerated my ideas on this subject but gave me very little encouragement. The walls of the school were covered with reproductions of Daumiers, Rembrandts, and Millets, and these looked like illustrations to me, so I couldn't understand his objection to illustrators."

Wickey became dissatisfied and decided to go to Chicago. He signed up as a student guard on the Chicago Elevated and as a student at the Art Institute. He became a timekeeper and dis-

PORTRAIT OF HARRY WICKEY

PHOTOGRAPH

HARRY WICKEY: SAILORS' SNUG HARBOR

DRYPOINT

7½ x 10⅜ INCHES

HARRY WICKEY: RAILROAD CUT NO. 3

ETCHING

8 x 11⅞ INCHES

HARRY WICKEY: SULTRY AUGUST AFTERNOON

LITHOGRAPH

11⅜ x 12⅛ INCHES

patcher's clerk on the El. He was conscientious and not afraid to work. His art studies progressed none too smoothly: " Chicago was a thrilling city, but the Art Institute in those days was not. They insisted that I draw from casts and I was firm that I wouldn't. A wise registrar finally admitted me to a life class. My first morning in this class was an unpleasant one. In Detroit we were shown the model and told to get something down and see to it that the product was alive. In this art class they were spending too much time taking measurements and sharpening their charcoals. I felt I had been stung, but decided I would give them a show before I got out. So I swung in on a drawing and told all the boys to watch how a real drawing was made. There was little effect from this demonstration until the next day when the instructor arrived. He looked at everyone's work but mine. I left the class for good and pitched my studio in Hinky Dink's Saloon on South Clark Street. I spent most of my time in this section of Chicago, and made hundreds of drawings of my surroundings and of the tramps off the Panhandle, as well as illustrations, for my own amusement, of stories by Dickens, Poe, Hawthorne, and O. Henry. I remained in Chicago for almost two years and finally had enough money saved to make the trip to New York City. New York was my goal from the time I left home, and I finally made it in 1914."

In New York he got a job as a platform guard at the Union Square subway station. He was always cheerful and as courteous as was possible under the circumstances. Sometimes he would get pushed into the trains himself and would have to get out at the next station. He was looking for a place to study where he could work his own way. He wrote to George Bellows for advice. Bellows mentioned the Ferrer Modern School. " I went there with a portfolio loaded with my work. Henri was there that first evening and I showed him what I had been doing. He looked them over very carefully and laid about a dozen aside. I was very much thrilled when he pointed to this group

and said: 'I would be very proud if I were the author of that work.' I didn't quite believe the statement but received a great deal of encouragement from it nevertheless. After six months at the Ferrer School I could no longer pay the tuition and looked for a place where I could work free of charge. I found this at the New York School of Industrial Art under Arthur S. Covey. He gave me much encouragement and, after I had been with him for a few months, he introduced me to Harvey Dunn. Dunn was and is a personality, and I liked his vitality. He liked my work and told me I could study with him free of charge. I was interested in getting work for magazines, was willing to make concessions, and within a short while I received work from the *Saturday Evening Post*."

In 1917 the United States entered the World War and Wickey was called in the second draft. He spent eighteen months in the army, thirteen of which were overseas. He saw service at Saint-Mihiel. He tells many interesting stories about his experiences: how, for example, the young rookie, out of his farm experience and passionate love for animals, broke army regulations and gave pungent advice to a lieutenant who was ordering an inexperienced man to clean a spirited and frightened horse at some risk to life and limb. The result of this was that he was ordered to curry and brush the horse himself. It was found that he had a way with animals. He was made a sergeant and sent out in France to gather horses for the artillery brigade. He hated the war, however, and refused further promotion. He and two other buddies held out against accepting commissions as officers when the fighting was over. They won their point, but to punish them, as it was thought, they were sent back in a transport filled with Negroes. He had the time of his life listening to the singing and the tales.

During his stay in the army he did a great deal of drawing (the tough doughboys would tear up his drawings when he was not around) and thinking about art. He came to the conclusion that he

74

was temperamentally unsuited for the conventional illustration then in vogue. When he was discharged from service he was without money or a job. He determined to give illustration one more try. He made a set of drawings for a prize-fight story. Dunn thought they were the best of their kind ever made, but was not sure they would get by. A telegram came from the *Saturday Evening Post* saying that they accepted the drawings although they were not up to their standard. He swore he would never make an illustration again. Faced with the need of making a living, he began teaching and doing any odd jobs that came to hand. It was not long before his class began to grow, and within a couple of years brought in a living. Teaching was to be a means of livelihood from 1919 to 1933.

"In 1920 I became interested in etching. Knowing little of the use of acids, my first efforts were in drypoint with an occasional attempt at the bitten plate. This was the most trying period of my experiences as an artist, for a number of those who had admired my work, and thought I had possibilities when I was illustrating, gave up all hope for me at this time. A young artist, who later became my wife, was painting in an adjoining studio, and had seen work by me preceding my *Saturday Evening Post* days. Under her encouragement and that of another friend or two, I worked with some hope and a great deal of anxiety."

Harry Wickey has made about seventy-five etchings and drypoints and six lithographs. His first eight drypoints are dated 1920. They were tentative and experimental, and so were the seven of 1921. But in 1922 he found his stride and burst forth with three of the most distinguished drypoints of modern times, *Midsummer Night, Bryant Park,* and *Snug Harbor.* They are spirited, beautifully balanced in black and white pattern, rich in atmosphere and tonal color. These three and *Ninth Avenue* of 1925 mark perhaps the peak of his drypoint work. He had now exhausted whatever possibilities there were in the medium for him, and he was not content to repeat past suc-

75

cesses. He was now on the track of a more acutely realized three-dimensional form. He would approach this in the more austere medium of etching rather than in sensuous drypoint. Copper-engraving no doubt would have suited his purpose better, had it occurred to him. He undertook an intensive research into plastic or sculptural form, minute realization of spatiality, monumentality of the kind that Mantegna and Signorelli achieved. He was preoccupied largely with the human figure, and made a series of six *Bathers* and three *Wrestlers* in etching. *Wrestlers No. 1, Bathers No. 4,* and *The Jungle* are possibly the most impressive prints of this phase. The figures are neither graceful nor beautiful, but their brute actuality, their tactile solidity, are overwhelming.

In 1929 he moved to Cornwall Landing, one of the most beautiful and romantic spots in the Hudson River Valley. With a perception of form and space sharpened by his studies of the human figure, he now attacked rock and mountain forms, so difficult to render in scale and solidity. In the next few years he produced a number of etchings of the rocks and cliffs along the Hudson, three of *Railroad Cut* (he thinks No. 3 is the best), *Mr. Gleason on His Beat* (also of a railroad cut along the river), and *Hudson River Landscape,* which stand out for their vivid impress of reality. Two others, *Rocks at Cornwall* and *Waterfall,* were also notable for their successful solution of a difficult problem — to render a mountain wall of rock or a wood interior compositionally interesting. In 1933, having delineated to his own satisfaction the rocks and mountains in their eternal unchanging aspect, he became fascinated with the kaleidoscopic play of wind and weather, of rain and snow upon these stark realities. He enveloped them with atmosphere, and decked them in a soft mantle of snow while always suggesting the solidities underneath. *Storm King in Winter, Hudson Highlands under Snow, Storm Sweeping the Hudson,* and *Storm at Night* are the most distinguished of these

prints. They were also his hail and farewell to the etching medium (1935). Once again he had extracted the utmost from a medium and he felt impelled to go on to other conquests; but in addition the constant use of acid began to bother his eyes and forced him to take up other art forms. In 1936 he made six lithographs of Midwestern farm life, a distillation of early childhood memories and of recent visits to his birthplace. They are about the finest things of their kind. Such vital and masterly delineation of animals is possible only after long and devoted research and countless studies and drawings. It is a treat to hear Wickey talk about pigs, for example, their habits and structure, the different breeds, their cleanliness, quickness, elegance, curiosity, humor, their language, which he imitates to perfection. All this is carried over into the lithographs *Sultry August Afternoon* and *Hogs near a Corn Crib. Stallion and Mare* and *Bringing Up the Mare* are likewise distinguished renderings of horses and of a dramatic climax of farm life.

As to his artistic aims and manner of working he has had this to say: "I wish to convey a full sense of the actual to those looking at my work. By actual I mean that each object, in its individual color, texture, weight, volume, and movement, is so related and interrelated with every other object that it functions vitally within the given space. These entities and qualities must be unified by the spirit of life. No two people see and feel things in exactly the same way, but there is no such great difference as some would have us believe. The great majority of us can differentiate between an apple and a pear, and I wish to express objects in such a way that anyone will be able to recognize them. My work is the result of feeling, observation, and thinking, and I cannot dispense with any one of these qualities without serious loss to my work. I generally work from memory: once I have received an impression from life, I begin working on the main relationships of the objects to be contained within

my space. After this relationship has been established I gain as thorough a knowledge as possible of the individual objects I am concerned with. When I feel I have a firm grasp of the composition and the form of the objects, I work very freely, and, rarely, if ever, refer to the preparatory studies. There are, as I see it, three stages in an artist's career: the childlike stage, the self-conscious stage preoccupied with æsthetic values, and the final stage where with the technique acquired in self-consciousness, one draws again as naturally as a child. Daumier, Goya, Rembrandt are examples of artists who attained the final stage. I myself have as yet rarely achieved it."

Mention should be made of Wickey's activity as a teacher, for it is an important facet of his personality. He is — or rather was, since he no longer functions as such — a great teacher. He was so not only by virtue of his sound instruction and knowledge, but also through certain personal qualities, an infectious enthusiasm, and a spiritual positiveness on which the pupil could and did lean. His generosity drove him to lavish prodigally upon others the emotional reserves of his nature, with the result that sometimes he was left in a state of psychic collapse. In spite of his protestations, there was something in him that attracted the master-pupil relationship in very much the same way that Stieglitz did. He was wise enough, however, to realize that satellite dependency was bad when too prolonged. He is exceedingly intuitive and sensitive to psychological attitudinizing in others. Being high-principled, he will have no commerce with it. He is honest to a quixotic degree. He has an intolerant hatred of cruelty to man and beast. He has passionate admirations in music — Bruckner, Mahler — and in literature — Goethe and Walt Whitman, and especially those sympathetic interpreters of fallible humanity, Burns and Dickens. He loves to talk and recite poetry. He is hearty, booming, blustery, and surprisingly avid of praise. Does the choice of some of his subject matter, bull, stallion, and boar, betray an unconscious need for male assertiveness? In spite of all the bluster,

78

there is something childlike about him, something that cries to be mothered. He is an all-around human being, warm-hearted, generous, lovable, and sincere.

Harry Wickey has often been called an artist's artist. And it is true that a number of the best artists of the country have expressed their admiration of his work in the most discerning and enthusiastic terms. The outstanding quality of his work is its vitality and robustness. He is a realist: with zeal and integrity he has interpreted what he has seen about him, in city and country alike.

BENTON SPRUANCE

ONE of the major problems every artist has to face is his relation to society. Can he make a living solely from his art or must he resort to other means of livelihood? Does he have a sense of self-respect and pride in his calling or does he feel that both he and his profession are not appreciated? In a society based on function or an equitable division of duties, such as, with all its faults, the feudal system or the ideal caste system of ancient India, in such a society the problem hardly existed at all. The artist was a worker of whom society demanded certain products of his hand and brain. He supplied those demands and thus was a normal and functioning member of society. In modern times, however, the artist is confronted with a disturbing and at times unflattering dilemma: he lives in a society which cares little for his product, or at any rate feels little obligation for his support. The keynote becomes commodity, not function. In a social system where everything is bought and sold, the artist, if he is to live by his art, must turn salesman to dispose of his wares — a system which introduces chance and other extraneous factors besides creative achievement into the resultant of success. Or he must give up the unequal struggle, make his living some other way, and pursue

80

BENTON SPRUANCE: SELF PORTRAIT

LITHOGRAPH

$11\frac{1}{4}$ X $14\frac{5}{8}$ INCHES

BENTON SPRUANCE: BRIDGE AT RACE ST.

LITHOGRAPH

$15\frac{1}{4}$ x $8\frac{1}{2}$ INCHES

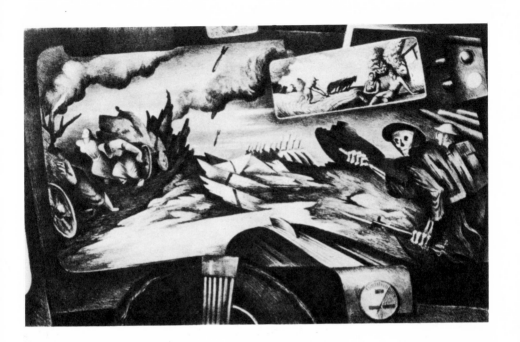

BENTON SPRUANCE: WINDSHIELD—THE NINETEEN THIRTIES

LITHOGRAPH

9 X 14¼ INCHES

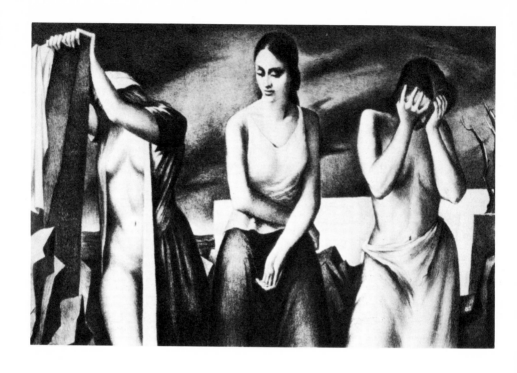

BENTON SPRUANCE: THE LAMENTATION

LITHOGRAPH

12¼ x 18¼ INCHES

his art as a side line. Society has forced upon the artist a galling duality in what was once a single and honorable function, the duality of gainfully employed citizen versus practicing artist. It is the rare exception among artists who makes his living solely by his art. Many artists, through temperament or circumstance, are unable to resolve this duality, and yield to one or the other dominant force. In the one case, following his ruling passion, he tends to become a bohemian, a pariah living a hand-to-mouth existence, neglected by society and disdainful of it. In the other case, through an undue sense of obligation to society or to dependents, he is apt to quench the vital spark of creation and lose his birthright as an artist.

Benton Spruance is an artist who has made a rather successful adjustment to this recurrent dilemma. In so doing he has carried on, whether consciously or unconsciously, something of the spirit and tradition of Benjamin Franklin in the very city where the personality of that great man once held sway. Not the spirit of the creator of pinchbeck slogans for savings banks, but the spirit of the great philosopher, the man in his noblest dimensions, the student of human nature, the character of sterling integrity who never borrowed but always paid his way, who gave to the limit of his capacity in the service of his country, who possessed the spirit of infinite curiosity, the courage and imagination of the great inventor. Franklin, above all, resolved the dilemma successfully: reasonable, practical, keenly aware of his duty to society and dedicated to its service, nevertheless he prospered and, withal, kept his soul alive. Spruance likewise has always paid his way and maintained a nice balance between the opposing forces: he fulfills his duty both to society and to his inner life. Not without a certain struggle always, and doubts and misgivings sometimes — but then that is life. Eternal vigilance is necessary to preserve so neat a balance. Fortunately the creative urge is strong enough to hold its own against the call of obligation. That he is acutely aware of the problem is perhaps his greatest safeguard

against the temptation to yield completely to either side. This sense of balance does not imply moderation in the exercise of either calling; he goes to the limit of his capacity in either direction. The balance consists in directing and apportioning the energies expended. Such personalities as his may be said to be mature and philosophic in their outlook on life: conscious of all the fundamental factors they make their lode-star dynamic balance.

Benton Spruance was born in Philadelphia in 1904. All the Spruances stem from a Frenchman, Esperance, who came over to this country around 1700. His parents died when he was very young and he was brought up by his stepfather. His stepfather, who was an engineer, did not interfere with this young boy's aspirations except to lay down the economic law that he would not be able to make a living at art. So young Ben went to work in an architect's office, took architectural courses on the side at the University of Pennsylvania, in addition to attending the graphic sketch class on off nights. He attempted to do too much, broke down, and spent six months in a lumber camp in Virginia. There never was a time he can remember that he did not want to be an artist. He had accepted architecture as a compromise, but, as he meditated in the lumber camp, he was doing a lot of work he did not care about and getting nowhere; why not expend the work on something he really did care for? When he returned he competed for a scholarship at the Pennsylvania Academy and won it. From then on, his path was clear. He won a Cresson Scholarship for travel abroad. Returning to Europe on a second Cresson Scholarship, he found his way to the lithographic printing shop of Desjobert, where he saw John Carroll and Kuniyoshi at work on stones. Desjobert allowed him to work in his shop. When he was not drawing on the stone he was watching printing operations. In this way he learned a great deal about lithography. Back in America, he found it hard sledding for a while, but gradually he found his social adjustment in teaching. He is now head of the Department of Fine

Arts at Beaver College and also has classes at the School of Industrial Art of the Philadelphia Museum. He divides his time about equally between teaching and creative work, and there issues from his studio a steady but selected stream of lithographs, drawings, gouaches, easel and mural paintings.

He paints a few oils every year and gets a mural commission now and then, but his great love is for lithography. He loves the smell of the ink and all the paraphernalia connected with the stone, and is fond of quoting a saying of Goya's about civilized man preferring values of light and dark to color. His first lithograph was made in Paris in 1928. To date he has made almost two hundred prints. The bulk of his production was made in Philadelphia and printed by that excellent craftsman of the old school residing there, Theodore Cuno. His maturity came slowly and with considerable effort; he had much of his early training to unlearn. His early work, most of which he has since destroyed, had a touch of Bellows in its characterization and was facile and rather thin in its form. As he said later: " I have realized two things more clearly — what form is and that a work of art can't be good when it is neglected. That was more of my trouble than anything. Failure to realize how fatal that neglect can be. I've learned a lot from Poussin and Picasso (strange bedfellows, but not to me) and Georges de la Tour."

As the years rolled on, he became wiser in experience and more sure of his technique; his work became richer by virtue of the fusion of diverse creative drives. But he has never given up his experimental and dispassionate attitude toward his work, the hall-mark of the true creator's quest for ever greater perfection. One New Year's Day, as people sometimes do, he sat down to take stock of himself and his work. It might be appropriate to quote what he then wrote almost in its entirety for the light it throws on the creator's attitude:

" The business of taking stock as a new year starts, should not be denied to artists, don't you think? I've been trying to take some sensi-

ble kind of stock of the pictures that I have done, of what they mean to me now that they are done, and if possible how they fit in with the way that this country thinks and feels in the 1900's.

"I guess that my own reactions to them are rather unimportant. They all leave me rather cold — the heat having been expended in nearly full capacity for their creation. The only thing I really like is the one in the process of being made — and I love that one! Or, rather, love the conception of it — and what I want it to become. And there is where the hard part comes in. You know T. S. Eliot's poem *The Hollow Men,* in which he says: 'Between the conception and the creation — between the emotion and the response — falls the shadow.' It is this shadow that defeats me nearly every time. It is not because of lack of working, or lack of time to work. I really believe that I work in my studio drawing and painting as much as most men. I try to use the time intelligently with and without models, carefully preparing for a new lithograph or canvas. When I start, the heat is always there, and I wish that I could start a thing and work so unconsciously that in my next moment of touch with the world, the thing would be finished. Then there would be no shadow and the conception which I hold good — and I hold it good in a dispassionate manner — would be created in all its goodness.

"The great men must have felt that, and it may be that their work is great because they mastered it. I do believe that I am in touch — Lord, in embrace — with life. And I believe that my sensibilities are growing in awareness and in depth. Now if only I can transmit that awareness to the medium. It has to be communicable, doesn't it? I feel some of this coming in my new things. And I feel something else in them, a surer mastery of the medium. I am becoming less and less bothered by the fact that a stone may be spoiled, technically; and the physical job is more a part of me. Now if only the insides will come."

There are several salient trends observable in his work. Sometimes

one or another is dominant in his creative approach; sometimes he manages to fuse most of them together in a major opus such as *The People Work*. One of these is a classic impulse toward order, balance, serenity, tending at times toward a universal abstract framework. " I never realized," he once said, " how profound one must be in really architectural abstract art. The logic of the architectonic basis I believe to be so fundamental that it is inescapable. Whether carried through or not, it has always been the basis on which I create a picture. Or am I doing a spot of wishful thinking? " This stylizing tendency toward abstract pattern is manifest as early as 1932 and 1933 in *Bull Dog Edition* and *Shells of the Living*, and is continued in such recent stones as the exciting *Bridge at Race Street*, the more serene *American Pattern: Barn,* and the completely cubist *Arrangement for Drums*, wherein the drummers and their drums, their forms and motions, are universalized into the precision and balance of a machine. The classic impulse also takes shape in certain big serene forms, not obviously abstract but leaning rather toward pure ideal beauty, in such prints as the *Seated Nude* and *Figure with Still Life* of 1939, the more recent *Girl with Hands to Face* and neatly ordered *Gifts from the Kings*, and notably in three of the richest and most completely realized of his works: *Young Lincoln, The Lamentation,* and *Brief Balance*. In contrast to these one discovers a tendency toward an almost Gothic emotionalism of characterization, an almost baroque delight in grotesqueness of gesture in (to mention only the most successful ones) *Philatelists* of 1935, *Plans for the Future* of 1939, *Prelude* of 1941. This aspect has always seemed the least convincing part of his work. Such excessive emotionalism bordering on the grotesque somehow seems foreign to his temperament, responding, as it does, more completely to order and restraint. He is not one who can let himself go beyond a certain point; his nature, finely attuned to balance, cannot be driven to excess except in terms of grotesqueness. An expression predominantly emotional is with him best

channeled into an orderly framework of emotional symbolism, where the feeling has been to a slight extent rendered abstract by a universal idea. This may be seen in such pictures as *Visitor to Germantown, Harps Once Played, Parting at Dawn, Morning in Babylon,* and with notable success in *Macbeth Act V.* What was in back of these last two pictures he once indicated in a letter in which he wondered, rather mistakenly, whether his subject matter was at fault: " Each had a reason for being, and each was carefully worked out for weeks before it was put on stone. The structure — formal in both mass and movement — was considered with my greatest love and thought. I guess the content must leave much to be desired. Who for instance save myself cares a screw about the loveliness of a young girl in front of a window in the early morning? The softness of her body about to be subjected to the day of a city's life? Who again save me would gaze respectfully from the other side of the street at the funeral of a poor old guy and feel in it the tragedy, the utter futility that Shakespeare put into that Act V of *Macbeth*? Who gives a damn about *Macbeth,* unless Orson Wells puts it on? "

One aspect that is noticeable in his work is his almost exclusive preoccupation with the figure, with human beings. He has made very little pure landscape; in those few stones where figures do not appear, the landscape is generally urban. He usually manages to do two or three portraits on stone every year; notable examples are *Win in Black Silk* (1929), *Young Colored Girl* (1931), *Self-Portrait* (1932), *Portrait of a Teacher* (1936), *Head J. T.* (1938), *Portrait at Dusk* (1939), *Portrait of Toby* (1941). In art as in life he is sociable, interested in personality, at ease with people. Another obvious characteristic is his interest in broad general ideas, whether moral, philosophic, or social. As he says: " I am not afraid of intellectual content." More than most artists, he is aware of his time. He takes an intelligent interest in the forces that shape our modern life, and he has attempted in some measure to synthesize them in his art. He began, for

86

example, a critique of the 1930's which only ran to three plates (*The 1930's: Windshield, Graduation, Requiem*) and of which only the first was successful and formally published. The *Windshield* is quite an extraordinary print, most original in its device of projecting past and future (the point of view is that of a man at the wheel of an automobile; through the windshield ahead of him he sees a war-stricken landscape with nothing but death and desolation; in the mirror to the rear he sees an idyllic farm landscape) — and strangely prophetic, having been made in July of 1939, of the World War that was to break in September. He has recently completed another notable war picture, a triptych entitled *Credo,* in which he portrays the chaos of an air raid here and now, and at the same time affirms his faith in the ultimate triumph of human liberty and a better world. It is a major work, admirably organized both in form and content. In its formal aspect the two side pieces, with their complex, angular, and restless " pin-wheel " composition, are in striking contrast to the curving and somewhat ecstatic upward flow of the middle. In meaning there is likewise a dramatic contrast between the destructive disorder of the sides and the positive affirmation of faith in the center.

Spruance is one of the few artists who have come to terms with the automobile — which has had such an influence on our civilization — and used it as material for his pictures. Among several lithographs, he produced two that are notable: *Road from the Shore* of 1936, a dramatic night scene of whizzing cars and headlights with Death floating above, and *Traffic Control* of 1937, an abstract pattern of speed and more speed. His views of Philadelphia, *Changing City* and *Supplies for Suburbia,* are filled with penetrating observations in graphic terms. One of his most ambitious works has been the four large lithographs of the series *The People Work* of 1937. Monumental in composition, they present a wealth of scenes and imagery, tied together in space and in simultaneity by various witty and ingenious devices. They and the recent companion series, *The People Play,*

have the impact, though not the dryness, of a sociological treatise, yet function consistently as works of graphic art. Among other subject matter that he has treated with originality and authority may be cited football, of which he has always been an ardent devotee. Of the dozen and a half football prints he has made, perhaps the most notable is the large *Pass to the Flat* of 1939. Still another field that has engaged his attention has been that of religion in modern dress, as it were. He has taken certain dramatic incidents of Biblical legend and reinterpreted them in modern terms, such as *Annunciation, Rest on the Flight into Egypt, Destiny at Damascus,* and most successful of all, *Gifts from the Kings.*

Thus it will be seen that subject matter plays an important role in his æsthetic. Indeed, it is one that seldom presents any difficulties to a man of his temperament. His stumbling-block has been more often in the field of expression than of meaning. He has had to overcome certain false starts in his early training — it is curious how often an architectural training has been a handicap to a creative artist, particularly in relation to the figure. He has had to learn really how to draw, to educate his form perception, his feeling for plasticity and the third dimension. It has not been easy. It has meant much hard work, but he has never shirked the work: there must be a dozen stones that he has done over because he was not satisfied with the first version (one of them was done over four times). An untold amount of work in all mediums has been destroyed as soon as completed because it did not measure up to his expectations. Perhaps at times he is a bit too serious about his work, and lacking in a certain light-hearted casualness about it. There are some things that cannot be attained by taking thought. One of them is that innate sense of style that renders every line momentous, that gives umph to the most insignificant production. Thus in general — though there are notable exceptions — Spruance's work has more meaning than *élan.* It lacks, broadly speaking, a certain instantaneous appeal; it

88

must be studied and met half-way before its significance unfolds. The bulk of his work, therefore, will probably not be widely popular in that it is addressed to the mature and reflective temperament. Perhaps there is another reason for the lack of a widespread audience — the very nature of the task he has set for himself. He is a man of his time and has undertaken to render a graphic synthesis of it. He must record the obvious and find significance in the things that the average man takes for granted because present everywhere about him. The average man is bored by this, for he seeks in art chiefly escape into the past, into unreality of some sort. Thus, paradoxically enough, the artist who works in the present will not receive his just recognition until the present has become the past. This is specially true of Spruance. He quite literally does not make his prints to sell. He makes his living in other ways, and does not have to inject the note of salability into his print-making. This is a great advantage to art, although it calls for a disinterestedness rare in artists.

Spruance is a man of exceptional integrity, as honest with himself as he is before others. Honest and upright to a degree. He is no bootlicker or time-server. He has never once sought to advance the sale or fame of his art by flattery, personal influence, or devious ways, and he has had plenty of opportunity. He leans over backwards to keep his hands off: his work must make its way on its own or not at all. He holds his art and his inner life inviolate. And he can do so because he is not dependent upon it for a livelihood. Of course he yearns for the time when he can devote all his energies to his art, but he realizes that perhaps that time may never come. Nevertheless he guards jealously his time for creative work; he has never made any far-reaching decisions in his everyday life without considering carefully its bearing on his free time. In his personal life, when he is not withdrawn and working in his studio, he is sociable, warm, spontaneous, outgoing, fun-loving. Curiously enough, this sense of fun does not overflow into his work: art is something lofty,

not to be trifled with. He lives a pleasant middle-class existence. His milieu is middle class in the best sense — the professional class. His intimate friends are doctors, librarians, museum curators, artists, musicians, school teachers, and college professors. They may discourse pleasantly and wittily on music or literature or sociology; they may sing old Christmas carols or part-songs while sipping hot buttered rum; they may play charades or dance or improvise poetry. In all of these Ben Spruance moves naturally and amiably, neither martyr nor man apart. But right at hand, yet never flaunted, is the studio where burns the midnight oil. It somehow reminds one of Ben Franklin, the philosopher of the golden mean: no excess or bohemianism, moderation in all things, hard thinking and simple living, fulfilling all obligations, but keeping the inner spark alive. There is always another Ben to carry on the tradition.

GEORGE BIDDLE

THE ARTIST as man of affairs, or the man of affairs as artist — either phrase sums up George Biddle. Born of an old and distinguished family, with a lineage reaching back to before the Revolution, furnished with every facility of schooling from Haverford School and Groton to Harvard College and Law School, granted ample opportunity for travel in Europe and America, and endowed with exceptional intelligence, ability, and charm, he has the *savoir faire*, the easy entrée into the best circles, the wide acquaintance with distinguished people that betoken the real man of affairs. The number of great men whom he has known on terms of easy familiarity and with whom he has exchanged ideas is impressive. His initiative and active participation in national and artistic affairs are far-reaching. Through his friendship with President Roosevelt, a schoolmate at Groton, with Edward Bruce and other influential people, he was to a large extent responsible for the initiation of the Administration's plan of employing artists, both as a relief measure through the W.P.A. and other agencies, and also as a permanent policy in the decoration of public building. As an artist he is well known for his pictures of exotic and tropical life in Tahiti, Mexico, and the Caribbean, his portraits, his

91

sculpture and pottery, and his frescoes in the Department of Justice Building in Washington. As a printmaker he has made well over a hundred woodcuts and lithographs distinguished for their original technique and sprightly composition.

He was born in Philadelphia in 1885. In his autobiography, *An American Artist's Story,* he gives an exciting picture of his exuberant childhood in company with his equally exuberant brothers, Moncure, Sydney, and Francis. The author goes on to trace with candor and intelligence — he writes well — phase after phase of the artist's " education." It has a faint trace of the objectivity of Henry Adams, for the work has its somberly revealing and critical side as well. Of special interest is the record of his groping and floundering toward personal expression, his hopes and despairs as a creative artist. Ironically enough, with every educational facility at his disposal, he reveals how desperately little all his schooling prepared him for the one thing above all else he wanted to be — an artist: " If I think, then, of my college years in terms of preparation for creative art they are a complete blank. Never would the chances of my becoming an artist seem so negligible. But even thinking of these years in terms of preparation for life they are irrelevant. At Groton I had been in my own eyes something of a failure and I was consequently miserable. I could not conform sufficiently — though God knows I tried — and so I remained, against my will, a rebel. But I was neither miserable nor a rebel at Harvard. I was learning to conform; consequently life was no longer of much educational value. . . . If some proper evaluation of the benefit to one's growth and character were possible — as I believe it never is — or if we could measure the degree to which we have found life ripely blooming and sucked it dry — as I believe we always can in the bright satisfaction of our memory — then the eleven years' schooling in New England and at Harvard seem in retrospect eleven years of retardation of growth. The memories which throb with the quickened pulse of life's adventure are those of the two years away

from schooling and New England for reasons of ill health. Later in Tahiti I learned — or rather I severely drilled and compelled myself to observe — the absolute necessity for an artist to keep life at arm's length, to see objectively. One could only savor its beauty — the beauty was there — if one were not crushed by the ugliness of its little unimportant impacts."

His indictment reaches beyond his regular schooling and touches upon his specific art education: " I could hardly indeed know how right McCarter was in divining that by instinct and training I should attempt to possess art through determination and method rather than through self-surrender and self-scrutiny. Nor could I realize that my friend was a supremely great teacher in that he was more interested in his students as human beings than ever in art theories. Accordingly for three or four years — in Paris, at the Pennsylvania Academy of Fine Arts, in Munich — I doggedly set out to become a proficient art student; thereby acquiring a certain volume of the completely dead but none the less weighty and cumbersome Beaux Arts tradition; which paraphernalia it would take me another decade to eliminate. Perhaps there is no other way to muddle through. Perhaps since it takes three or four years to acquire a certain manual skill, it is quite immaterial what tradition one follows or what is the mental and artistic waste in the process of acquiring this physical dexterity. Perhaps it may take ten years or so to mature one's individual and creative personality, the only obviously necessary thing being that one has matured.

" One thing perplexed me at the time and for years to come. While in art school the ultimate goal, rewarded always by the highest praise, was one's approximation to the standard of the most talented student; whereas the moment one graduated, the meanest dig that one could thrust at a fellow artist was the suggestion that ' perhaps he was slightly reminiscent of so-and-so.' This absolute contradiction between what one had so laboriously achieved for so many years and

what, as a mature artist, one aspired to, is an instance of the muddled, purposeless, and dead-traditional aspects of all art schools, as I have known them. An artist's profession is highly technical; yet these needed techniques are not commonly taught at the academies. . . . One might further suppose that there is no permanent loss in immediately teaching what one must subsequently learn. Drawing, as taught in the academies, is largely a stippled competition with photography; or as taught in modern schools, a psycho-emotional vent. Why not teach it from the beginning as it is ultimately used, as a mode of language, expressed in personal symbols? Any child of four can tell his mother in word symbols that he has dreamed of an animal with six legs, a geranium growing out of its forehead, the face of an old horse, and a permanent wave in its tail. But few mature painters, alas, have the fluency in their own professional media of a four-year-old child in his. Why not from the beginning, then, teach drawing as a personal language of thought and narrative? If this were once generally understood, it would not seem so completely unreasonable to the art student or layman, as often now it must, that the Chinese, the fifth-century Copts, the Trecento Florentines, and the contemporary French do not necessarily speak in the same art idiom."

I have stressed Biddle's critical account of his early perplexities because they dramatize the confusion of standards in art and education which so many of his contemporaries faced. As they in turn have matured and carried on the torch, they have considerably lightened the burden of dead weight in teaching imposed upon the younger generation. Biddle probably learned more from his friends, Borie, Frieseke, McCarter, Cassatt, and Pascin, than he ever did from his teachers in art schools. From Mary Cassatt he imbibed something of the Degas tradition, and some of his earliest lithographs such as the *Bather* are a reflection of it. The experience which first matured him as an artist was his sojourn in the South Seas during 1920–2. From this adventure came canvases glowing with color, decorative lino-

leum cuts, and sculpture. It set the direction, the impulse toward the decorative, that he was to follow for many years to come. His lino-leum cuts of South Sea life, *Spearing Fish, Tahitian Girl,* and the like, were decorative in intent, with pleasing stylized curves and broad flat patterns of black and white. Sometimes they were printed on sil-ver paper to enhance the ornamental effect. Biddle has a real feeling for decoration, and it may be that fundamentally it is the leitmotiv of his art career. Certainly his strongest work is decorative; and his long continued interest in crafts, such as furniture, marquetry, batik design, and ceramics, seems to confirm this conclusion.

His exhibitions in New York of Tahitian work were a great suc-cess; they came at the proper psychological moment when America was inclined to turn to a vision of simplicity and exotic beauty for relief from the turmoil of the World War. He himself had been driven to embark on the South Seas adventure for precisely the same reason: to recover his balance from the shattering experience of the war, in which he served as a staff officer. His success did not go to his head, for he has always been singularly modest and honest about his work, and he has never used his position in any way to enhance his success as an artist. In fact he felt that his prestige had been at-tained too easily and cheaply, and decided that he should measure his achievement against the best that was done in Paris — in other words, try for European recognition. In the spring of 1923 he left for Paris. He had a good time there, but at the end of three years he decided his place was in America: " It took me three years to learn my lesson. I could have pitted my own work against the best paintings in the Metropolitan Museum, which were better than any-thing being done in Paris. I could have pitted my actual achieve-ments against what I really wanted to achieve. That would have been better still."

He did, however, bring something back from Paris which was to remain a strong influence. It was something he learned from Pascin,

95

a new freedom of drawing, a habit of free distortion for vital effect or design. Pascin had evolved this style of drawing naturally; it was the way he drew instinctively. No matter how many liberties he took, how much he deviated from "correctness," his figures always came to life. With Biddle the method was a liberating influence; it loosened up the tightness of his design, it gave him more plasticity in his flat patterns, and relaxed the tenseness of his general approach. It gave scope to more sprightliness and wit, introduced a spirit of play into what had hitherto been a very serious business. If his figures did not always come to life, no matter, it was lots of fun anyway. The decorative intention was still there, but it now embraced another dimension and a livelier overtone. The flat patterns became more three-dimensional in design, the treatment more whimsical and droll. All this bore fruit in the lithographs of 1926–8. They also were researches into new techniques of drawing on stone. In *Adam and Eve, Europa,* and *Hombre Que Sin Verguenza* he built up the entire composition with tiny dots or stipples of crayon. In *Bringing Home the Cows, Twenty-three Little Women,* and *Cows and Sugar Cane,* he experimented with the linear and solid black effects that can be obtained with so-called lithographic engraving or dry point. The stone is first completely desensitized with gum arabic, and the line is then cut through with a diamond or other point. The advantage of this method is that one can combine a crisp etching-like line with all the tonal resources of lithography. Biddle is, as far as I know, the only artist who has employed this technical device used by commercial lithographers for lettering and the like. In numerous other works, beginning with *Three Graces* and *Two Goats and a Rooster* of 1926, he first blackened his stone with lithographic crayon and then scraped out his lights with sandpaper and razor blade. Extraordinary variety and richness of texture are possible by this method, and such prints as the above two and *Expectant Thistles, Goat Herder's Wife, Banana Grove,* and *Coffee Huskers,* based upon

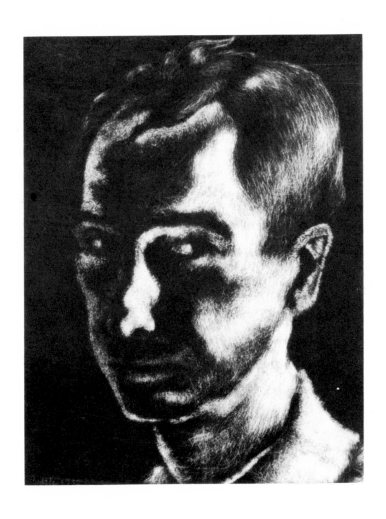

GEORGE BIDDLE: SELF PORTRAIT

LITHOGRAPH

10½ x 8 INCHES

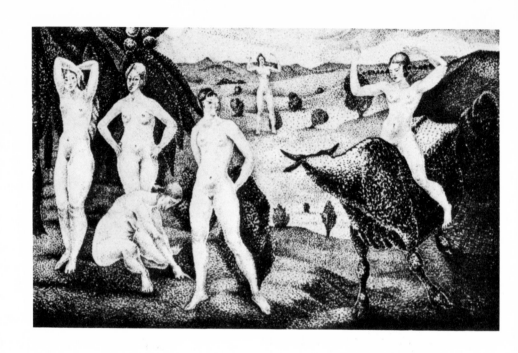

GEORGE BIDDLE: EUROPA

LITHOGRAPH

$7\frac{1}{2}$ x $11\frac{5}{8}$ INCHES

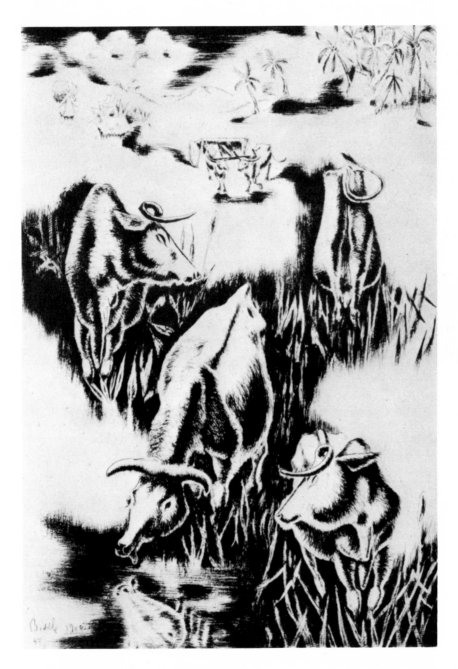

GEORGE BIDDLE: COWS AND SUGAR CANE

LITHOGRAPH

11 ⅝ x 7 ¾ INCHES

GEORGE BIDDLE: IN MEMORIAM SPAIN

LITHOGRAPH

11⅞ x 16½ INCHES

studies made in the West Indies, are among the artist's most charming and orignial work. This group was followed by a Mexican series (*Pollo y Pulque, Woodchopper*).

With the depression there came to him, as to many other artists, the challenge of social, political, and economic problems. With his intelligence and diversified training he saw the implications of these problems more clearly than many. Impelled by the logic of his own conclusions, which in the main might be called the liberal position, he tried wherever possible to translate his beliefs into action. His initiative with regard to the relief program for artists has already been mentioned. Further examples were his protest against the destruction of the Rivera murals in Rockefeller Center, his participation in the brave beginnings of the American Artists Congress, his public stand against co-operation with Nazism and Fascism. His liberal opinions aroused considerable opposition from ultra-conservative and ultra-radical alike. He was accused by the Communists of being a coward and by the conservatives of being a traitor to his class, and thus these impeachments to a certain extent canceled each other. He also attempted to translate some of these convictions into art. The socially conscious phase or, rather, aspect of his art (since its manifestations are concurrent with other types of expression) is not numerically large, and may be said to begin in 1930 with *In Memoriam: Sacco-Vanzetti* and possibly the illustrations to Alexander Bloch's poem *The Twelve*, and to include also *Dulce et Decorum Est*, Hitler and Mussolini as rats, or *In Memoriam Spain*. They seem somehow to be among the least convincing of his prints. He has not yet fused his ideas with an appropriate æsthetic expression. It is not that the ideas are not powerful nor their symbolism ingenious, it is merely that he has used the same language to express them that he employed in his decorative compositions. The wayward playful line and impulsive distortion seem out of place in a deep and moving symbolism. There are a few other prints of his that have so-

cial implications, such as *Sand* and *Death in the Plains*, his contribution to the dust-bowl phase of American art. These and about a score of others were made in his most recent burst of print-making in 1935. He spent a year teaching at Colorado Springs Fine Arts Center, and worked there in co-operation with the lithographic printer Lawrence Barrett. Of this group may be cited *Fire in the Night, Young Girl's Head,* and *Frank Loper.* His two most recent lithographs are *Winter: Croton on Hudson* and a charming portrait of his son *Michael John.* He has a flair for technical experimentation. In fact he considers it one of his most useful contributions to lithography. In addition to the methods already mentioned, he has worked with straight oil paint or with tusche applied directly on the stone with a brush (*Spleen* and the *Nudes* of 1935) and even with lipstick on zinc. These fluid mediums have a certain sweep and elasticity impossible to obtain with ordinary methods, but the effects are hard to control and their use is restricted.

Biddle's achievement must always be evaluated in a dual role. Whether this came about through choice or fate, one can never know. He took up the serious study of art after he had become a member of the Philadelphia bar. His autobiography reveals that he had two breakdowns in his youth. One may speculate about their significance. Could they have been the result of a conflict between his unconscious inclination toward art and the outward course that led to the law? If he had followed art from the beginning, would he still have attempted "to possess art through determination and method rather than through self-surrender"? Would his art have been different? One can never know. At any rate he has had, and has, a full rich life, an achievement gained not by social position but by his own effort and merit. Marsden Hartley, he recounts, once said to him in Paris, "with one of his sour flashes of clipped New England understatement, fixing on me his pale, icy, and judicial glance, and sadistically mouthing his words: 'Biddle, I like your work . . . but there are

two things about you, which, in achieving any measurable reputation, you will have a hard time ever to live down . . . your name and the fact that you have painted in Tahiti.'" He has surmounted both these handicaps, if such they be. It is not as a Biddle, but as an artist and man of affairs that he has his say.

FEDERICO CASTELLÓN

THE ART of Federico Castellón has a baffling yet fascinating quality. It has a classic air, yet is concerned with internal verities far removed from external plausibility. The artist sojourns in a world of free imagination, untrammeled by a logic of literal fact; he brings report of strange realms, uncharted seas of symbolism and the unconscious. The emblems and images which he brings back to us are clothed with the most minute and convincing verisimilitude, a kind of super-realism.

Castellón's life is in strange contrast to his art, uneventful, normal save for its singleminded dedication to self-expression in art. He was born at Alhabia, Province of Almería, Spain, in 1914. When he was seven years old his parents left Spain on account of the reactionary dictatorship of Primo de Rivera and settled in Brooklyn. He went to school and graduated from Erasmus High School in 1933. While he was there he took the regular school art course with brilliant success. Much praise must be given to his teachers for the sensitiveness and respect with which they handled his very obvious talent. This high-school art course was the only formal art instruction he was to have. Young Castellón was absorbed in art: he read books, went to muse-

ums and exhibitions, and studied all the art movements about him.
He experimented with various art forms. At fourteen years of age he
was copying Leonardo, Michelangelo, and Botticelli, his great ad-
mirations at this time. By sixteen he had mastered realism and was
on the point of experimenting with modern styles — cubism, futur-
ism, and the like. At eighteen he was painting a huge mural at the
high school, *Sources and Influences of Modern Art,* and had such a
grasp of the field that he was able to suggest the salient character-
istics of all the modern painters, Cézanne, Van Gogh, Picasso, Ma-
tisse, Derain, Chirico, Mondrian, Lurçat, Rivera, Rouault, and many
others. Meanwhile he continued making experiments in distortion, in
a pointilist or curlicue manner, in a trenchant realistic line somewhat
like Gropper's, as well as producing some extraordinarily clever post-
ers. At twenty he was working out a style of symbolic distortion,
paintings with forms distorted for psychological emphasis, to ex-
press, for example, sorrow at the death of a friend or the reverbera-
tions of a quarrel.

This research was interrupted by an opportunity to travel in Eu-
rope. The liberal Spanish government, through Diego Rivera, had
become interested in the talent of its native son in a far distant land,
and awarded him a traveling fellowship for a year and a half. In
1934 he went to Madrid and studied the pictures of the Prado. " There
is a wonderful collection," he wrote, " of Goyas and El Grecos there.
I have rarely seen anything quite so beautiful as Goya's grotesque-
ries. They were taken from his home, about ten paintings of witches
and goblins and distorted figures. They would, I am sure, be quite at
home in an exhibition of Soutine, Kokoschka, and Rouault. The color,
or rather the lack of it, is beautiful. There are also several cartoons
for tapestries and portraits and his *Maja Desnuda* and *Maja Vestida,*
which enjoy greater fame than the work he preferred. Of course I
never read that he preferred the ghoulish things, but the fact that
when he painted for his own pleasure he painted these is proof

enough. The El Greco room has a splendid collection. The only things I despise in that room are the museum guides who explain that the trouble with his painting was faulty eyesight. As if such masterpieces needed an excuse for their existence! The Valásquez room is always well filled with people, copyists and so forth. I do not know how you feel about it, but I feel that El Greco and Goya deserve much more than Velásquez. There is a room devoted entirely to one of his paintings, *Meninas*. In this room there is a mirror opposite the painting to show how natural the people look — something to amuse the uncultured.

"I have traveled," he wrote, "through a number of cities in Spain since I arrived, finally ending up in Almería, my birthplace, where I remained with my relatives for a period of two months. I believe that the experience I have gained from traveling has improved my painting. At least, the eleven paintings that I made in Almería show, I believe, greater maturity, better understanding, and, fortunately, less influence." He went to Paris and also made a brief trip to London. He wrote enthusiastically about paintings in the Louvre by Ingres, Corot, Daumier, and Delacroix, though he thought the building itself was hideous and dirty. Meanwhile he was constantly working. The boy of nineteen needed no personal instruction; as far as he needed help, pictures were his teachers; he was capable of developing by himself. He had letters of introduction to such artists as Picasso, which he never presented because he was afraid the contact might be overwhelming for him at his age. Wherever he went, however, his precocious talent was recognized. In Madrid he had a one-man show (he had had one in New York before that); in Paris he participated in a big show of Spanish artists on an equal footing with Picasso, Gris, Miro, Dali, and others. He pursued several lines of research. He made a series of abstract form studies in white and black on brown to sharpen his plastic sense. He worked out a drybrush technique employing distortion and free rendering of the hu-

man figure to express elements of the unconscious. This manner was to receive its fullest development in the next two years. He poured forth drawing after drawing with the most amazing fertility of invention and beauty of execution. Another style which he was to amplify in succeeding years was also initiated at this time, the so-called resist-ink paintings, a combination of India ink and tempera colors. They were classic in feeling, human figures expressed in big serene forms akin to those of Piero della Francesca. His greatest achievement in this genre is perhaps the *Pomona* and *Judgment of Paris* of 1940.

He returned to New York at the end of 1935 and has lived there ever since, interrupted by two summers at the artists' colony of Yaddo. He has continued to work along two concurrent lines, in a decorative classical tradition akin to certain phases of Picasso and the old Italian masters, and in a somewhat surrealist manner. In this latter mode he has probably been influenced to a certain extent by the work of Picasso, de Chirico, Tanguy, and Dali. But this influence has been greatly exaggerated because of superficial resemblances. After all, surrealism represents a school, an attitude or approach held in common by a number of artists. They receive encouragement and stimulus from one another just as the cubist school did.

But what really is this surrealism that is so much talked about? In the first place, a distinction should be made between surrealism in its narrowest sense and what might be called symbolic representation. Surrealism, in so far as it is genuine and not just exhibitionism *pour épater le bourgeois,* rests upon an inner or unconscious compulsion. It is expression to relieve an inner strain, in much the same way that dreams are, according to Freudian interpretation. The conflict of unconscious (and often anti-social) motivations with the repressive demands of conditioned social behavior is mollified by the oblique expression of these motivations through symbols that somehow pass the censor. Surrealism is anti-rational, preoccupied with

self, and to a large extent morbid and pathological. Its manifestations have a certain therapeutic value for the practitioner, since the personality might crack if the inner conflict were to become too great. That they also furnish insight into the workings of the unconscious, many psychologists can testify. Surrealist pictures in themselves, thus, may interest their creators and certain specialists, but hardly the world at large, except in so far as they include other æsthetic values of form and design. They tell us much about the artists, but contain no valid message from them.

Symbolic representation derives its impulse largely from another source. It aims to express something more than self; it seeks rather to express an emotion, an intuition, a relationship, an idea, by way of symbols tellingly combined and employed. It may juxtapose irreconcilable objects in a seemingly irrational way. It may violate unities of time and space, boundaries of sense and nonsense, the whole logical fabric of the phenomenal world. It may be as unconstrained in its creative imagination as the wildest surrealist dream. But it always has a *raison d'être.* Beyond its obscurity to the literal eye is its significance to the mind's eye. It has an inner meaning, either emotional or intellectual, which binds together all the seemingly unrelated objects. Its rationale is noumenal. It furnishes the technique whereby we may approximately realize in graphic form the irrationalities or infinities of our experience. Symbolic representation has been used at times by the old masters. Dürer, for instance, in his *Melancholia* assembled in one composition various objects related only through the meaning of the title. Brueghel gathered together all the symbols and attributes of the virtues and vices to form fantastic allegories. Blake and Goya used the method and so have many other artists. The principle does not change, but the symbols may vary with time. In the Middle Ages and the Renaissance, the details and dogmas of religion or humanism were matters of common knowledge. The artist could use the symbols based upon this common knowledge with full

FEDERICO CASTELLÓN: SELF PORTRAIT

ETCHING

$5\frac{5}{8}$ x $7\frac{1}{2}$ INCHES

FEDERICO CASTELLÓN: RENDEZVOUS IN A LANDSCAPE

LITHOGRAPH

9⅝ x 15⅛ INCHES

FEDERICO CASTELLÓN: OF LAND AND SEA

LITHOGRAPH

10⅜ x 9⅞ INCHES

FEDERICO CASTELLÓN: MEMORIES

LITHOGRAPH

12⅝ X 9⅜ INCHES

assurance that their meaning would be clear. In modern times the range of symbology has been extended to the fields of economics, politics, and psychology (especially the unconscious). The audience to whom these symbols are intelligible is growing; eventually it may become universal. Meanwhile the symbolism and the art constructed upon it appeal to relatively few. Among American printmakers Orozco, Harry Sternberg, Lamar Baker, Eugene Morley, Benton Spruance, Grace Clements, and others have used symbolic representation.

Some of Castellón's painting is definitely surrealist. There is in him some devious but relentless drive to produce, some inner conflict that must be resolved in expression. These paintings mean much to him; if he were rich, he would never part with any of them. In his own words: " In spite of the unanimous damning my surrealism receives, I like it more than my more rational work. . . . It is something far above money. It is more for spiritual stability, if it may be called that." Most of his prints, however, are symbolic representations. Take, for example, the lithograph, *The Gordian Knot:* the apparently absurd and fantastic composition takes on a new meaning when the group of figures are viewed as the representation of the complexities of multiple divorce and marriage. The conception betokens a psychological maturity rather amazing in a youth of twenty-two. Two of his most beautiful lithographs, *Of Land and Sea* and *Rendezvous in a Landscape*, evoke overtones of brooding mystery. What deep enchantment, what spell of fay, brings two men, an unclad maiden, and the figurehead of a ship together on a desert plain? Does *Rendezvous* re-enact that æon of wonder in Eden when Adam first saw Eve? His characters, the strange, tall, serious men, the graceful women with slender hands and enigmatic faces, seem charged to the full with emotion, seem to move as if possessed. They fascinate and disturb the beholder; once seen, they are not easily forgotten. On the technical side, too, *Rendezvous in a Landscape* is of great interest. It is

printed from two stones somewhat in the manner of a chiaroscuro woodcut — that is to say, from a key plate (giving the outlines) and from a tone plate. This double printing gives a sort of stereoscopic effect and enhances the three-dimensional quality of the picture. All of his prints exhibit technical virtuosity. The lithographs *The New Robe* (also in two printings), and *By the Arks* and *Memories,* and the serigraph *Tête-à-tête,* and all the etchings, are related to the classical tempera paintings, and are decorative in character. He has no great interest in landscape for its own sake. His two landscape prints, *Landscape in Spain* and *Spanish Landscape,* express rather his feeling about the Spanish tragedy.

In 1941 Castellón made his first etching. This and a half dozen others were not finished until 1942. Several are experimental plates to try out the process. In general they follow the trend laid down by his classic painting. More ambitious and perhaps most effective is the *Self-Portrait* with a background of symbolic figures and landscape. Other successful plates are *Utopia* and *Nude,* a freely executed delightful sketch.

An astonishing trait in Castellón is the free range of his thought, his lack of mental restrictions or taboos. He has an intuitive maturity far beyond his years. He seems to have been born with a sense of freedom "beyond good and evil." He approaches the conventional categories with the objectivity of a scientist. Possibly he is unaware of the implications of some of the things he has painted. Nevertheless the fact remains that the restraints of convention carry relatively little weight in his mental life. What takes their place as the "governor" of the mechanism, the only brake on the absence of inhibition, is an innate sense of style. This sense of style pervades his whole being and governs his thought, his feeling, and his action. It is possible that his feeling for style is due to his Spanish background, for the Latin temperament, as Santayana and Norman Douglas have pointed out, seems to possess it instinctively. The Latins, having a

sense of pride in life as well as a sense of its limitations, know how to live. Their rule of life is not moral precept but æsthetic value, a sense of fitness, an awareness of limitation.

Castellón is uninhibited in another amazing way — in the immediacy of his expression, with hardly any hindrance between idea and execution. With most artists, terrific effort is necessary to cast their inspiration into concrete form, a struggle to refine the conception and a struggle to set it down adequately. The paradox is that those who can delineate visual reality easily and faithfully are the very ones who treat exact representation lightly. A certain measure of travail must take place every time. Those who have difficulty in " copying nature " spend all their energies on it and achieve their due meed of success. Those artists to whom such tricks come easily, needs must meet other challenges and try to transcend nature, to express the inexpressible, and so on. With Castellón, the conception or idea is so crystal-clear and so completely elaborated in every detail, and furthermore his technical facility is so astounding, that each picture is poured forth at white heat as it were. In working at his pictures he sometimes will start with some prominent section and work it out complete in all its values, then go on to another section likewise. There is never any fumbling: the composition and design are all worked out in his mind beforehand. He has an extraordinarily visual memory. He drew from a model in high school and very occasionally in the studio of a fellow artist in Madrid, but otherwise he draws from the fund of his imagination. His technical mastery is so assured that there is nothing he cannot do and do easily. He can lay a uniform tone involving the most meticulous control of detail, without loss of inspiration. His ideas come to him at odd moments, listening to music or just before dropping off to sleep. Sometimes they come thick and fast, many more than he can carry out. At other times there are fallow periods when nothing comes. He likes to lie on the floor and listen to symphony concerts over the radio and let the images flow

through his mind. Sometimes he will make a rough sketch of a half dozen essential lines to fix the drawing in his memory. His favorite authors are Poe, Lewis Carroll, and Blake. But in general he does not read much. His waking hours are spent in drawing and painting. I asked him if he had ever read Freud. He said he had once asked for his works in a London library, but they were out at the time and he has never pursued the matter further. He occasionally writes poetry, sometimes on the back of drawings in a coiled serpentine fashion.

As a person Castellón is modest, unassuming, youthful as befits his years. In high school he was a typical student engaged in all normal activities, in no sense set apart save by his precocious talent in art. He has a fund of healthy animal spirits. He is full of boyish enthusiasms, sometimes a bit naïve, sometimes a bit immaturely self-conscious. His instinctive reactions are healthy and normal. Like so many Americans he has an interest in machinery. He and another boy bought a jalopy for twenty-five dollars, tinkered with it (as he said, the only part in it that was not second-hand was an electric light bulb), and scooted around in the country with it. With three youths he spent a week-end camping out in New Jersey. He made some sketches at an old quarry; not liking them, he made paper airplanes of them to launch over the quarry. The quartet baked two banana cakes one foot in diameter and consumed them in quarter sections. At midnight they landed on a lawn in Montclair, where they enacted murder mysteries, such as one hears over the radio, with screams and sound effects. At times when he was fed up with art, he would knock off work, swim and loaf in the sun for a week or so.

Castellón has called himself man-child. And so he is — with a normal youthful physical life and an amazingly mature and rich inner life. Usually shy and reticent, every once in a while he will say something that reveals shrewd observation or ripened wisdom. He has psychological awareness and can be very acute in analysis of character and motive. He sometimes, though not often, carries this analysis

to extravagant limits and gets involved in a complexity of *arrière-pensées*, hinging for example on whether or not to accept an invitation to lunch when he has no money in his pocket. In addition to the concerns of a personal nature, his inner life is rich in reactions to ideas, to music and art and literature, to people and situations, to world events, and above all to subliminal entities, microcosms of thought and feeling.

He once related an experience when he was disturbed by a visitor. The letter was written many years ago in a rather adolescent self-conscious style, but it will throw some light on the amplitude of his psychological reverberations: " I am painting peacefully and ecstatically on the kitchen table. Nothing exists about me but space, pure air for miles. Wondrous forms come by, as in a dream, and look over my shoulder. They shudder with emotion, and my heart shudders in sympathy. We are friends. We know each other. At night we act in secret, away from this morbid world, the roles which in the awakening are humanly impossible. Nights and nights with these friends and intimate strangers have made us all one. Suddenly the doorbell rings. A vistor. My friends flee through the cracks in the wall, and through the open window into space, hating the visitor as much as I, for having so brutally invaded our midst." It is not without reason that he knows and admires Blake and Redon.

Federico Castellón is an artist young in years but ripe in talent, normal in life but emancipated in imagination. His technical facility is amazing: there is no form or subject that he cannot depict in masterly fashion. Seldom has there been so little resistance, in a creative artist, between conception and concrete embodiment. This facility is tempered by a natural seriousness of mind and a certain humility of attitude which prevents him from becoming superficially clever and repeating past triumphs. There is in him a fertility of imagination, an intensity of feeling, an emotional timbre, combined with beautiful drawing and vivid tactile sense, that give his work rare distinction.

109

ALFRED STIEGLITZ

ALFRED STIEGLITZ is one of the most extraordinary men of our age.
Not so many people recognize this now, but I think that to succeed-
ing generations, with the added perspective of years, he will loom
greater and greater. There is no doubt he is the greatest living pho-
tographer, a notable pioneer in the introduction of modern art in
America, and an active encourager of art, literature, music, and
drama. Fundamentally he is a " seer " — in a double sense. He sees,
truthfully and beautifully — rendering his vision concrete in memor-
able photographs — and he also sees beyond, into human and tran-
scendent values. It is this spiritual quality, as well as his innate taste
and passion for perfection as an artist, that has made him what he is.
He functions as a creator, yes, but also as a spiritual leader sub-
ordinating his own creative activity to a spiritual ministry. He is as
much interested in the development of the artist as he is in the de-
velopment of art.

How else can one explain the role he has undertaken toward the
artists in whom he has had faith, Marin, O'Keeffe, and Dove? With
a full sense of his own responsibility he has become an intermediary
between the artist and the art patron. How else can one explain his

habit of using art as an instrument for testing people in that psychological laboratory known as " 291 " or " An American Place." He will often confront a man or woman with a picture or photograph, the emotive power of which he has calibrated by previous experience; and by observing that person's reaction, gain an insight into the unknown character. I wonder if Stieglitz has not evolved for himself a " photographic " philosophy of life. Every manifestation of behavior in a person can be considered an instantaneous photograph of that person, and the totality of these photographs constitutes his life. Stieglitz is a camera of unusual sensitiveness, and is constantly recording impressions — taking snapshots — of people, whether they know it or not. He is quite detached about it and seldom moved to spite or rancor by his findings; he accepts deception or betrayal as he does heroism or generosity. There are times, of course, when he is moved to action, but it is in an impersonal way — one force setting another force in motion. In any case he sees his subject clearly. He judges, or rather registers, every momentary gesture as significant, just as he accepts full responsibility for every manifestation of his own behavior. Those who are tried and found wanting in their relations with Stieglitz often dig their own graves without his intervention. They may deceive themselves but not him. Throughout his life he has consistently appealed to what he calls " the record " in his judgment of people and events. For example, in the files of *Camera Work* he confronted the art critics with their own published stupidities in relation to the introduction of modern art in America. What an autobiography Stieglitz could write if he would but set down the records that are stored in his memory.

The conduct of his gallery has been a source of puzzled surprise to many. He is literally and figuratively not a business man. He has never made a penny profit from the sale of art; the years he has spent in galleries have been for the sake of the artists he has befriended. His amateur standing has made his attitude all the more uncompro-

mising. He does not have to kowtow for business reasons. Like a physician, he may charge a rich man a high price, and give another picture away to a poor student. Often he forces the buyer to make an offer of what he is prepared to pay. He is concerned with the moral issues involved: what sacrifice is the so-called art patron prepared to make in order to obtain the priceless object. He maintains that a work of art has no monetary value: it quite literally is without price. He and his gallery function as a medium of exchange between the patron's money (good for the artist's body) and the artist's picture (good for the patron's soul). However disconcerting he may be to the worldly type, to the real artist he is sympathetic and helpful in a practical way. No one will ever know how many struggling artists he has encouraged toward creation.

It is these qualities of the man that set the tone and purpose of his public activities. In his three enterprises for bringing art and the public together, "291," "The Intimate Gallery," and "An American Place," it is not difficult to see a unifying idea or leitmotiv running through them all. It is what he calls the Spirit of the Place, and it makes his gallery stand for something definite, certain qualities of integrity and vitality and adventure. It is that which fosters and encourages the experimental approach, the creative attitude, that divine discontent which tolerates no diminution of effort but drives on to new conquests. It is that which demands both purity of motive and purity of expression, which demands significance of meaning as well as perfection of means. Stieglitz has been fortunate in finding three other artists who, like himself, have consistently maintained this creative approach, Marin, O'Keeffe, and Dove. Their paintings and his photographs have formed the germinative nucleus, the touchstone, of his exhibiting activities. He has shown the work of other men and women, if it had some relation to the spirit of the place. It is astonishing how many fine artists he has introduced or encouraged, at a time when it was daring and prescient to do so, and when above

PORTRAIT OF ALFRED STIEGLITZ

PHOTOGRAPH BY DOROTHY NORMAN

ALFRED STIEGLITZ: GEORGIA O'KEEFFE—HANDS, IV. 1919

PHOTOGRAPH

ALFRED STIEGLITZ: LAKE GEORGE, 1921

PHOTOGRAPH

ALFRED STIEGLITZ: DOROTHY TRUE, 1919

PHOTOGRAPH

all it was crucial either in the artist's development or in its bearing on American culture. Some of the details of this enterprise can be found in *Camera Work* and in the book *America and Alfred Stieglitz*. Thus his gallery, and the spirit that animates it, have been a constructive impulse both in the encouragement of genuine artists and in the education of men and women toward higher values. It has been more than a gallery: it has been an experimental and psychological laboratory (and, as with all laboratories, a corner where things are clean in every sense of the word); it has been a spot where exciting adventures could and did take place, a refreshing oasis of the spirit amid the wasteland of Mammon.

Sherwood Anderson has written of Stieglitz's superb sense of craftsmanship. And it is very true that he has a profound feeling for materials and a passion for excellence that leads him to untold expenditure of time and energy. In his photographs, as far as is humanly possible, there is perfection and the completest realization of his intention. Every possible factor of light, atmosphere, temperature, chemicals, paper, and the like is consciously considered; any lucky accident is immediately seized and taken advantage of. By having the process as a whole, the first and last conception, clearly and consciously in mind, he can hold to the bigness and intensity of his vision while working on the details, and can even modify his original plan in favor of a better one as he goes along. He registers sensibilities involving variations of a hair's breadth in the proportions of a photographic mount, discriminations between infinitesimal variations of shades and values in judging prints from the same negative. Beyond all these concrete or material factors are psychological elements such as his waiting patiently but alertly for years to get the most perfect combination of circumstances for the photographing of a plant, a tree, a building, a cloud, or a bit of landscape; or his storing up for years and years of knowledge of a human being to make the one photograph that would emphasize the essential out of the many

113

thousands of superficial aspects. (Stieglitz once refused a commission, involving thousands of dollars, to make a photograph of a man, on the ground that he did not know him well enough.)

In addition to the intrinsic qualities of his prints, one must emphasize their historic importance. He was the first to make pictures of night scenes (*Icy Night, Night: The Savoy, Night: Fifth Avenue,* all of 1897); and likewise in *Winter on Fifth Avenue* and *The Terminal* of 1892, and *Wet Day on the Boulevard, Paris* of 1894, he achieved technical and atmospheric effects hitherto considered impossible to obtain in photography. This was in the days before fast lenses and fast plates when one had to work with slow gelatine-bromide emulsions. As he has said: " In my time, many many years ago, when I was young and photographing nearly daily, never dreaming of painters or paintings or artists or exhibitions, I made thousands of negatives and prints. This was before the kodak had been invented or the film either. Even the detective camera, as the first hand cameras were called, had hardly come into being. I used glass plates, 18 x 24 centimeters, used a tripod and no shutter. I dragged the heavy outfit over Alpine passes and through streets of many European villages and cities, never exposing a plate until I was sure it was worth while to risk one. There was no random firing as is so often the custom of today. Those were still pioneer days in photography."

Stieglitz has been an expert technician ever since his thorough grounding in photographic chemistry at the Berlin Polytechnic during the years 1882–5. His inventiveness has been displayed not only in technique but also in subject matter. He has been a pioneer in portraying New York, both its people and its skyscrapers, in rendering textures of old barns or of blades of grass, in creating psychological dramas by means of trees or clouds. His portraits have never been surpassed. He has made hundreds of photographs, of the utmost variety, devoted to a single theme — the composite portrait of one

woman — so amazing in their intimacy, subtlety, and emotional over-tones that they might be called the essence of Woman. In another vein he made a *Portrait of Dorothy True* in 1919, which, with its double printing, pointed the way to a procedure much used later by other photographers, especially in the advertising field. Ever since he started making prints in 1883, he has consistently fought for photography as a true and independent art, having intrinsic stand-ards of its own, and for photographs, free of flattering retouch or "artistic" manipulation, straightforward prints which did not try to imitate painting effects. He has waged this fight not only for him-self but for all sound practitioners. The broad outlines of this story can be found in the pages of *Camera Notes* and *Camera Work*.

Everywhere and always he has had a passion for perfection. He will accept no compromise or half-way measures. Of course such an attitude is hardly possible except on a basis of minimum economic security. Stieglitz has been fortunate in having such a minimum basis. It often guaranteed only the bare necessities, but nevertheless it left him free to follow to the uttermost whatever interested him, be it sport, photography, or the study of life and human nature. This freedom from economic pressure, this ability to pursue a thing for its own sake without thought of tomorrow's bread and butter, has endowed him with a rather rare virtue among men — integrity. In-tegrity is seldom possible without security: almost everybody has given hostages to fortune through the necessity of earning a living for himself or those dependent on him. There are, on the other hand, many men who have riches but not integrity. Stieglitz has made countless sacrifices in the pursuit of his ideals, and often waged a quixotic fight in the defense of a principle. Nevertheless the fact remains that economic security is almost a *sine qua non* in his career, just as it was in the lives of Cézanne or Gertrude Stein, to mention two unrelated examples. It also serves to emphasize his concern at the deterioration of personal pride in workmanship brought about by

the collectivization of craft and industry. As an individualist and creator, valuing above all else the constructive aspects of art and culture, he is opposed to the domination of militarism and mechanical efficiency which is taking hold even in his own country. To call Stieglitz a dilettante, however, who pursues art for art's sake, with all that this implies of sterility and preciousness, is to miss his character completely. Though his attitude, like that of the ideal amateur, is pure and free from pecuniary motives, yet his interests are entirely bound up with life, and subordinated to attaining spiritual mastery through all-around development.

Like many another seer or prophet, Stieglitz, apart from his activity as a photographer, is concerned with " creating a legend." It is preoccupation with " the record " in another form. Most often he writes his scripture not on paper but on the minds and feelings of men and women. He is like an embodied male principle, a concrete psychological force, fertilizing here, challenging, influencing, or dominating there, being betrayed or repelled; like all uncompromising forces, sometimes constructive, sometimes destructive. He is ever driven by his dramatic instinct to put his impress on whatever personalities he happen to meet. His spiritual power stands ever as a challenge to a worldly scale of values, always in favor of essential contacts in place of superficialities, in favor of self-development and individuality and the higher vibrations of creation. So long as he comes in contact with personalities who are his equals, actually or potentially, such a power is stimulating; but when this same power is in contact with personalities undeveloped or of a lower rate of vibration, the resultant is more likely to be negative than positive. Consequently there have been in his life a number of crises in which he feels that those who professed sympathy and understanding of his aims failed or betrayed him. The sad refrain: " They do not see," or " They do not understand," is often on his lips.

Philip Mairet once wrote of D. H. Lawrence: " Lawrence was one

of those rare men who have what is called *mana*. Such a personality is in a specially intimate relation with its own intuition. It can radiate psychic life to others and make them feel that they are deeply, peculiarly understood — but it is aloof all the time, dedicated in some way to itself, and will not brook the slightest opposition. You cannot have friendship, in any usual sense of the word, with such a person." Much of this description applies, I think, with equal force to Stieglitz. Apart from those individualities strong in their own right, the relations between him and others (always excepting those that were casual, temporary, or formal) were not friendships between equals, but relations of the disciple-master type, and they usually degenerated into the disciple-misunderstood-master type. The disciples, usually understanding or responding to only one aspect of the master's all-embracing philosophy, and hence without his qualifying breadth of viewpoint, were apt to say ridiculous or do foolish things even if they did not actually fail him in a crisis. Stieglitz and Lawrence have many other things in common, such as their passionate intensity, their almost neurotic sensibility, their flaming assertion of individuality. They both longed to found Utopias, Lawrence with a band of equals in Mexico, and Stieglitz with a band of artists as " 291." And is not a Lawrence legend growing by leaps and bounds, just as Stieglitz's influence is being manifested or paid tribute to by numerous writers and artists of today?

One cannot get far in the creation of legend without dramatic instinct. Stieglitz, like all of us, dramatizes himself in a purposive role. Naturally the role will vary according to the person before him. Sometimes in his anxiety to create an impression he overreaches himself: I have witnessed him straining for effect in a first contact with a stranger when he was pressed for time. Again I have observed in him occasionally a tendency to be long-winded (he can talk without effort for hours at a stretch) and on rare occasions to " orate " or talk ostensibly to one person but in reality to direct his speech toward

a group of mute listeners. I have even heard that he can be insulting, arrogant, and overbearing. I myself have never found him so in the thirty years that I have known him. I can imagine him to be disconcerting to those who do not know him — for it is not often that one meets an uncompromising force in the flesh — but insulting, never. On the basis of the truism that one takes from a situation what one brings to it, it is possible that those who chronicle such conversations were merely reporting their own feelings and reactions. But all these faults, if faults they be, are to my mind but the peccadilloes of greatness. At his best he is a marvelous conversationalist. Story after story, crammed with the significant detail of a trained observer, come forth from his prodigious experience. They are not casual stories: they always illustrate a principle or a trait of human nature under discussion. What intuitive sympathy and tolerant wisdom of life, what an understanding of the ways of the world as well as of mystical experience, are implicit in his speech!

Stieglitz is loved or hated by many, but comprehended by few. A prophet is seldom understood in his time. If it has seemed that Stieglitz has spoken or acted in parables, it is because people have not had the insight or foresight to discern that he was speaking plainly. Like so many spiritual leaders he unites in himself many paradoxes. He combines disinterestedness with the utmost interestedness. He, who has no truck with commerce, spends many years of his life disposing of pictures for artists. He is an amateur in his attitude toward life, yet professional in his standards of achievement. He is the seer, a see-er of both near and far, the greatest living photographer and a prophet as of old. In his own words: " I am an American. Photography is my passion. The search for Truth my obsession."

YASUO KUNIYOSHI

Yasuo Kuniyoshi has made a unique contribution to American graphic art. His innate sense of style, the directness and sensibility, the personal vision manifest in all his lithographs, render them quite literally apart from the great bulk of factual American prints. There is possibly a reason for this. " I have wished to express," he once wrote, " the thought of the East, my race, using the tradition of expressing inner thoughts through a full realization of the matter of my experience." In other words, Kuniyoshi is an artist of innate talent, with a point of view conditioned by his early Oriental background, who uses the technique and mode of expression of the Western World. There are in his prints a sure realization of form, sensitiveness to tone and color, and racy and idiomatic draftsmanship. There is always purity of mood, and, above all, intensity of feeling. There is, as I have said, a sense of style that is rare among American artists. But all these qualities are given edge and direction by his individual approach, blended of Oriental and American experience. He is thus both native and exotic, and he thereby adds a special note to American graphic art, a new and personal way of looking at things. Take for example the lithograph *From the Board*

119

Walk. Nothing could be more American in subject matter than these two girls on the beach at Coney Island, yet see how they have been transformed into something timeless and universal. The scope of his subject matter is limited by his idiosyncrasy — still life, quaint figure pieces, circus performers, and a few landscapes — but within that limit his work is pure, intense, and of a haunting beauty. He is never intellectual, for all that his works are beautifully designed and constructed. There is a directness of feeling and perception in his drawing that is never premeditated. It is interesting to record that among his favorite artists are Korin, Sesshu, Moronobu, and the other woodcut primitives, Sharaku, Courbet, Signorelli, Daumier, and Delacroix. It is also interesting to record that when he revisited Japan in 1931 and held an exhibition of his work in Tokyo, Japanese artists and critics thought that his work was European (not differentiating between Europe and America) rather than Oriental. They were impressed by the dissimilarities between his work and their own, and failed to note the similarities that were not so obvious.

Yasuo Kuniyoshi was born of middle-class family at Okayama, Japan, in 1893. He showed no striking aptitude for art as a child, nor does he recollect anyone in his family or ancestry who showed a proficiency in the arts. The quality that was conspicuous in his character even in this early period was a sense of determination and adventure. At the age of thirteen he laid before his father two propositions as to his future career: either that he enter the military school in preparation for a life in the army, or that he be allowed to go to the United States. He himself, lured by the adventure of exploring strange lands, foreign customs, new ways of life, favored the United States plan, but he knew that he must present his father with a more drastic dilemma in order to gain his ends. And so it turned out; his father compromised on the trip to America, and he landed as a student in Vancouver and then in Seattle in 1906. Thereupon followed a quixotic gesture which again throws light on his character: he sent

PORTRAIT OF YASUO KUNIYOSHI

PHOTOGRAPH BY YAVNO

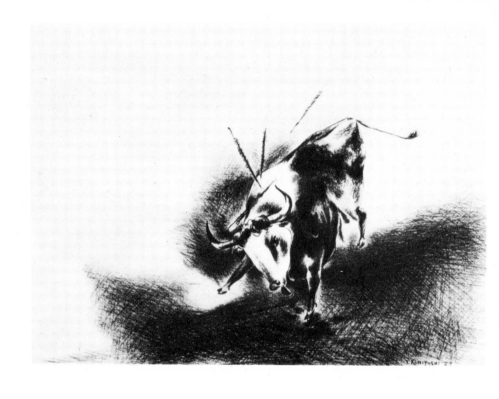

YASUO KUNIYOSHI: BULL

LITHOGRAPH

9¼ x 13 INCHES

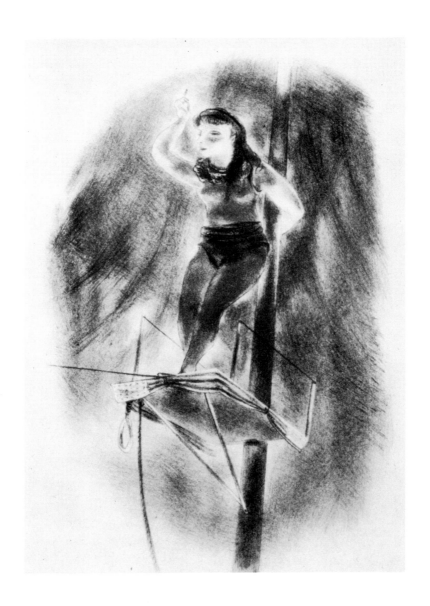

YASUO KUNIYOSHI: TIGHTROPE PERFORMER

LITHOGRAPH

13 X 9 INCHES

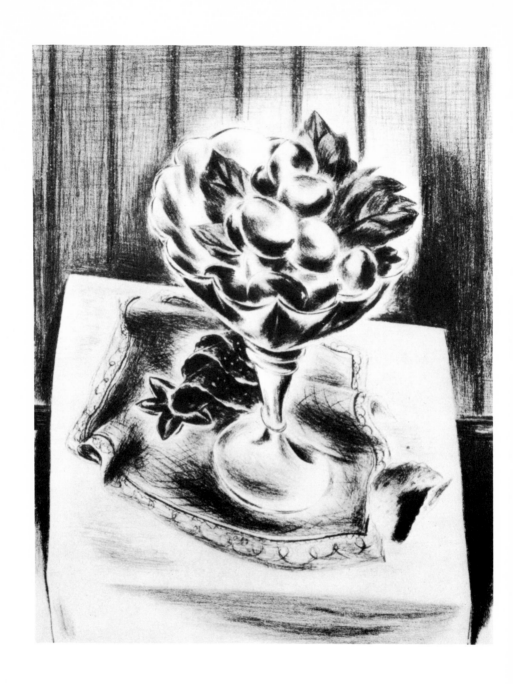

YASUO KUNIYOSHI: PEACHES

LITHOGRAPH

12 x 9⅜ INCHES

back to his family all but fifty dollars of the money they had given him to live on, for he was determined to make his way on his own — an amazingly courageous decision for a boy of thirteen, speaking but a few words of English, alone, without any friends in a strange land.

He sometimes wonders how he ever got along during those next few years. Sometimes he half repented that the die had been cast, but he never gave up. He weathered the winter cold of the North-west and the heat of southern California. He worked at odd jobs in restaurants, scrubbing floors, as a bell hop or ranch hand, in railroad shops, picking cantaloupes and grapes in the Steinbeck country. He learned English in a mission school and in the public schools of Los Angeles. A teacher in the latter, noticing his emerging aptitude for drawing, suggested that he go to art school. His zest for new experience still being with him, he attended the Los Angeles School of Art and Design, as well as having a try at aviation, then in its pioneer stage. In the end the pull toward art proved to be stronger, and he set about seriously preparing himself for the profession of art. He came to New York and studied briefly at the National Academy, at the Independent School with Homer Boss, and finally at the Art Students League, where he found in Kenneth Hayes Miller a friend and mentor. Economic problems were inextricably mixed with art-school problems, and his schooling was sometimes interrupted by periods of earning a living. For instance he never saw the Armory Show because at that time he was working in a restaurant in Syracuse. It was a period of excitement and stimulus and earnest endeavor, for a vigorous and inventive younger generation was knocking at doors of the Academy and the conservative dealers. There were few outlets for their art at the time, yet Kuniyoshi remembers, as a high spot, in addition to the exhibitions at 291, his association with the Penguins, that lively band of artists who came together to draw and play and show their work. Through this group he widened his circle of friends, first exhibited his work, and received much en-

couragement to go on. That sense of adventure and determination which showed itself so early in life became sublimated, one might say, into the imagination and the intensity of his art. His development has been slow but steady. Gradually recognition, honors, sales, a Guggenheim Fellowship have come to him, until his place in American art is now secure. But in the midst of all his success he has never forgotten that he was once a struggling and hungry art student. He has given freely of his time and energy to those organizations which aim to increase the dignity and standing of artists in America.

Kuniyoshi has made in all about seventy-five lithographs, and perhaps a dozen etchings. The first one, *Cow*, was made in 1922 more or less by chance. It was in the old days of the Whitney Studio Club, and Mrs. Force commissioned George Miller to come down with his lithographic press and demonstrate how lithographs were made. Zinc plates were distributed to Bouché, Duffy, Niles Spencer, and Kuniyoshi, and were drawn upon by the artists and printed by Miller on the spot. Beginning about 1924, Kuniyoshi made a few lithographs every year. At first he never took them very seriously; he made them just for fun. He would take a number of zinc plates with him when he went to Maine. When the fancy seized him he would draw on them. If they did not turn out successfully he would throw them away. In 1927 he became more and more interested, and made a larger number, including some big transfers. It was not until 1928, however, that he plumbed the full possibilities of the medium. He spent a year, while in Paris, working in black and white to the exclusion of painting. For the first time he worked on stone, and found it so much more sympathetic and flexible that he has never used zinc since. He made about thirty lithographs during that year and had them printed by Desjobert. The whole group, containing some of his most famous prints, was later exhibited at the Daniel Gallery during December 1928. Among the subjects were two scenes from the bull ring, *Bull* and *Bull Fight,* the fruit of a journey to Spain,

several Paris scenes, *The Night Police, Landscape* (along the Seine), and *Rail Road* (that curious belt railroad that encircles Paris), and numerous still lifes and scenes from the circus and night life.

Along with the transition from zinc to stone lithographs had come a development of technical means and a more sensitive æsthetic approach. The early lithographs were literally black and white. He used the relatively coarser-grained zinc for black linear accents to the exclusion of any subtle gradation of tone. He saw everything as black or white. But henceforth his lithographs were permeated with a sense of color. This was the influence that his painting had upon his graphic work. He built up his semi-tints simply but surely, ever playing for color, for tonal relations. His compositions had always been distinguished, but now his lithographs became bathed in atmosphere and light. It takes him about a week, with much sharpening of lithographic crayon, to complete a stone. His means are simple: he employs no tricks or bravura short cuts. If he were ever inclined to employ them, he says, one look at the simplicity of a Daumier lithograph would convince him of the futility of showing off.

After his big splurge of 1928, Kuniyoshi has fallen back into his old habit of making two or three lithographs a year. Among the most notable of the recent prints are *The Shower* and *Before the Act* of 1932, *Artificial Flowers* of 1934, *Taxco* of 1935, *From the Board Walk, Café,* and *Performer* of 1936, *Aerialist* of 1938, and *The Deserted Brickyard* of 1939. His lithographs are always independent works of art; that is to say, he never copies a painting or drawing in lithography. In fact, he rarely makes anything but the most summary preliminary sketch of the composition on paper. He prefers to build up the whole conception directly on stone, making use of the virtues and limitations inherent in the medium. His views on the use of photography by artists are interesting. He is an accomplished photographer and at one time made a living by photographing paintings for other artists. But he never makes use of photography in his creative work.

He once made a lithograph from a photograph, and after the edition was all printed he destroyed it, because it did not have the quality he sought for. In this his instinct was sound, for the values emphasized by the camera lens are never those of the creative artist's vision. Kuniyoshi, sensitive to the inherent qualities of the medium, keeps his lithography, painting, and photography separate, though each has enriched his experience as artist.

Kuniyoshi enjoys making lithographs and believes that graphic art is an important branch of the arts, important because democratic and potentially accessible to many people. When he first started making lithographs, relatively few artists practiced in a medium little known to the public. Fifteen years later the interest in the graphic arts is widespread, and Kuniyoshi has a substantial body of distinguished lithographs to his credit.

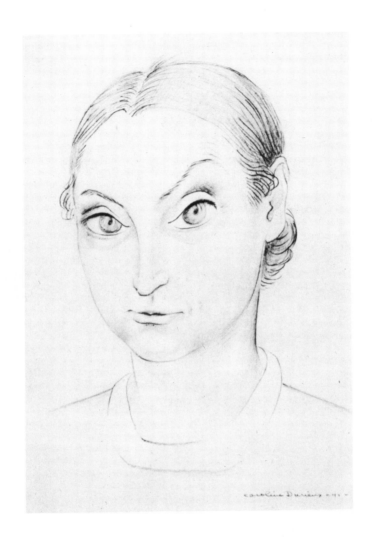

CAROLINE DURIEUX: SELF PORTRAIT

DRAWING

10 X 7½ INCHES

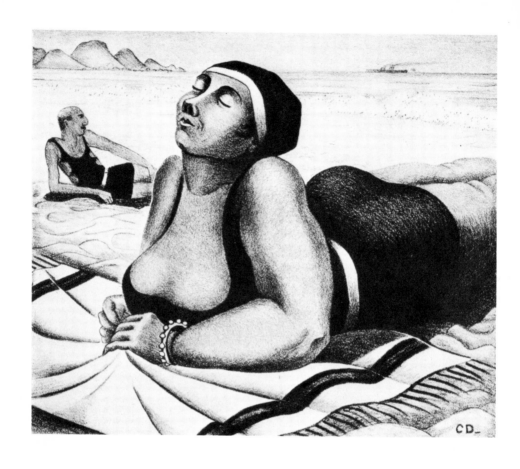

CAROLINE DURIEUX: IN TUNE WITH THE INFINITE

LITHOGRAPH

9 X 10¾ INCHES

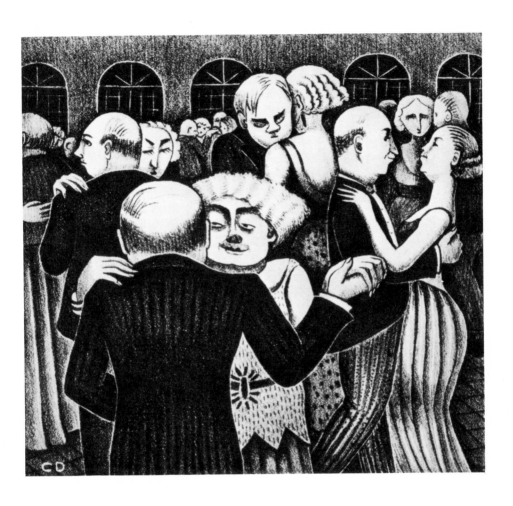

CAROLINE DURIEUX: BIPEDS DANCING

LITHOGRAPH

7⅞ x 8⅝ INCHES

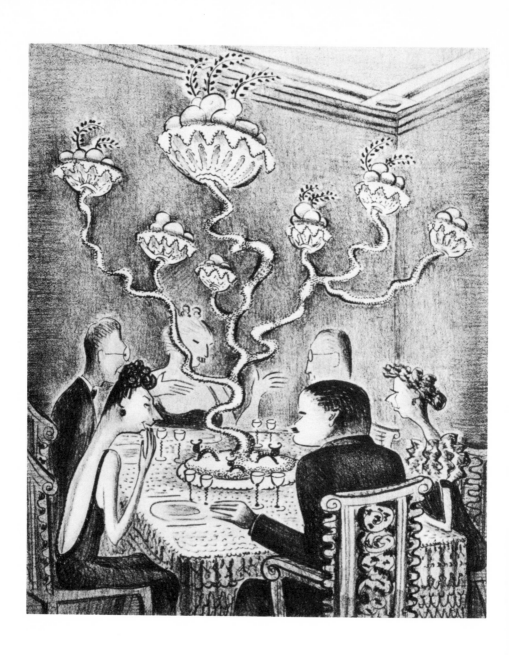

CAROLINE DURIEUX: DINNER

LITHOGRAPH

10¼ x 8⅜ INCHES

CAROLINE DURIEUX

NEW ORLEANS is as American a city as Boston or Philadelphia. It merely stems from another tradition, and stresses another of the components of our American civilization. Just as another city started as *New* Amsterdam and *New* York, so it started as *New* Orleans. Symbolizing the cultural influence of France and to a lesser extent the kindred Latin culture of Spain, it stood for civilization and the amenities of life, in the pioneer days when the Mississippi River was the only artery of travel inland. Thus its effect on refinement and culture in the adjacent South and in the river valley was incalculable. During the past two hundred years New Orleans had evolved a characteristic way of life, French elegance grafted on an easy-going Southern existence. It was pleasant and picturesque, and influenced even those who were not in a position to enjoy it to the full. In modern times many of its characteristic *mores* have withered away, even though one striking example still remains, the Carnival at the beginning of Lent. New Orleans, like Boston and Charleston and San Francisco, lives in the past, as it were. It cultivates its picturesqueness for tourists. It offers quaint and enchanting surroundings and about as delicious food as is to be found in America.

125

Here and there groups of people, small closed circles of refinement and sophistication, have survived to typify the tradition of New Orleans. Thus, they may not be rich but they are comfortable. They may have no money but they have background; they may have no ambition but they have style. No need for them to be go-getters: their great grandfathers went through the motions long ago. This inner circle laughs at, while obeying, the social conventions that are *de rigeur* to a larger group, conventions that are as impractical and absurd, as racy and delightful, as only Latin customs can be. This circle of the intelligentsia, as it were, laughs at everything, most of all at themselves. The prime word in their vocabulary is " amusing." Life is not worth living if it be not amusing. Since subsistence is comfortable, and leisure unlimited, they proceed to make it so. People must be amusing or they are not tolerated. Hence they themselves are witty, gay, charming, facetious, and full of quirks. They are ready for any amusing adventure at any time of the day or night. They can be heartless and cruel in the pursuit of a practical joke. But they are good sports, intelligent, well read, and completely civilized. Above all, they are articulate, with a Latin relish for gossip and a Latin vivacity in telling stories. They relate what so-and-so did at the last Mardi Gras, what happened to so-and-so on his wedding night. They have little ambition to do; only the ambition to be — amusing. Sometimes they blame the heat for it. The heat is so enervating, they say, that no one could possibly do any work all through the summer, and it takes all winter to recover from the summer. Why, they don't even get divorces: they just go on living with one another all their lives. Their background is colorful and becoming: picturesque old buildings and courtyards, beautiful antique furniture and tasteful interiors, delicious food and drink, quaint customs — a life that is rich in amenities. But it is a life that is almost completely unrelated to the machine age. They are the last stand of the ancient regime — these aristocrats of hedonism — and their cause is a losing one. Which in a

way is sad, for they do know how to live. If only more and more people could have the gift and the means to make living a fine art!

Caroline Durieux is of this life, yet apart from it. She was born in it, yet has broken out of the circle of beguiling dilettanti. She was born in New Orleans in 1896 of French-Irish ancestry. Perhaps it was the dash of Irish blood, or the fact that her mother is a Yankee, or her innate satiric gift, that has made her just that little bit different. Whatever it was, it was enough to break the spell of amiable futility, to lead her out of the " Cherry Orchard." She participates in the life, enjoys it, and uses its methods for her own creative ends. She is a satirist. She takes the droll story, the witty byplay of social intercourse, and universalizes it into a comment on the human race. It is the detachment, the objectivity, that sets her apart. She is in the game but also above it. She sees beyond the inner circle into the world at large. She transmutes social intercourse into social content.

She came to satire by way of painting. She studied first at the Newcomb College of Tulane University in New Orleans (she now is assistant professor in the Fine Arts Department of the same institution). Later she studied at the Pennsylvania Academy of Fine Arts under Henry McCarter and A. B. Carles. Her formal education completed, she began working out her own ideas. Travel helped in the evolution of her painting — travel in Cuba, Mexico, and South America, with intervals in New York. Her early paintings were of flowers, landscapes, and a few portraits of Indian types. By about 1927 her special talent for satire had matured and it was with this genre that she has concerned herself ever since. Diego Rivera has aptly described these paintings of hers: " Because of the fine plastic quality of her work, its delightful color and acute drawing, Caroline Durieux has lifted *la peinture mondaine* back to the position of importance it once occupied. Not since the eighteenth century, perhaps, have such subtle social chronicles been so ably put on canvas. The delicious satirical qualities of her painting do not, however, make it ' literary,'

nor does the satire detract from the plastic quality of her work. Her pointed and politely cruel persiflage is after all a motive, a pretext, for constructing pictures distinctive in color and keenly caustic in line. Both Raeburn and Toulouse-Lautrec would have appreciated them."

In 1931 she wrote in a letter: "What you say about satiric genre is perfectly true. I realize that it has been about a hundred years since the color and plasticity of oil has been used as a medium for satire. The modern attitude toward satiric expression is definitely black and white. . . . As soon as I develop some kind of technique which looks different from the usual lithograph, I will send you some." The following year she made eleven lithographs, including *Bipeds Dancing, In Tune with the Infinite, Burlesque, Benediction, Four Men,* and *Three Women.* In 1933 the popular *First Communion* appeared. Her first etchings were made in 1934, *Hunger* and *Blind.* "I am glad you like the etchings. All my etchings are harrowing. I think it is because the medium is such a precarious one — the least slip and all is lost. I can't be funny with a copper plate. I feel tragic the moment I think of doing an etching." And later she wrote: "I ought to get six more lithographs done this summer. After which I am going to do some more beggars. I have to get those birds off my chest somehow. They haunt me." 1936 was another productive lithograph year: eight prints of which *Rugged America, Nice Men, Nice Women,* and *Playboys* are perhaps the most distinguished. In 1938 there were three, including *Reception;* and in 1939 there were four, including the delightful *Dinner, The Veil,* and *Art Class.* The simplicity and seeming naïveté of her prints are deceptive. They are always the product of conscious art. She has a feeling for decorative pattern, flat rather than three-dimensional. She always starts with the pattern first. Then she fills in the human content. This she does with deft and subtle characterizations, in several values of gray from white to black.

Her prints are amazing in their psychological implications. Like

George Grosz, she manages to convey the feeling one has when, by a flash of awful insight, one realizes the complete and unescapable automatism of man. It is as if the scales were suddenly dropped from our eyes and we saw humanity as it really is: not man, but manikin, pulled hither and yon, and motivated by every outward circumstance. Yet her things do not seem to be frozen into eternity. One always expects the figures to resume, by some magic, their own natural expression, so characteristic are the gestures, so subtly true to life their behavior. In a letter she wrote: " I mailed you three proofs of each dancing lithograph, because I don't know which it is that you call Dancing Bipeds — to me they are all that." René d'Harnoncourt has spoken of the quality of her satire. It is never an explosion of bitterness or hate; it is rather the detached probings of a surgeon stripping off layer after layer of protective tissue until the essential nature is revealed. Even the clothes, the furniture, and accessories are laid bare. She has an unerring eye for all the weak and ridiculous spots and a malicious delight in the elaboration of absurd ornament. She herself maintains that her work is not satire but realism.

There is a tradition that the impulse to satire stems from some inferiority or dissatisfaction in real life, that satirists and caricaturists are ugly and bitter and disillusioned people who are thirsting for revenge. I have not found it so. Most of the satiric printmakers I have known — Peggy Bacon, Miguel Covarrubias, Adolf Dehn, Mabel Dwight, and the like — have been charming and delightful people in real life. So it is with Caroline Durieux. She has had a rich normal life with a full range of experience as wife and mother, as artist and human being. She is a thoroughbred — well balanced, sophisticated, yet simple, handsome, intelligent, unaffected, quiet and sparing of speech, yet she can be devastating, truly devastating, on occasion, to people who bore or cross her. Her warm, deep, vibrant tone of voice gives the lie to the impression of coldness which is made by her rather aloof and undemonstrative manner. If she carries inside her a secret

concerning the human race, an intuition such as completely shattered Swift, she carries it with a light heart. She is tough-minded about it, and can still enter into the business of living with gusto. " I wish," she wrote, " that you would come down and let me show you the old town – it is quite a love of a place. No one worries about anything except those who have dubious ancestors, and these spend their lives polishing up the past. . . . Day after tomororw is Mardi Gras. I wish you could be here to mask with us. All our gang meet at Flinn's Bar around 11 a.m. and start the usual hell-raising. . . . I am completing three more of the same series [of lithographs] which I call ——, but not out loud. . . . The Museum here [San Antonio] is giving me a show soon and also the ones in Dallas and Houston. I am making the Grand Tour of the Southwest. Oh boy! And am I going to paint the Southwest! I am full of ideas about shoeshine parlors and ear-splitting quick lunches. . . . I have seen *Coronet* and am delighted with the spread they gave us. Also do you see the *New Masses* now and then? Well, they like me too."

In addition to her prints and paintings, she has made many drawings in a characteristic personal style. " I am doing the illustrations for the *New Orleans Guide*. Lyle Saxon is the editor. His own book *Children of Strangers* is about to be published [1937]. Be sure to read it; it is all about the Mulatto in Louisiana. The stuff I have done for the *Guide* will amuse you – Negro spirituals, Creole ladies, whores, cemeteries, etc. . . . I mean to do some lithographs with the material I have gathered working on the project [she is now director of the W.P.A. art project]. The field workers take me to all kinds of amazing places where Negroes do their stuff – not the New York kind of Negro who is sophisticated, but the African kind who practically beats a tomtom. We have a Negro on the project who knows everything and everybody on the dark side of New Orleans. Nothing goes on here that we miss – prominent church men and women, *sportin' ladies,* voodoo queens – he gets them all to pose for me, and I am hav-

ing a swell time. But for this Negro, we would not be admitted to the colored night clubs; he takes us as his guests. It is all very different from your part of the world — much more primitive, wilder, and more unorganized."

The work of Caroline Durieux has two outstanding qualities: style and individuality. Her work is her own, original, personal, without outside influence. She belongs to the group of social commentators, satiric, witty, and keen in her observation of the foibles of humanity. She creates *types* and endows them with the truth of life and the enduring memorability of art.

THOMAS W. NASON

It is curious about wood-engravers: there is one thing they all seem to have in common, a kind of quiet dignity and rectitude that pervades their life and work; probity perhaps is the word. It may have something to do with the medium in which they work, the discipline involved in so exacting an art, the necessity for planning and foresight in a method wherein a mistake is always fatal. Perhaps it derives from the nature of the medium itself, so unobtrusive, precise, and uncompromising that for its appreciation one must meet it more than half way. Method and rightness inhere in the work of all true wood-engravers, and somehow these virtues are to be discovered in their characters also. In real life they are the most estimable of men. Quiet and industrious, sober and responsible, they let their work speak for them. Timothy Cole was such a character and so are Ruzicka, Landacre, Cook, Lynd Ward, and Allen Lewis, however much their work may differ, one's from the others'. And the characterization fits Thomas W. Nason like a glove. In his case there may be a fusion of two moralities, New England virtues aged in the wood, so to speak.

Thomas Nason is conservative in the best sense of the word. He has

PORTRAIT OF THOMAS W. NASON

PHOTOGRAPH

THOMAS W. NASON: BACK COUNTRY

WOOD-ENGRAVING

8⅛ x 9 INCHES

THOMAS W. NASON: PENNSYLVANIA LANDSCAPE

WOOD-ENGRAVING

$4\frac{1}{4}$ x 9 INCHES

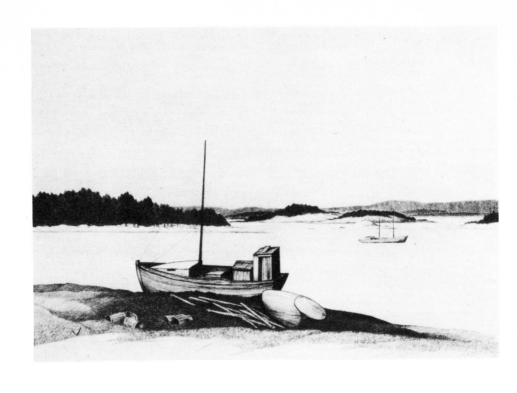

THOMAS W. NASON: PENOBSCOT BAY

COPPER-ENGRAVING

6 x 8¾ INCHES

his feet solidly planted on the ground; and he sees no need for change just for the sake of change. He has a theory of personal culpability that possibly is a heritage of a minister father: " I can't help wondering if, after all, the ills of the world aren't really traceable to human weakness, greed, ambition, dishonesty, jealousy, and all such, and that no man-made system could ever be devised which would be proof against them." Meanwhile he has amply demonstrated that life can be ameliorated by art and good taste, and that a simple country life in Connecticut can be made a work of art in itself. He cherishes the good things of this world, and is no shallow connoisseur of wine, food, or tobacco. Always with dignity and restraint: there is nothing grasping or flamboyant in his nature. With true New England honesty he believes that no one can get something for nothing. He asks no favors or special privileges; he gives as much as he receives. Art and probity, thus, are part of his life passively and actively, in his surroundings and in his work. His wood- and copper-engraving gives scope to his passion for perfection. He is critical of his own work; within its limitations — and perfection requires limitation — it is as perfect as he can possibly make it.

He came upon engraving by way of a hobby. "As a youth," he has written, "there was no thought of my going in for art in any form as a profession, although I had early shown a certain ability to draw." He was born in 1889 in the village of Dracut, Massachusetts." When he grew up he embarked on a business career. While thus employed, he became interested in wood-cutting, and with such increasing absorption that eventually it became a profession and not an avocation.

He has described his beginnings in the foreword to a publication of the Woodcut Society: "In the early twenties, I became aware of an increasing interest in wood-engravings, based mainly on seeing them used as book decorations and magazine illustrations. These prints, done for the most part in a bold and effective manner with

rich blacks and sparkling whites, appealed to me very strongly. I seemed to see great possibilities in the medium for personal art expression. In 1922, I made my first wood-engraving, which was more of a laboratory experiment than anything else. The decision was soon reached that I would never find it particularly thrilling to cut away the wood around the lines on the block simply to reproduce my drawing. But I was exceedingly interested in engraving extemporaneously directly on the block with a smooth-cutting engraver's tool which would go in any direction with equal freedom and which would cut a fine line or a broad one with much the same movement. I found this kind of engraving on wood a creative process within itself. As I became familiar with the use of the burin on boxwood and perfected my knowledge of printing from engraved blocks, the fascination of the process really got hold of me.

"But my progress was slow. I produced a few blocks each year but continued to engrave them purely as an avocation; constantly experimenting, and striving to improve both my technique and composition. It has now been some fifteen years since the first block came into my hands. I do not know exactly how many have succeeded it but I do know that each one has presented an individual problem and that the final result is always a matter of conjecture. The first trial proof always brings a moment of keen anticipation and excitement — and often brings disappointment."

His earliest productions were somewhat in the woodcut tradition of Lankes (*New England Farm* of 1922), a suggestion of mood in broad, contrasting strokes. But he soon began to refine upon his technique, vary his cutting with finer lines and stippling, introduce a great range of semi-tints into his composition. Such blocks as *Blacksmith Shop* and *House in Digby* are representative of the transition, which is also dramatized in the difference between the first and second states of *In New Hampshire*. The new manner, full-fledged, appears in the *Lyme Farm* of 1929, the *Ipswich Barns* of 1930, and all

the works from 1931 on. He is now master of a technique as flexible and accomplished as that of the British school. In these prints and in others of the same period, such as the powerful *On the Maine Coast, Farm Buildings, Back Country,* and *Deserted Farm,* he makes use of the silhouette in his compositional scheme; that is to say, he projects his elements against a clear white sky. In 1932 his engravings begin to show a greater preoccupation with atmospheric effects, more elaborately worked out, ranging in mood from *Summer Clouds* to *November Twilight.* In some of these (*The Leaning Silo, November Twilight, Tranquility, Landscape with Sheep*) he has made use of an additional block or two for chiaroscuro effect. He has given an explanation of his procedure with regard to another one published by the Woodcut Society, and it might be instructive to quote his analysis: " In the present print, *Morning,* I have made use of three blocks. First, the so-called key block, which comprises the darkest portion of the work and which is really the framework of the print. The second block covers the same area and, in addition, supplies the darker accents of the clouds. The third is used for the light tint over the sky. The second and third blocks are also used over the lower part of the composition and over the tree to assist in the modeling and to gain the effect of transparency. This is the order in which the blocks were engraved; they were printed in reverse order, the lightest tint first and the succeeding blocks on top of that. There has been no attempt to use color for its own sake: the three blocks being employed to achieve a wider range of tonal values as well as to lend the effect of luminosity and the illusion of space. I have called the print *Morning,* not only because it is supposed to be cast at that particular time of day but also because I had in mind the *Morning of Life* — the boy's outlook and the freshness of nature."

Much of the year 1934 was devoted to a new field of activity, engraving on copper. In turning to the old but nowadays seldom practiced art of copper-engraving he no doubt was actuated by a desire

to widen the range of his expression. An entirely new scale of values and textures are possible by an intaglio emphasis. But the change also had the effect of giving him a wider audience and the entrée to the exhibition opportunities of the etching societies. His approach to the copper was tonal rather than linear; through his facility over the graver, he burst, full-fledged as it were, into the print world with such excellent plates as *Woodcock, Early Snow,* and *Vermont Landscape,* and the *Hartwell Farm, Little Valley,* and *Farm Lane* of the succeeding year. *Mountain Farm* and *Hebron Barns* are notable among the more recent engravings. The sphere of his subject matter has gradually been expanding from Massachusetts to Vermont, New Hampshire, and Connecticut and more recently to Maine and Bucks County, Pennsylvania: *On the Island, Abandoned House, Trees along the Delaware, Boats Penobscot Bay,* and *Summer Storm.*

His subject matter is almost entirely rural, with an occasional glimpse of a country village. His only venture into the urban scene was the *Louisburg Square* of 1930. Of this famous Boston landmark he wrote in a letter: " I am influenced too much, in doing a subject like this, by what is before my eyes and by association, etc., and the result is not what I would like in all respects, although I feel I was successful in getting in something of the dignity and solidity of the Square." There is a suggestion, in the constraint he voiced above, that he feels more free as an imaginative composer than as a realistic interperter. He is a poet rather than a reporter. He creates visual idylls and threnodies. He surveys New England as an elegiac and pastoral poet. He finds a somber note in the countryside, its loneliness and dilapidation: *New England Scene, Back Country, The Leaning Silo, Deserted Farm.* But also the serene melody of still waters and green pastures: *End of Day, Tranquility, Landscape with Sheep, Pennsylvania Landscape.* His pulse is tuned to country matters. He was brought up in a rural environment, and although for some years he lived near Boston, he has gone back to the country again. He has

THOMAS W. NASON

built himself a house in Joshuatown, Connecticut. There he lives with modest dignity and a kind of antique stoic virtue. A pastoral poet on wood, he seems to say with Meredith:

> No disenchantment follows here,
> For nature's inspiration moves
> The dream which she herself fulfils;
> And he whose heart, like valley warmth,
> Steams up with joy at scenes like this
> Shall never be forlorn.

MERRITT MAUZEY

THROUGHOUT the length and breadth of the land, one comes across men and women set apart in a particular way from the general mass of humanity. They are literally people apart: dedicated to some all-absorbing cause whether it be for self-expression or service. Forsaking all comfort and ease, they spend their energies prodigally in the pursuit of their aim. It is heartening to see these little particles of the great collective creative impulse germinating and sprouting throughout the land. As long as they do, all is well with the world: the seed has fallen on fertile ground. Many of them, most of them, will receive little recompense in money or fame, little reward save their own inner satisfaction, and this fact makes their effort seem all the more pure and disinterested. Many are called but few are chosen. Nevertheless these mute inglorious Miltons make a contribution of great value. They are the steps toward the apex from the broad base of the great pyramid which is a country's culture.

Merritt Mauzey is in many ways a typical example of this disinterested dedication. In his case the expression is in terms of art. His one great passion in life is to transform cotton into art. He longs to document every aspect of a far-flung industry, not by statistics or socio-

logical treatise, but by graphic illustration that all may see. Mauzey
will never be a Rembrandt or a Leonardo, but his creative impulse is
none the less intense for being on a smaller scale. He is sincere and
very much in earnest. And since his words have a very moving and
revealing quality, it might be well to let him tell his story in his own
way. He was born in a cotton-raising country, and has been associ-
ated with cotton in various capacities all his life. He knows whereof
he speaks.

"I was born in Clifton, Texas, 1898, and always loved all forms of
art from early childhood, attempting it in my youth. I had a corre-
spondence course in art, but owing to circumstances was unable to
do much with it then. In my early manhood or all through life I have
always studied all forms of art, commercial or otherwise, reading
some but looking more, visiting galleries at all opportunities. Then
at the age of thirty-six, or in 1934, the desire for creative and actual
art overpowered me. At night school I started doing etching and
some life drawing, but my work with the cotton company required
such long hours that my training had to be gained at the price of
terrible hours. If you could see the number of outdoor sketches that
I have made, the number of objects that I have done, you would say
it was impossible even without working at anything else than art. I
have never copied but always created, as I can never make the same
drawing twice, always have to change it. I have made some paintings
of my lithographs and vice versa, but never alike. My still life has
been very limited since it does not give me the field of expression
that my nature requires, or my talent rather. After a year or two of this
terrific pace, my health began to fail because of a stomach ulcer. So
last October I had to give up my cotton job, and have been doing odd
jobs to help out along with my art. I had some definite things in mind
that I wanted to accomplish in the art world. I felt with my age and
health as a handicap, as well as lack of training, that it would re-
quire more than the strength and ability of man to do so. Therefore

it has been my appeal to Deity that has enabled me to do the things I have done, and it is with this aid that I shall go on to real things in the art world. I am much improved in health, and although it is a come-down in living, I have no complaints but much thankfulness, and I am confident of the future. I am terribly sincere with my art.

"I was raised on a cotton farm in the West Texas cattle country, and have worked with cotton in various ways. Up until my health gave way, I was connected with Cotton Exporters for the past thirteen years in the clerical end of the work. So I feel I know some of the problems from different angles, and at all times my heart goes out to the ones who produce the cotton, as their standard of living is very low in 95 per cent of the cases. Of course the Cotton Belt, as it is known, covers so much of the South that you will find all sorts of conditions, from the person who works his crop with one mule or horse, to the one who works several hundred acres with his mechanized equipment, from the one-horse tenant to the plantation with hundreds of tenants or sharecroppers. But my idea of the farmer is one who has had great faith in the earth, but not always in men, as they have been 'city-slicked,' as they term it, so many times that they are not always trusting. They have bitter tragic lives in many instances, and many disappointments due to the hazards of their lot, but they all, 100 per cent, never lose faith in Deity, which is their greatest asset. As a class they never have much material wealth, neither do they expect much.

"In doing the Cotton Series in lithography, I realized how diverse were the conditions of the cotton belt, and so I tried to get the important points in cotton from planting to export. I feel the series of ten covers that pretty thoroughly but of course the subject matter is endless. It seemed to me it was a great field, with its surface never scratched by art. Full of romance, life, action, moods, drama, tragedy, laughter, seasons. I wanted each work to represent such things, not mechanical, nor as illustrations, but something with meaning,

PORTRAIT OF MERRITT MAUZEY

PHOTOGRAPH

MERRITT MAUZEY: GRANDPA SNAZZY

LITHOGRAPH

12 X 10 INCHES

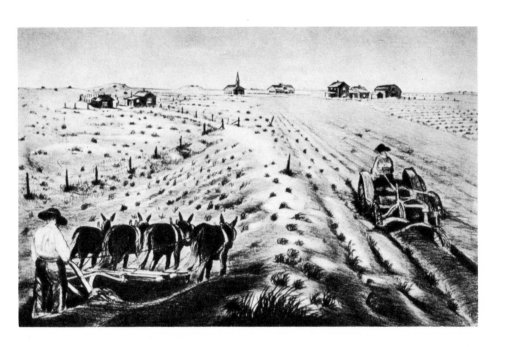

MERRITT MAUZEY: NEIGHBORS

LITHOGRAPH

10¾ x 17 INCHES

MERRITT MAUZEY: PRAIRIE GHOST

LITHOGRAPH

14⅜ x 9⅝ INCHES

something vital, something with the real life of the industry in it. I will continue with the Cotton Series, but the ten prints as outlined cover the major lights. I have done the work trying at all times to use good design, each one a problem alone, and although the work was done in a fairly short period, it has a life-time amount of thought in it. I know its weakness, which is technical skill, but I had a story that should more than overbalance this. I chose lithography to tell my story in black and white, as I am partial in my personal taste for lithography over all other black and white mediums. I love the strength of it, its vital qualities. Of course, it is all personal, but it seems to me so much time wasted trying to get a perfect technical work. But do not misunderstand me, I use all that I have, and will continue as long as I work to try to improve my ability at that end. In other words I have something more to say in my work, other than making a perfect mechanical work."

He has analyzed and explained each lithograph of the series. I shall quote two or three: " *Grandpa Snazzy*. This is the first phase of cotton, the planting of the seed. This is done in different sections of the belt in various manners from the one-horse planters as you see in this, to the big tractor planters. But to me this had more of the pioneer spirit of cotton, and not only of cotton, but representing that sturdiness of our forebears that would not accept defeat. Although this soil is worn and barren, the will to go on is there, the inherited faith in the earth to bring forth man's sustenance. From it he sprang, to it he must return. It is a lesson to all of this world of soft living into which we have drifted; it is a lesson in faith well founded. I used one of Bob Burns' radio characters for the name, and to some this print will be more humorous than tragic. This print could have been named *Earth*, for it was my interest to get earthiness in it. I have tried to give within this print the feeling of contentment that comes from real effort upon one's part to do something, and one typical of the cotton-raiser.

"*Crop Talk*. This is the next stage, of chopping cotton, a typical scene of the neighbor men talking crops, politics, etc., over the fence, while their womenfolk are chopping on. The man is always lord and master of all he surveys. This print was made from sketches in West Texas where I was reared. *Row's End*. This print also covers chopping cotton but has a different story. I wanted to tell the plight of the cotton-raiser in this, one of despair, of tragedy, one of poverty so prevalent. You will note that the man and wife have stacked arms, or have placed their hoes across the stump as if in surrender. This print depicts the blight that all cotton-raisers may expect any season, as their crop is upon barren soil. The hog and dog are symbolic of the cotton farmer, and most all have both, and more especially the dog. They also add to the dejection and desolation. The locale is East Texas but could be any part of the Eastern cotton belt. *Cotton Compress*. The cotton comes from the cotton yard to the compress to be pressed in smaller bales, which saves space in transportation. You will note that the bales at the gin have six bands and after being compressed have nine bands. I have tried to place action in the picture, as this work is most always performed under rush order. I have used my figures going to central location from different directions to help convey this, and to further give it action, I have used the smoke clouds to good effect, or tried to at least."

"*Neighbors*. In this I have attempted to portray the contrast in cotton farmers' methods of working, typical all over the belt. One farmer on poorer land works with inferior equipment; the other with mechanized equipment on better land. This applies not only to farmers but to us all. We are all endowed with the same mind and body, but not with the same gift to prosper, not with the same gift to progress, not with the same gift of aggressiveness. This picture tells another story. You will note the church on the side with the poor farmer, and the school on the side of the richer farmer. The school helps the better farmer; but as we gain in material things, we oftentimes see

less of religion. *Prairie Ghost*. This is not in the cotton series. When I was a boy, I had to tend a windmill similar to the one shown, repairing, greasing, etc. The tower was twenty-four feet to the platform. I have often seen it and other windmills covered with ice; and they reminded me of ghosts silhouetted against a dark sky. That memory has been with me throughout my life. Sometimes the mills would break down in cold weather, and this no doubt added to the vividness of my expression."

To date there are twenty lithographs in the cotton series. No doubt there will be more. They make an extraordinary document, a complete interpretation of an industry from the inside. A wealth of accurate factual detail is tied together in a dramatic way. Although there is a lack of freedom in the draftsmanship and in the handling of the figure due to the artist's limited technical experience, this is compensated for by the fervor of his zeal and by a certain naïve and primitive air that lends an additional touch of authenticity to the whole. His emotional intensity is impressive and appealing. He has made other lithographs besides the cotton series, perhaps thirty in all. He has a press now, and prints his own proofs from stone. His improvement of late has been phenomenal. His more recent prints, *Southern Memories, Goat Ranch, Offat's Bayou, West Texas Snow, Nugent's Homestead, Oasis, The Giles Place*, and *Prairie Ghost*, in particular mark a definite technical and artistic advance over his earlier transfers; and the subject matter likewise is interesting, for it portrays Texas in other aspects than cotton. But cotton will always be his major interest. Knowledge he has aplenty, bred in the bone, and an ever growing facility to record. His passion has differentiated him from the mass, his very zeal has given him a marked individuality. " It might be," he confesses, " that I have hitched my wagon to a most distant star, but from observation I find that those who do, go much farther than the ones who do not." There is something very appealing about this zeal of his, and it certainly has added a new folk-tune to the

music of America. " I feel that I have something that should be passed on to posterity," he has said, " something that will always be interesting, a record that should be preserved. I fully realize that I have days and nights of hard work ahead to do all the things that I must do at any cost. I ask for nothing much in a material way, I ask to be able to keep going only. *Southern Memories* was bought from the Corcoran Gallery exhibit and presented to the Gallery by a Southern Congressman. This of course in my circumstances is very welcome; it does not appeal to my vanity, for I have none, but that inner spirit that is driving me forward is refreshed and fed. If our Maker will give me five more years with reasonable opportunity to do art, my goal will have been partly realized."

MABEL DWIGHT

MABEL DWIGHT is a master of the *comédie humaine*. I say this not as a catch phrase but as a mature judgment in the fullest meaning of those much abused words. The master of the *comédie humaine* does not just skim the surface of the comic and incongruous, he probes into the depths, ever imbued with pity and compassion, a sense of irony, and the understanding that comes of deep experience. There is as much of the tragic as of the comic in the *comédie humaine* – tragic drama: the contrast between what is and what might be. There is detachment also, the sense of seeing life from afar, the long view of things. So I say Mabel Dwight is a master of the *comédie humaine*.

That she has a feeling for the comic, everyone who has heard her laugh will testify. A delicious laugh it is, infectious, irresistible, trilling forth suddenly and unexpectedly as if she just could not hold it back any longer. Anything will bring it forth, some little glimpse of the incongruous, some recollection of a funny or absurd situation. The laughter is always kindly, always in the mood of " Aren't we all! " It is so fresh and youthful and spontaneous, so completely without any sense of *arrière-pensée*, that it kindles in everybody the same gaiety and delight. It is this quality that she carries over into her

145

drawing, into such lithographs as *The Ferry Boat, Abstract Thinking, Bargain Counter, Queer Fish*. In her talk during such gay moods she becomes fanciful, she embroiders the theme with witty and subtle conceits, all contributing to the ridiculous denouement. She might have been a great comic writer. In back of all this comic sense is a relish for life. This is revealed in the subject matter of her lithographs: from the streets and cafés of Paris to the studios and subways of New York, from Coney Island to the movies, from the Battery to Harlem. She is essentially an urban person: the city is her happy hunting-ground. Although she has made a few pure landscapes (even those usually have animals or human habitations in them), her interest is primarily in people, in humanity.

But there is also the somber side of the picture — as there is a somber side to her nature — humanity in darkness, irrationality, and despair. " I have done a few lithographs," she once wrote, " two of which are graveyard scenes down South. Miller looked at me, kind of troubled, and wanted to know why I was doing so many graveyards. Well, I suppose I'll have to plunge into the tragedy of Coney Island and subway scenes to prove that I am a humorist! " This dark side finds outlet to a limited extent in certain lithographs expressive of her sympathy with the underdog, *Derelict Banana Men of New Orleans, In the Crowd, Derelicts, N. Y.*, but is manifest chiefly in her writings. Drawing and lithography she feels do not express her nature completely: " Only one angle of a scene can be caught pictorially. With words I can swim farther, dive deeper, and capture more angles. I am tired of composition, balance of parts, organization; I want to cut loose — and I never could do it in pictures." Her so-called autobiography — digging around in the subconscious, she has termed it — is an amazing document; it tells little of her outward life but reveals an abundant and exciting interior life. It is fantastic, subtle, profound, steeped in irrationality and paradox — a perfect foil to the level-headed objectivity of her lithographs. In Mabel Dwight there

is the will to life — but there is also the will to negation, almost as po-
tent. Sometimes the one and sometimes the other is dominant. It is
this constant seesaw that gives her a kind of detachment — this and a
rich inner life disciplined by experience and subtle philosophy. An
inner life is essential to detachment, some place to withdraw from
the exigencies of everyday reactions, some place to change from par-
ticipation to quiescence. All the dramas enacted there, the ecstasies
and despairs, no one except herself will ever fully know. She has,
however, shown us glimpses in her fascinating autobiography. I
should like to quote some characteristic passages, first some subtle
reflections on the past:

" The past hypnotizes me. I have walked through life with my back
to the future. We are all rapidly walking into the past every second
of our lives; the future has no reality. Yesterday, today, and tomor-
row — light and dark, day and night, past and future keep us finite
beings. I don't remember at just what period of my life I started
walking backward, but it was quite early. Of course the future did
its siren beckoning, and I gazed rapturously in its direction at times,
but today was always underfoot. I seldom liked my todays, so I
turned my back and began looking into the past — not my own but the
world's past. Then I discovered that no one was going forward; time
was flowing backward. I faced the panorama of what had been. I
looked at reality. I was not really walking backward after all; I was
facing the direction in which I was moving.

" My past is not dead; it is striving to be born. I am pregnant with
my past. Creative people give birth to their past. They are fortunate.
Most people just have pains but nothing is born. Dumb souls are
sterile, no matter how much past they have. Our past outlives us
frequently. I can remember back to my third year — before that,
blank, and after that, many many blanks. My conscious memory
has turned much of the weight over to my unconscious memory. I
sometimes meet these fragments of my past in my dreams, I dare-

say — strange sleep-walkers, mad actors behaving so absurdly in the dead of the night. They, too, are striving to be born; they are unhappy at being separated from my conscious memory. But I meet these strangers in broad daylight too, at times; they are not just creatures of the night. Sometimes I bow to one or more of them, feeling dimly that I have met them before. Memory has too much authority, and is incompetent. But she cannot be discharged. I want to know what she is hiding from me — although judging by many things she has preserved so conspicuously for me I should be grateful indeed for her limbo! But perhaps my past extends much farther back than I think it does. If I once was a queen in Babylon, I want to know it. . . . And a kitchen wench? . . . Well, all right."

Not all the passages are as paradoxical as the above. Here is another in a more reminiscent vein: " Great harbors liberate my emotions and companion my thoughts. The amply-decked ferry boats that ply the harbor waters around New York were my pals for years. The one that went to Staten Island gave the longest ride, and so it was my favorite. Generally I was satisfied with a good round-trip passage, but occasionally I broke the sea voyage by a trolley trip inland. The car I preferred skirted along the shore line in the direction of the New Jersey coast. We passed a group of dead mansions, Greek-columned and proud-looking in their decay; we went by a beautiful place called Sailors' Snug Harbor, with salty old men in blue suits dotting the grounds in friendly groups. I always began to warm up immensely about here. Still following the shore we began to run parallel to New Jersey, with that narrow stream of water called the Kill van Kull between. Evening was the best time, just after sunset. This was the hour of dusk: enchantment walked the earth. Gas tanks, foundries, funnels, chutes, pagoda-like towers made up of big pans, each one resting in another one, the masts of boats, and a strange little Sargasso Sea where dead tugs and ferry boats slowly and peacefully sank into the mud, their black hulks listing grotesquely, with-

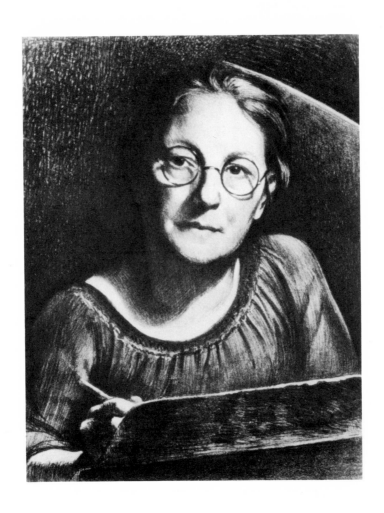

MABEL DWIGHT: SELF PORTRAIT

LITHOGRAPH

10½ x 8¼ INCHES

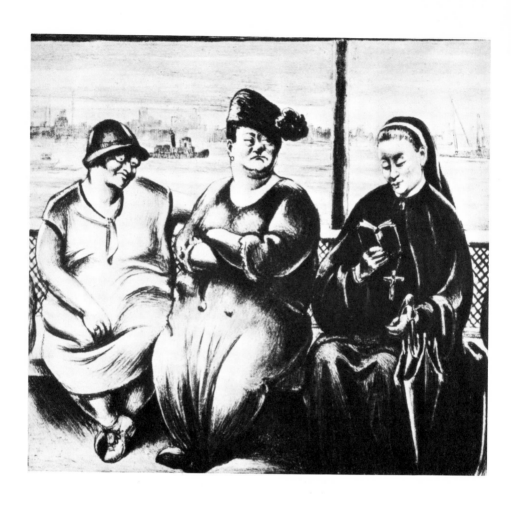

MABEL DWIGHT: FERRY BOAT

LITHOGRAPH

9½ x 10¼ INCHES

MABEL DWIGHT: RAIN

LITHOGRAPH

10 X 14 INCHES

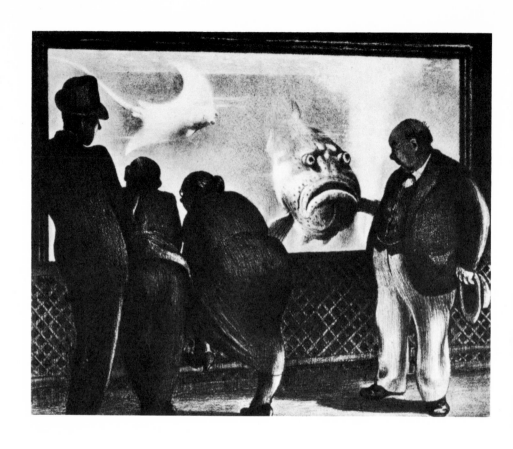

MABEL DWIGHT: QUEER FISH

LITHOGRAPH

$10\frac{5}{8}$ x 13 INCHES

out thought of port or starboard; now and then an old mansion with delicate pilasters and gracious lines decaying sadly between black monsters, Paddy's long underwear swelling and flapping in the bit of weed-choked yard — all these things became a symphony with beauty the developed theme. The hour was an artist that softly blurred details, simplified masses, and gave sculpturesque power to sordid facts. When I began to make lithographs I did not forget this shore."

Mabel Dwight took up lithography in the maturity of her powers. She comes of old American stock. She was born in Cincinnati in 1876, but spent her childhood and youth in New Orleans and California. She traveled extensively in Europe and the Orient. Though she studied painting in her youth at the Hopkins School of Art in San Francisco, she concerned herself little with art until 1927. It was in Paris in that year that she found her real métier, lithography. In collaboration with the printer Duchatel, she made seventeen prints in Paris, a fastening upon the more obvious and picturesque aspects of the city, without the true inwardness that characterizes the best of her later work. Her Basque subjects already show a great advance in characterization and technical mastery. The first American lithograph, *In the Subway,* indicated the path she was to follow with increasing success. In 1928 she made seventeen lithographs in collaboration with the printer George Miller, including such well-known prints as *Hat Sale, The Ocean* (which pointed the way to similar use of Coney Island material by other artists), *The Clinch,* and other cinema subjects. For the next six years there was a steady stream of prints illuminating certain major themes: circus in *The Great Trapeze Act* and *Circus* of 1930; the Aquarium in *Fish* (in color), *Aquarium,* and *Queer Fish;* Staten Island in *The Survivor,* 1929 (essay in the history of progress), *Dusk,* 1929 (saturated with mood), the immortal *Ferry Boat* of 1930, and *Staten Island Shore* of 1931. Other notable prints were *Robeson as Emperor Jones* (in color, 1930), *Har-*

lem Rent Party, 1929, *Danse Macabre,* 1933, *Rain,* 1935, *Montauk Light,* 1937.

To date she has made about one hundred lithographs. She is not a facile artist. She works over her sketches and compositions for a long time before transferring them to stone. Her prints do not have an obvious or uniform " manner." Each stone is approached as a new and individual problem. *Ferry Boat* is as different from *In the Crowd* as *White Mansion* is from *Fishing Village Nova Scotia.* This ever new approach naturally increases the hazard of failure, but it also enhances the success of those that do come off. It might be illuminating to compare her print *Life Class* with Peggy Bacon's drypoint *Frenzied Effort,* for it happens that they both treat of exactly the same theme, a life class at the Whitney Studio Club (in fact Mabel Dwight is one of the artists caricatured in Peggy Bacon's print). Peggy Bacon's drypoint is frankly caricature: all the characters are observed through a colored or distorting glass, the imposed unity of her own style. Mabel Dwight's print is an assemblage of individual studies of characters, which by the logic of situation also acquire a comic aspect. One is caricature, the other is drama. This casting of character, this arrangement of *mise en scène,* absorbs an extraordinary amount of time and energy. Sometimes the thing does not quite come off, and the characters remain dead; but when she is successful she endows them with an air of life. She has the rare faculty of creating types, of portraying figures with individual traits and universal application, of objectifying experience. Her drawing is not clever or flashy; it is unobtrusive in its completeness. Her figures are solid, carefully built up, psychological as well as physical. Each is a portrait and a personality. She gossips neither in her conversation nor in her art.

In life Mabel Dwight is a whole and integrated personality, very womanly, with the intuition, the subtlety and finesse, the nobility of feeling, the wisdom of experience that only a woman of great beauty and character can garner. There is something almost queenly in her

presence, something that inspires deference and respect even from those who do not know her. She is at times detached, remote, mysterious. Perhaps this quality has been accentuated by her increasing deafness in later years, but much of it is innate, stemming from that inner life that few if any have penetrated. She can be delightful company, be light-hearted and gay with the experienced art of one who knows how to be both merry and sad. The duality of the *comédie humaine* exists both in her life and in her art.

PAUL LANDACRE

ONCE on a sea voyage, while pacing the deck of the steamer on a wild stormy night, Paul Landacre almost stumbled over a bird that was lying prostrate and exhausted on the deck. It was a black petrel, one of those shy wild birds that inhabit the islands of the Pacific Ocean. Moved by a generous impulse, he picked it up and cared for it in his cabin overnight. The next day in port, when he found that it still could not fly, he took it with him to his home, carefully wrapped up in his beret. He went to the library and read up on the habits of these shy creatures. He built a home for it in the bathtub, of mud and rocks and sand with a lagoon of salt water. He fed it and nursed it tenderly back to health. It apparently had been exhausted from lack of food, and its wing had been slightly bruised. He trained it to fly again. He would set it on the foot of his crossed leg and catapult it into space, for the petrels with their awkward legs have great difficulty in launching into flight. On the ocean they launch from the crest of a wave, and once they are in flight, they can soar and soar. He and the little black bird struck up quite a friendship. When he was sitting reading he would put it inside his shirt. Every once in a while it would peck at him for a little at-

PORTRAIT OF PAUL LANDACRE.

PHOTOGRAPH BY JAKOBSEN

PAUL LANDACRE: DEATH OF A FOREST

WOOD-ENGRAVING

8¼ X 11 INCHES

PAUL LANDACRE: SULTRY DAY

WOOD-ENGRAVING

8 x 6 INCHES

PAUL LANDACRE: THE PRESS

WOOD-ENGRAVING

$8\frac{1}{4}$ x $8\frac{1}{4}$ INCHES

tention. After about a week he judged that it was well and strong again. He took it down to the sea. When they got to within a mile of the ocean, the excitement of the bird became almost uncontrollable. Perhaps it sensed its native habitat in some mysterious way, or else it smelled the salt air. Finally they were on the shore and he launched the bird into space from his hand. Off it flew to the ocean and to freedom.

There is something beautiful about this story, beautiful and symbolic. There is a marked identification between Paul Landacre and the wild black petrel. He too has a wild lonely streak in him. He too is a bit clumsy on his feet, but soars and soars in his chosen sphere. He too has been bruised and broken and has learned to fly again. He too has a fierce and uncompromising desire for freedom. The petrel was black, and he was a black and white artist. It loved to soar at night and so did he. He made a printing mark of a stylized petrel and stamped his prints with it.

Like so many Californians, he is so not by birth but by adoption. He was born in Columbus, Ohio. He came of a family of scientists and teachers, and continued the tradition by attending Ohio State University and specializing in entomology. He was active in athletics (in high school he had been captain of the track team). Suddenly he was stricken with a streptococcus infection which left him crippled and twisted in his legs. He was flat on his back for a long time and was sent to California, where his father happened to be working. This was in 1922 and he has remained in California ever since. In time he recovered somewhat and set about making a living. He had always liked drawing and had a knack for it. In college it had helped him with his laboratory notes. Now without special training, he got a job with an advertising firm, the standards not being too exacting. After some years he went to another advertising agency and met there a copy-writer who eventually became his wife.

In due course he became dissatisfied with his commercial work,

hated its routine job of drawing machinery, French bread, or what not. His wife believed in his destiny and said: "Do whatever you most want to do, I will stake you." And for three years he did. With prodigious efforts he set about to learn the technique of the graphic arts. He tried them all, etching, drypoint, mezzotint, lithograph, but came to the conclusion that he liked wood-engraving best of all. Wood-engraving, he felt, had a greater range. Its exacting technical requirements were a challenge, and no one had yet touched the possibilities inherent in the medium. He floundered around with tremendous energy learning his craft, cutting block after block and throwing away the result. He would make a color block of eight or nine colors, and register the printing crudely but with infinite patience. When it was all finished he would tear up the print because it reminded him of something else he had seen. He would try again: this time he would not copy anybody, it would be his own. When it was completed he would look at it with disgust, for it had not turned out as he had expected, and it still had a familiar look. Where had he seen it? — and then it came to him that some months before he had seen something similar. And so he would again destroy it ruthlessly. He was determined to have something his own, however poor it was. This was the way he acquired his technical facility — through a long and arduous apprenticeship, the result of the most ruthless self-criticism. He now had become a master craftsman. There was nothing he could not do if he wanted to. "I have everything in my fingers," he said; "now I will have to worry about what I have in my head."

He need not have worried, for his artistry was apparent in his capacity for self-development, and he had the creator's deep feeling and imagination. He set to work as an artist-engraver. Recognition came to him slowly but surely during the past decade. He received prizes and awards; Jake Zeitlin gave him a show; museums and collectors such as Kay Francis, Delmore Daves, and Mrs. L. M. Maitland began to acquire his work. His wife's faith in him was more than jus-

tified. Since 1928 he has made about 125 separate wood-engravings, not including vignettes, spots, and book illustrations. His range of interest is wide. His identification with the forces of nature is manifest in such prints as *Rima, Tuonela, Storm,* and *Death of a Forest.* His mastery of the human figure is shown in *Anna, A Woman,* and *Counterpoint.* His strong feeling for design, verging at times almost upon the abstract, gives distinction to such blocks as *Growing Corn, Iris, Allegro,* and *The Press.* That he is not without a sense of humor and an interest in everyday things is proved by *Sultry Day, Amateurs, Monday,* and *Lot Cleaning.* He has admirably caught the spirit and the contour of the California landscape in such prints as *Smoke Tree Ranch, Desert Wall, Nimbus, Coachella Valley,* and *Point Sur.*

" Art to me," he has written, " is more or less an emotional catharsis, and while I usually suffer during the process, I feel grand when a block is completed — that is, for a short time. So I have to do another one. They always fall so far short of what I tried to do that I am miserable until the next one. Of course, as a balance, there is the physical pleasure of the feel of the graver in boxwood, and the fascinating and exasperating mechanics of printing, and, as I said, the marvelous feeling of having completed something. . . . To me the most important elements in a work of art are imagination first, and simplicity, and, of course, design. I have no favorite artists — my ideas seem to change all the time, but I have admired various ones from El Greco to Gauguin and Van Gogh, and among wood-engravers Blair Hughes-Stanton, Agnes Miller Parker, Rockwell Kent, Howard Cook, and others, though I know little enough about any of them. One Sibelius symphony carries me to greater heights than all the graphic art I have seen." It is true, as he says, that music has had a certain influence on his art. Like Wanda Gág, he has made use of certain formal principles inherent in music, ideas of orchestration and counterpoint, melodies of line and curve, fugues of pattern and space. In his own words: " I have been trying for some time to get some of

the abstract qualities of expression that one finds in music, but have not laid much stress on it for fear of seeming to try to *illustrate* music."

He and his wife live in a curiously isolated, almost wild spot on one of the hills in the midst of Los Angeles. There in his garden he prunes trees, makes terraces, plants corn and watches it grow (witness his *Growing Corn*), observes the birds, takes sun baths, and generally lives the simple life — all in the midst of a big city. He is content in the sun, and often he laughs — a beautiful, infectious, unequivocal laugh. He does not see much of other artists and certainly does not bother to cultivate " the right people." He works hard, but does not produce much, for he likes to do everything perfectly. His hand press, beautifully polished, stands in one corner of his studio. It served as the inspiration of one of his most powerful designs, *The Press*. He found it in a barn in Bodie, an abandoned old newspaper press. In addition to his published prints, he has also made book illustrations on wood for Ward Ritchie and other printers. Lately he has illustrated, with a rare combination of naturalism and abstract pattern, Edward Doro's *The Boar and Shibboleth* and Donald Culross Peattie's *Flowering Earth* and *The Road of a Naturalist*. He sometimes finds it difficult to do things on order, but when the commission coincides with his own line of interest, his execution is both speedy and inspired. He has known what poverty means and therefore is always insistent on proper payment in full in business transactions. He sometimes paints in oil for the sake of variety. He is in no sense an ivory-tower isolationist: he wants to do things of today with social implication. But, being the lonely petrel that he is, he shrinks away from too close absorption in the social question. Nature, rather than Man, calls the tune. He has a great reverence for everything in nature and for everything that happens as a result of nature's laws. He has traveled much in California and would like to explore Arizona and New Mexico. I asked him if he loved the desert; no, he said, he really loves only the sea, but he never does any work by the ocean.

PAUL LANDACRE

Paul Landacre is now the outstanding wood-engraver on the west coast. His technical mastery is beyond question. His hand is sure in the rendering of textures. He has an inspired sense of composition and design. His cutting is a perpetual delight to the eye. But beyond these matters of technique shine the qualities of the man himself, his integrity and passion for perfection, the intensity of his feeling for nature, for life, and for beauty. He and his mate have found a niche for themselves in society, modest to be sure, a bit precarious at times, but nevertheless a place. It is a credit to our society that we have not crushed this wild petrel but rather have let him soar and soar.

JASPER PLUM

JASPER PLUM became an artist rather by accident. While he was a student at the University of Chicago he became acquainted with several art students from the Art Institute. He played around a great deal with them. He liked their free and easy ways and became fascinated with drawing and the flow of color on canvas. He had intended at first to specialize in English at college. After he had graduated, the call to art became so strong that he decided to take it up as a profession.

He was born in 1893 in a small town in Illinois of middle-class parents in moderate circumstances. He was a good scholar, quick to grasp things and eager to taste experience. He had a certain facility in writing and was ambitious to become a successful author. He determined to go to college as much for the sophistication and polish he might acquire as for the training in writing he hoped to obtain. At college he was popular. He joined a good fraternity, was chairman of the junior prom and in his senior year business manager of the college newspaper. His ambitions for authorship had waned as his interest in art increased. Having made up his mind to study art, he reasoned that he stood a better chance if he studied in New York.

So, with what he was able to earn during the summer supplemented by the modest aid his parents gave, he came to New York to study at the Art Students League. He had studied about two years when America entered the war.

He was called in the first draft and got himself a berth in the Intelligence Service. The war over, he remained in Paris and continued his art studies. He plunged into the exciting and multiform movements of the school of Paris. He finished his apprenticeship and set up a studio of his own. Having facility and a knack of picking things up easily, he soon acquired a certain local reputation, at least in the American colony. When the influx of American tourists began, he was well prepared to receive them. He knew his way about Paris — the picturesque spots and restaurants of Montparnasse. He frequented the Rotonde and the Dome at the right hours. He would even on occasion guide visitors through the Louvre, showing them the best pictures. He was affable and charming, had a pleasant fund of gossip about art and artists. The Americans were fortunate in having so polished a cicerone to culture in Paris. He also painted. In his art he was no extremist; he never went very far beyond the comprehension of his good American friends. To be sure, he was just a little beyond them, but not too far, just enough to create the impression of newness and originality. Cézanne and Renoir were his gods at the time. Cubism or abstraction he avoided entirely: its public was too limited. However, he did learn later from Matisse, Derain, Pascin, and Picasso in the earlier phases. He managed to sell quite a number of paintings to American visitors. He had made the acquaintance of a rich spinster from Akron, Ohio. She took quite a fancy to him, he was so cultured and charming and had such nice manners. He in turn subtly revealed to her that she had a real flair for art. She bought a number of his pictures every year; indeed, she was his most lucrative patron until she died in 1926. The year before, he married an attractive girl who had come to study music in Paris. Though ex-

ceedingly ambitious, she was shrewd enough to realize that she would never become a great pianist. Henceforth she channeled her ambitions toward her husband's success. She was quite a helpmate to him, for she was able to convey certain enthusiastic superlatives which he with his more subtle and polished technique had not felt free to express. They established an attractive studio, and many Americans were pleasantly entertained with cocktails and music and art.

In the fall of 1926 they returned to America. He had decided it would be wiser for him to spend the winters in this country for the sake of a wider market. The summers were to be spent in France not only for pleasure but also for possible new contacts and in order to keep in touch with the last word from Paris. There was another consideration: rich ladies he found he could handle in America, but rich men were more receptive and more in a buying mood abroad than at home, where they were close to the office. He had become intimate with a group of brokers and business men. They had given him occasional inside tips on the market. Along in 1928 he became definitely interested in speculation on Wall Street. He painted little; he thought and breathed and talked finance. Starting with the nest egg he had obtained from the rich lady of Akron, he had pyramided it to the sum of $100,000 when the crash of 1929 came. He had aimed for another $50,000 and then he was going to retire to enjoy life. Now he had lost everything and had to start all over again.

Toward the end of 1930 he went to Texas on a portrait commission. Through an acquaintance of old Paris standing he had met an oil millionaire who was passing through New York. He found occasion to intimate that the one thing he always preferred to do was portraiture, but he so seldom found a worthy subject. " Now, your wife — she would be an inspiration to any painter! " So he went to Houston and painted the portrait. It was not a great success, for he found out that the Texan did not want a school-of-Paris portrait.

These were lean years, and he was hard put to it to make ends meet. His rich patrons, like himself, had been wiped out by the crash. Although museums still made purchases, they were few and far between. Nevertheless he did manage to sell several works at fairly good prices. He had always made a point of cultivating museum directors and trustees when they came to New York. He would invite them to parties, take them around, and generally make much of them. He always was seen at select openings, such as those at the Whitney Museum, the Museum of Modern Art, and the private galleries, and he was always affable and courteous, always pleasant-spoken with a subtly flattering word. Some of this foresight bore fruit. Nevertheless he had to fall back on teaching. He spent one summer teaching at a Western summer school, but he was more successful with private and select pupils. He could put himself over so much better with them.

Curiously enough, he never had a dealer. Early in the game he asked himself why he should pay a dealer a commission when it was more than likely that the artist would bring all the customers around, and why he should turn over his best clients to the dealer to exploit. He was always secretive about his patrons. Nevertheless he sent work to all the shows, and was always invited to the Carnegie International, to Chicago and the Whitney. He never resented the amount of time these forwarding and bookkeeping operations took away from his painting hours. A little more or less did not make much difference since he spent almost more time cultivating the best people than he did in painting anyway. Nor did he ever employ a public-relations counsel or publicity agent, as some artists did. He managed such things for himself. In fact, he did so well with publicity that he could easily have made a place for himself in the profession. He was a boon companion of the art critics, reviewers, and those in key positions in the periodical field. Through them he received quite a build-up. Prizes and awards helped along, too. It did not take him

long to realize the importance of being a juror. His wide acquaintance and ingratiating manners made his selection relatively easy. In the course of his frequent service, he piled up on others obligations of gratitude which subsequently bore fruit by repayment in kind.

He was always rather shrewd in sizing up the art market. He was always one jump ahead of any change in the prevailing taste. The landscapes of his Paris days were in the impressionist manner, and his nudes somewhat like Derain with a dash of Pascin. Of course he made still lifes, sanely modernist in tone. During his American sojourn the elements of the still lifes took on a more American flavor. The guitars, Benedictine bottles, and checkered French tablecloths were transformed into early American pottery and native flowers. His landscapes had a faint tone of Currier and Ives. He also painted some watercolors à la Marin. When Mexican art began to loom up on the horizon, he made a trip to Mexico. He foresaw the mural trend and was on the inside track when mural commissions were first handed out without competition. Of course he had a job at the World's Fair. However, his mural painting (he never had time to learn true fresco) was not among his best work. He adapted the manner of the Mexicans to historical American subject matter, but the results were always inflated easel paintings. When the American scene came to the fore he revisited his home town and made studies of the adjacent country. He made much of his Midwestern origin, which he had previously been rather inclined to keep dark. The prices of his pictures have risen steadily. Even in the depression they did not suffer as badly as those of some of his fellow artists. Once during that time an important painting of his came up for auction; the owner had been forced to sell on account of the crash. Plum, through several intermediaries, ran it up to a fairly good price and purchased it anonymously, although at the time he could ill afford to do so.

His first lithographs were made in Paris. It occurred to him that a small original lithograph would make a charming Christmas card to give to his friends and acquaintances; it stood a better chance of being preserved and remembered than the conventional greeting. While working in Desjobert's atelier he made a number of other lithographs, several landscapes and Paris views and a nude or two. They would be useful to give away as presents instead of sketches and drawings, of which he had no plentiful supply — a graceful souvenir of a visit to his studio. Upon his return to America he ceased making lithographs until the second year of the depression. He figured that people might be then able to afford a print who could not afford a painting. He has continued with the medium off and on ever since. He made some more still lifes (of which the *Vase with Flowers* was perhaps the most successful), some rather sweet nudes (*Seated Nude*), and a series of Dancers (notably *Dancer No. 2,* one of the Duncan dancers). His five Taxco Scenes were quite successful. He had been going to Woodstock for several summers until he bought himself a little farm in Bucks County, Pennsylvania. The landscape inspired him and he made a very successful lithograph, *Bucks County Winter.* This was so popular that he made three more, using somewhere in the picture the same clump of trees, conformation of fences, and distant view of a barn. It began to look as if he had adopted that combination as a trademark. But he broke the spell with a view of *The Church at Ranchos de Taos* made on a trip to California. His latest works are of course of the American scene. The most successful of these — having a faint reminiscence of Benton — are *Threshing* and *The Hunter.* He has made in all about forty lithographs. He has tried etching but found its technique too complicated and time-consuming. Wood-engraving he has never touched at all. His major interest, however, never has been graphic art. He reckons that he could have applied himself to painting in oil and have earned ten times as much with the time spent in print-making.

Jasper Plum really missed his vocation. He should have been born in another country and in another age. He has done well, but consider how much more resplendently he would have functioned had he been attached to some royal court in the heyday of court life. A natural-born courtier, he would have made of his court life a beautiful work of art. He would have made his mark on truly a grand scale. For he has many appropriate gifts: a pleasing presence, an ingratiating manner, good taste in clothes and the amenities, a gift for intelligent small talk, a talent for intrigue, a realistic appraisal of situations, and dexterity in any craft he chooses to take up. What a pity that a man of such accomplishments should have to function in a machine-age democracy! How limited in scope! He is reduced to attending the openings of the Whitney Museum and the Museum of Modern Art. It might almost be worth while, for the sake of Plum and other artists like him, to create a Grand Duchy of Art: a Duke and Duchess, a Prime Minister, and a ducal court as a back-drop for Sir Jasper Plum, Knight Commander of the Order of the Golden Fleece. It is a pleasing and colorful fancy. What pleasant things the artists would have to think about — gorgeous clothes, resplendent fêtes and levees, niceties of court etiquette, whispered rumors of patronage and favor! This is the environment to which Jasper Plum belongs. If he had not been compelled to work as a painter in our prosaic world he would have produced one work of art — his manner of life.

EMIL GANSO

EMIL GANSO was the master technician among artists. His success was due largely to his dogged perseverance and determination. He became an artist against tremendous odds. His life, his past, had not been a bed of roses. By accident of birth he found himself in Halberstadt, Germany, in the class of the countless, nameless millions, the proletariat. His aspirations toward art were given scant encouragement: he was hedged in by economic necessity. The youngest of a large family of children, he lost his father in 1896 at the age of one. Years of poverty followed, changed in form only by apprenticeship to a brutal and stingy pastry cook and confectioner. He showed at an early age an inclination for drawing which his mother indulged to the limit of her ability by buying colored crayons for a few pennies, but beyond that it was impossible to go. Those were sordid days. Few people can realize the meanness, the pettiness, the miserliness, the brutal selfishness that characterize proletarian life and color human relations on the fringes of indigence, the absurd and galling distinctions of caste and precedence that exist between apprentices, journeymen, third, second, and first assistants, and master confectioner. Over everything there hangs, like a heavy pall, sordid self-

interest and the dull inertia of ignorance. Whenever young Ganso aspired, he was unfeelingly thrust back. But he always came up for more. A chance acquaintance in a hospital with a man who had been to America fired his ambition to do likewise. He went to sea as a journeyman pastry cook. Life at sea was a change of scene but not of environment. Indomitable perseverance — desperate saving.

Finally America. Penniless in Hoboken — before the days of quotas. A stranger speaking a strange language. Nights in the park. All his clothes on his back, his workday suit over his Sunday suit. Work at last in a bakery for three dollars a week. The painful learning of the language. Always scrimping and saving. After a year the first visit across the river to New York. Gropings toward art, the first attempts at drawing and painting, not knowing where to turn for instruction or advice, learning everything by slow and painful experience. A single anecdote that is characteristic: He reasoned that in a big city like New York there must be a museum. Therefore one Sunday on his day off, he went from Tenafly, where he was living, to New York and landed at One Hundred and Twenty-fifth Street. He asked a policeman where the museum was. It must have been an amusing colloquy between the Irishman and the German immigrant with his broken English. Finally he got the directions straight, and after a long trolley ride (there were no subways then) arrived at Twenty-third Street and the Eden Musée, the only museum the policeman knew about.

Residence at last in New York. Chance meeting with an artist, then becoming acquainted with other artists, hanging around their studios, picking up a hint here, a crumb of information there, always drawing and painting in all spare time, doggedly working. A couple of months at the free life class at the National Academy School was the limit of his formal instruction. It did not turn out so well in practice. He worked in a bakery all night, drew all day. At the beginning of the week he managed very well, but by Thursday he would fall

166

asleep in front of the model. He found a little book on etching at the library. He rigged up a cast-off wringer and made over a hundred etchings, blundering around for the proper technique. He later destroyed them all; they were incredibly bad. He cultivated a taste for music, plays, books, chess. He went to exhibitions, studied pictures, perfecting himself in art with an extraordinary singleness of aim. Gradually he made a little headway. Support and recognition came from the Weyhe Gallery and the Whitney Studio (later the Whitney Museum). He was now able to devote all his time to the practice of art. He had a studio of his own at 900 Sixth Avenue.

Such was the background of this artist; life in the raw, the school of hard knocks, made him an exemplar of the virtue of hard work and determination. He could keep you in stitches of laughter for hours on end when he told some of his early adventures. His experiences in the studio at 900 Sixth Avenue alone would make a book more thrilling than *Grand Hotel*. His stories were full of humor and deft characterizations of types, shot through with drama and adventure, the sense of life. A great story-teller, and a simple, sincere, likable man. Yet little of this sense of life filtered through into his art. He could laugh at his past experiences but he could not accept them. He had built up a humorous detached attitude toward them — a kind of *Galgenhumor* — but the actual memories were too incredibly bitter for good use. He had pulled himself up by his bootstraps from the proletariat into an artist's Bohemia.

Then there was Ganso's friendship with Pascin. It was more than a young painter's admiration for a great painter — artistic influence and all that. There was a deep bond between them. Ganso loved that man like a father. He took care of him, looked after his welfare, urged him to work, kept him as much as possible from dissipation. For Pascin was tired and disillusioned in his later years. He lost faith in everything — in himself, in life, in art — and then the end came. He was a baffling but lovable personality, that gentle, generous, sensi-

tive, perverse little man with the bowler hat. He had lived life to the full, had had a dozen men's experience; he had success, fame, riches; yet one always sensed in him a tragic undertone. Something had violated his sensitive spirit, had trampled upon his inmost defenses; and that something had warped and embittered him for the rest of his life. I have often speculated on what that something was. Perhaps dealers exploited him beyond endurance, for he was bitterly contemptuous of dealers. He never valued his work till a dealer wanted it, and then he made him pay through the nose. He, too, was a fascinating story-teller; he, too, had *Galgenhumor*, overlaid with gentle irony and amused detachment. Ganso learned a great deal from Pascin, not so much tricks (though they were obvious at first) as principles: subtlety, for example, the idea there were other kinds of strength besides brutal contrasts. Ganso was influenced by Pascin, but he was in no sense an imitator. He was too robust and healthy a personality to take on permanently the color and attitude of Pascin. He had thrown off the Pascin manner long ago.

Ganso was a prodigious worker. In the last ten years, in addition to a large number of paintings and watercolors and innumerable drawings, he made over fifty wood-engravings, over one hundred etchings and aquatints, and over one hundred lithographs, including wash and color work. I can think of no other artist who had such an all-around and complete knowledge of all the graphic processes. He not only etched, lithographed, and engraved on wood, but also did his own printing. In lithography that is quite an achievement, since such printing is a highly complicated art. There are perhaps only two other printers (and they are professionals) in the whole country who are in his class when it comes to technical proficiency. Yet he was very modest about his accomplishment, and was constantly saying that all this was nothing compared to what he hoped to do.

He had an interesting theory of procedure. He believed that first one must acquire technique, learn the grammar and language of art,

EMIL GANSO: SELF PORTRAIT WITH MODEL

WOOD-ENGRAVING

9⅞ x 8 INCHES

EMIL GANSO: 1001 NIGHTS

AQUATINT

9¾ x 7⅞ INCHES

EMIL GANSO: STILL LIFE WITH PITCHER

WOOD-ENGRAVING

8 x 10 INCHES

EMIL GANSO: SPRING

COLOR LITHOGRAPH

$11\frac{1}{2}$ x 16 INCHES

as it were. Thus it was not so much perfection that he sought for at first as flexibility and control: to master the instrument so that he would be able to concentrate later on expression solely. This attitude perhaps explained a certain amount of repetition that was to be found in his work; he would do a thing over and over again, doggedly refusing to be discouraged. He would work on a theme, a pose, a composition with which he was thoroughly familiar, in order that he might concentrate solely upon the manipulation of the technique. In recent years he was beginning to concentrate more on subject matter. Nevertheless technical proficiency always was and always would have been a great factor in his work. Fundamentally he was a stylist — that is to say, more concerned with how he said a thing than with what he said. Both by natural inclination and by early conditioning he was inclined to art for art's sake. As he once said: "It is very hard, when one has been trained in the tradition of Cézanne, suddenly to become interested in illustration." By illustration he meant those pictures in which subject matter is of paramount importance. On another occasion he said he would rather be a great painter than a great artist, meaning a great technician such as Manet, for instance, rather than a Van Gogh whose inspiration often outran his technique. It would have been instructive to have carried his theory to a logical conclusion. It might have worked for him, but with most artists form and content, technique and subject matter, go hand in hand, for content and meaning also have their stages of development and technique of appraisal.

In 1932–3 he went abroad as a Guggenheim Fellow to make a special study of the graphic processes, especially lithography, and of pigments and painting methods. His facility in manipulation with his hands was phenomenal. He was not a mechanical, coldly methodical practitioner. There was a warm, genial, almost happy-go-lucky quality about his manipulation. He had such an enormous practical knowledge at his fingertips that he knew that only at certain

crucial or essential points was precision necessary. He instinctively recognized these points and worked accordingly. It was this practical knowledge of when to concentrate and when to relax that gave him the capacity for long stretches of work. He could endure it, where one who was tense all the time would have been completely worn out. He also had a gift for mechanical invention and for adapting and improving processes, witness his offset soft ground technique, his variation in the handling of color lithography, and experiments in stencil technique. He had a keen eye and critical judgment: his comments on pictures as well as on people were often shrewd and penetrating.

One of the contributions he made to the graphic arts was a painter-like approach to the medium. Color was always strongly suggested in the subtle gradations and variations of tone, and in a compositional scheme that was based upon the effective placement and vigorous balance of light and dark values. Because of this feeling for tonal value he devoted considerable attention to aquatint, soft-ground etching, and roulette work, as well as to wash or tusche lithographs. Outstanding examples in this field were *Fisher's Pond, Nude with Mirror, 1001 Nights, Silo Winter, After the Storm,* and *Metropolis.* His wood-engravings were characterized by a dramatic contrast of black and white and an expert use of the multiple tool in such examples as *Still Life with Flowers, Still Life with Pitcher, Sun Bathers* (for the Cleveland Print Club), and *Self-Portrait with Model.* In *Cassis* was displayed a masterly use of pure lithographic tusche, vigorous yet subtle. In *Bearsville Meadow* and in *Mountain Lake* there was a mixture of wash, crayon, and scratch techniques, combined to suggest moods. The large oblong *Reclining Nude* was a beautiful example of pure crayon work. Other outstanding lithographs of figure work were *Daphne, Joyce, Bather with Towel, Nude Stepping into Tub, Make-up.* In the color lithographs *Still Life with Peaches, Long Island Creek, The Storm, Coast of Maine, Early Snow,*

and *Spring* from the series of the Seasons, five to six stones were combined to produce compositions of unusual richness and solidity. Mention should be made of his pochoir color stencils (the technique of which he worked out for himself), especially *Spring, Autumn, Winter,* and *Skaters.*

The range of his subject matter consisted of still life, the usual studio arrangements of fruit and flowers, of landscapes (for which he had considerable feeling), and of woman, nude or partially draped. The male figure hardly appeared in his work, and everything, with the possible exception of the landscapes, was conceived in the studio. He devoted a great deal of study to the female figure, in mastering its forms and contours, and in learning to suggest the sheen and surface of flesh. There was in him a sensuousness as frank and unashamed, as healthy and life-serving, as Renoir's. There is no doubt that he could draw a nude as well as any one in the country. It was in his heads and faces that he showed up to the least advantage; they were never realized with that passion and completeness that characterized his rendering of bodily forms.

Emil Ganso after untold hardship and sacrifice had achieved his heart's desire: he had become an artist. His world centered in his studio. With him it was not so much escape as absorbing passion. He cared little for social prestige, fame as such, political and social questions. He wanted above all to make pictures, to render concrete his ideal world in terms of ink and pigment. In this ideal world beauty dwelt — woman, palpitating flesh, color, sunlight, trees, flowers. It was a world of sensuous impressions complete in itself, yet unreal for all that its minutest detail was faithful to life. Such is a stylist's creed, and he was a conscious stylist, though not an instinctive one, for he had to work for whatever he got.

In April 1941, just forty-six years of age and in the fullness of his powers, he was suddenly stricken and died. He had just come into his own and was producing his best work. He had everything to live

171

for; after terrific privation he was beginning to find life a little bit easier. It had turned out that he had a real gift for teaching; in addition to his vast technical knowledge he had the knack of drawing out his pupils, respecting their individuality and giving them just what they needed. In his teaching work at Iowa State College he had been beloved and respected by colleagues and students alike. His later paintings and drawings — he had made hardly any prints during the last two years — were smooth and easy-flowing, rich in tonal harmony, masterly in every way. Emil Ganso's death was a real loss to American graphic art.

THOMAS HART BENTON

THOMAS HART BENTON is one of the most colorful figures in American art. Shrewd, energetic, disputatious, he has put art and himself very much on the map. He comes from a long line of lawyers and politicians. "Politics," he has said, "was the core of our family life." His great-uncle, after whom he was named, was the first Senator from Missouri, President Andrew Jackson's right-hand man, and a great factor in the opening of the West. His father, Colonel M. E. Benton, was a big figure in Missouri politics. "The Western Bentons," he explains, "who came out of the Carolinas into Tennessee after the Revolution, were an individualistic and cocksure people. They nursed their idiosyncrasies and took no advice. They were stubborn and had a tendency to regard all but themselves as fools." Many of the descriptions of the "fantastic" old Senator tally exactly with his namesake. It was in this tradition of frontier politics and Scotch-Irish individualism that young Tom grew up, and it explains much in his character and personality. Not only the way he was molded to type by heredity and environment, but also the way he revolted against it, was characteristic. "From the moment of my birth," he wrote, "my future was laid out in my father's mind. A Benton male

173

could be nothing but a lawyer — first because the law was the only field worthy of the attention of responsible and intelligent men, and second because it led naturally to political power. In Dad's mind only lawyers were equipped and fitted to possess political power." But the young boy felt otherwise. He was individualistic and impatient of discipline and study.

In his autobiography he has given an amusing account of the fortuitous circumstances which determined his future profession. One Saturday night when he was seventeen he had wandered into a saloon in Joplin where there was a notorious barroom nude painting. " I must have got sufficiently absorbed in this masterpiece to attract attention, for I became aware of some laughing down the bar, and I turned around to meet a line of grinning fellows and a barrage of kidding. These fellows saw how young I was. They probably sensed how hard I was laboring to be a man and they laid into me with all the obscenities bearing on the picture they could think of. They made me hot with embarrassment. In desperate defense of my position, I stated I wasn't particularly interested in the naked girl but that I was studying the picture because I was an artist and wanted to see how it was done. ' So, you're an artist, Shorty? ' one of my tormentors asked skeptically. ' Yes, by God! I am,' I said, ' and I'm a good one! ' I don't really remember the conversation that followed, but those kidding roughnecks with their good-humored, amused faces, lost as they are to me in the vague memory of the shining bar at the House of Lords, with its bright lights, glittering silver, and glassware, determined in a way the life I was to follow. Their bantering skepticism about my claims to artistry tied together the loose strings of all the purposeless activities of my adolescence. They threw me back on the only abilities that distinguished me from the run of boys, those abilities which I had abandoned for more active things. By a little quirk of fate, they made a professional artist out of me in a short half-hour. One of them asked me where I was working. When I de-

clared I was out of a job but looking for one, he suggested that I should try the new newspaper and, probably to test the veracity of my artistic claims, even offered to take me there. There was nothing for me to do but to accept. So I was led down the next block where some brightly lit second-floor windows shone above a dark stairway which tunneled steeply up to them. I went up. And I went, strangely enough, with perfect confidence. I don't think it had ever seriously occurred to me before that I wanted to be an artist. Certainly, until the kidding in the House of Lords, I had never declared myself one. I had never thought of being an artist in any definite way. In school and at home I had given lip service to the idea, because the practice of drawing, besides giving me pleasure, allowed me to avoid boresome study hours. But I would never take any training. I didn't see my drawing critically as something to improve but merely as a means of describing things that interested me. After I made a picture I cared nothing for what happened to it. When I entered the stairway leading up to the Joplin *American,* I hadn't touched a pencil for many months. Yet I was as sure of myself as if I were a trained and constant practitioner. . . . Borrowing a pencil and sheet of paper, I made my sketch — the first that I'd ever made directly from a living person. It was, by the grace of God, a sort of likeness." He got a job on the paper.

These early reminiscences are significant, for they furnish a key to much in his career. They reveal his complete self-confidence, his ability to take a chance and make good. They explain his undue pugnaciousness in the vindication of art. His father's opinion and the current attitude in his environment put him on the defensive. Art was something abnormal and unnatural, certainly no he-man's job. He would show the world that whatever he undertook was supremely good and supremely male, and he would beat anyone to the punch who denied it. His haphazard selection of a career suggests that there may not be an organic relation between his profes-

sion and his innate capabilities. In spite of his revolt against the Benton tradition, he remains a Benton and he practises art as only a Benton would. He is the Missouri senator of art. I put this forward not in a derogatory sense but as a dispassionate observation. Benton has never felt quite at home in the medium through which he has channeled his ebullient energies. His own phrase is: "My painting capabilities — never fluent under the best circumstances." He has passed through many phases and manners in art; with each he thinks he has found the solution of his technical and æsthetic problems, the ultimate secret of art, which will ease all his difficulties. Someone asked him why he made those elaborate clay models for his paintings and he replied jokingly: "It is because I have no imagination, damn it all!" In this faith in external props he reminds one of George Bellows. Indeed, they resemble each other in many ways; they both had the same insensitiveness and boyish vitality, the same zest for the American life around them. This insensitiveness is hard to define or describe. It is what Rivera meant when he said: "Benton has marvelous ideas but he is no painter." It has something perhaps to do with instinctive sensuous perceptions, a sense of medium, a feeling *into* things and forces, becoming imaginatively one with them. This Benton, superb egotist that he is, cannot do; he yields to nothing; he approaches everything from the outside — not only the visual world but the creative process itself. He is always devising some formula for creation when the process is as natural as life itself. As that penetrating critic Milton Brown has said, his pictures look like stage sets — an imitation of an imitation of life. By a quirk of fate he has been led to speak in a foreign language. He is facile and industrious; he knows the language from A to Z, but there is a subtle turn of accent which reveals that it is not his mother tongue.

On the other hand what an appetite for life he has! What boundless energy and unflagging curiosity, what incomparable gusto! Here he swings in the full tide of the great Benton tradition. Colorful per-

176

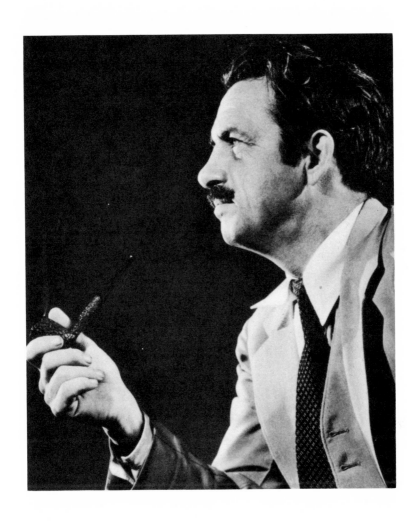

PORTRAIT OF THOMAS HART BENTON

PHOTOGRAPH BY ASSOCIATED AMERICAN ARTISTS

THOMAS HART BENTON: GOING WEST

LITHOGRAPH

$11\frac{1}{2}$ X $22\frac{1}{2}$ INCHES

THOMAS HART BENTON: COMING ROUND THE MOUNTAIN

LITHOGRAPH

$11\tfrac{1}{8}$ x $8\tfrac{3}{8}$ INCHES

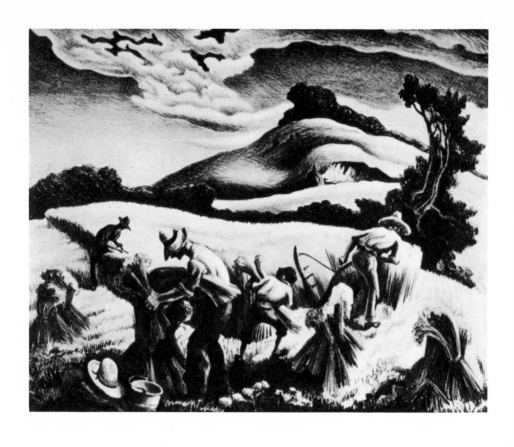

THOMAS HART BENTON: CRADLING WHEAT

LITHOGRAPH

9⅝ x 10 INCHES

sonality, knowledge of life, intelligence, showmanship, polemical eloquence, grasp of affairs — these he has in plenty. In his murals he has dramatized a panorama of American life more varied and pungent and grandiose than anyone has ever before attempted. It is as characteristically American a contribution as the movies. His travels all over the country, so engagingly described in *An Artist in America,* and the thousands of drawings he has made, more spontaneous and direct on the whole than his painting, reveal his keen and never ending interest in every aspect of American life. The South, the Ozarks and Appalachians, river life, farming and industry, religion and sex, New York a world in itself, Hollywood, and his own native haunts, all add their color and flavor to the big and robustious parade. As his illustrious forebear was a great factor in the original opening of the West, so Benton plays his part today in revealing to America the untold possibilities of its subject matter. He is a leader in a new Winning of the West, not only by his own sizable achievement but also by his ability to dramatize and publicize his ideas. His publicity sense, more robust and spontaneous than that of the suave member of the corn-belt trio, has a rough-and-tumble frontier quality. His impulsiveness sometimes acts as a boomerang and gets him in hot water, but his public utterances are always pungent and alive. As is the custom of senatorial spellbinders, he is apt to erect straw men and tumble them down triumphantly. But it is fun for the rest of us to separate the wheat from the chaff, for, coming from an intelligent if partisan observer, there is often more than a grain of truth in what he says.

There is a bit of the showman in Benton. We all remember Artemas Ward's advice to President Lincoln on how to choose his Cabinet: "Fill it up with Showmen, sir! Showmen is devoid of politics. They hain't got any 'principles'! They know how to cater for the public. They know what the public wants, North and South. Showmen, sir, is honest men. Ef you doubt their literary ability, look at their post-

ers." If he often gives the public what it wants, he sometimes hands it something it does not want. His pictures and murals have aroused controversies, storms of outraged protest. Whatever he does challenges attention, makes people react vigorously for or against, makes them aware that art can be an exciting adventure, makes them aware, too, in these later years, of how endowed and permeated with this new excitement called art their own American life can be.

Benton was born at Neosho, Missouri, in 1889. He wrote the following summary of his art education, which appeared in *Creative Art* in 1928: "Studied painting in Chicago and then in France. Influenced by modern French School, Delacroix onward, intensely by the Italian Renaissance, by McDonald Wright the synchromist, by Thomas Nast the cartoonist, by many depictors of the American scene from the early printmakers to Burchfield; by the publications of the Bureau of Ethnology, by the writings of modern psychologists including Watson, of modern æstheticians including Stein, and of many historians from Bancroft to Beard."

Since then he has settled in Kansas City to pursue and consolidate his discoveries of the American scene. Among his many activities he executed about thirty-five lithographs beginning in 1929 with the big railroad subject, *Going West,* his most famous and in certain respects his finest lithograph. His crayon work on stone has become richer in texture but he has never equaled the dynamic design of the thundering train. In this connection it might be illuminating to quote a passage from his autobiography. "More so than the other boys in town I was an habitual traveler. I went long distances to and from Washington and made frequent short trips with my father, but I think, in spite of that, that I was more emotional than any of them when the engine came pounding down on us. I often had to keep a strong hold on myself to restrain welling tears of excitement. To this day I cannot face an oncoming steam train without having itchy thrills run up and down my backbone. The automobile and the air-

plane have not been able to take away from it its old moving power as an assaulter of space and time. Its whistle is the most nostalgic of sounds to my ear. I never hear a train whistle blow without profound impulsions to change, without wanting to pack up my things, to tell all my acquaintances to be damned, to be done with them, and go somewhere." Another important early print was the *Coming Round the Mountain* of 1931, the first of his dashing dramatizations of folktunes. Benton is always conscious of design, and the best of his works are dynamically organized. *Kansas Farmyard* and *In the Ozarks* are good examples of his schematic rendering of locality; and *Cradling Wheat* and *Fence Mender* are representative of the lithographs more elaborately worked out in texture and color. *Cradling Wheat* in particular shows excellent observation of work-gestures, and from every aspect is one of the best of his later works. Many of his prints are lithographed versions of his paintings. Sometimes he is careless of ultimate effect; in his three largest prints, *Jesse James, Huckleberry Finn,* and *Frankie and Johnny,* he neglected to reverse his compositions when drawing them on stone, with the result that he had trouble with lettering in reverse, and all the shooting is done with the left hand. *Aaron,* the head of the old Negro, is an honest-to-goodness out-and-out tear-jerker. Nevertheless everything he does bears the stamp of his robust temperament.

In real life he is the most delightful of companions, simple, affable, intelligent and colorful in conversation, with a most engaging quality of charm. Above all, the man has gusto. How few people in the world possess that saving grace!

J. J. LANKES

THE COUNTRY-STORE PHILOSOPHER is a particularly American character, even though he is passing away in our present stream-lined era. Among the leisurely company that sat around the stove of the general store and swapped yarns and told what was wrong with the weather and the world, there was always one who stood out by reason of his wit or his ability to cuss. There was a touch of art in his stories or his profanity. His sayings did not sound like much at first, but they had a way of being quoted — without credit of course — until they became a byword. His speech was at once racy and full of clichés. To be sure, he was provincial and limited in his outlook, but he had a solid core of common sense and a shrewd penetration into sham and hypocrisy. And he never did chase the almighty dollar the way everybody else did. His more practical brethren looked at him with just a shade of good-natured contempt when they thought about him at all. "He's all right," they would say, "just a little touched in the head perhaps." But they certainly missed him when he was gone. He was the salt of the community, the prophet without honor in his own country, and they missed his savor when he was gone.

J. J. Lankes among the artists somehow reminds me of these

country-store philosophers. Not that the analogy is complete in every detail. Far from it. But the same spirit is there, the same gallant and impractical dedication to art in the midst of the commonplace. Lankes has always been on the firing line, a pioneer, a lone outpost among the Philistines, always on the defensive and exposed to misunderstanding and apathy. He never fled to the big city or to the artist colonies for support. He fought it out in a small town or in the country. He is essentially rural in his expression, never urban. He really distrusts the big city and what it stands for. Suspicious of big enterprise, modern industry, he is all for the little man, for handicraft and hand-work. His woodcuts are of the country, and have the smell and feel of the country in them.

J. J. Lankes was born in Buffalo in 1884 and his life has been a continual struggle to find himself and to keep the wolf from the door. " I started *life*," he once wrote, " after a dreary 1000 years of grammar school, in a one-horse factory that made flavorings, baking powder, etc. I was the horse. The ten-hour days were intolerably long. I was fifteen years old at the time. The pay was three cents an hour. My chief occupation was turning a mixing machine and stuffing baking powder into cans. That looked like a hell of a profession to my parents. So they sent me to a school to learn about mechanics. I got a smattering of mechanical drawing, a little mathematics, and considerable disgust. After two years of that, I got a job with a patent attorney. I was then seventeen and one-half years old. . . . Within a month of getting the job I was turning out finished patent drawings. I felt I was doing more than a man's work and getting only a child's pay. Art called. All my spare moments were spent in drawing faces on odd scraps of paper, margins of drawings, and the like. . . . Well, I got restless and quit suddenly. To hell with that game. There were jobs and looking for jobs, reading want ads, and chasing around for things I detested and dealing with people I loathed. I would have given my right leg at that time to have known any artist — just any

kind who could throw a paint brush. I was in a deep sea — miles and miles from nowhere — not a glimmer — just swimming around and around — no direction, no nuthin'. Where could a guy get a steer? Being excessively shy, excessively sensitive, and having excessive difficulty in expressing thoughts in talking, having no money, no influential friends, with parents at times in desperate financial difficulties — I was in a hell of a mess. . . . Suddenly I decided to get into the art game. I had learned that there was an art school in Buffalo and I could go to it, after paying the necessary tuition. In other words, the school was not for the fancy people entirely. I gave that the works for two years. Then a row broke out in the league operating the school. The instructor was fired in a way I did not like, and a strike resulted. I lost a year's scholarship with scant regret. We started our own school — on nothing. It could not endure, but we had some fun and scared hell out of the ancient powers."

Lankes would take up odd jobs when his funds ran low. At this time it was helping a man design and patent an adding machine. He went to Boston and attended the Museum of Fine Arts School, an action which he later was inclined to regret. As he subsequently wrote in a letter: " In connection with Wanda Gág and intensified vision, I was reminded of how Phil Hale in the Boston life class was wont to iron out my little intensities. Just the things that should have been developed were polished away. Of course I shouldn't blame Phil; I should have been intelligent enough to pull away. Teaching is a pretty sensitive business — many a promising guy has been pushed on the rocks because the instructor was cock-eyed." Meanwhile he browsed around in the bookshops on Cornhill, and in Alfred Bartlett's place in particular. There he found greeting cards and booklets that intrigued him. They were in the chapbook or pseudo-antique-woodcut style then in vogue. Among other odd jobs, commercial art and a spell in the drafting room of a sporting-rifle factory, he peddled some of these greeting cards. Finally he got the idea of

182

making his own designs, cutting them on wood, printing and distributing them himself. He stewed around not knowing where to get technical information on blocks and tools (the V-cutter he discovered in the shop of the rifle factory). A great storm blew down some old apple trees in his father's garden. He had read that the early engravers had used pear wood. He thought: why not try apple? He laboriously chopped out a few sticks. He says everybody should try it who wants to know what physical exertion really means. Thus he was launched on his career as a graphic artist.

In 1917 he made his first real woodcut on a maple plank, an interpretation of Millet's *Man with the Hoe*. Other blocks of that year were his own compositions, *Sundown* and *Deserted House*. The art of woodcutting, during that period, was at a very low ebb. Photomechanical techniques had destroyed its reproductive usefulness, and few artists had either the skill or the inclination to express themselves in woodcut. Lankes, along with his older confrères, Allen Lewis and Rudolf Ruzicka, were the pioneers in the rehabilitation of the woodcut as a means of creative expression — that is to say, independent of illustrative value or commercial application. He thus deserves credit for his share in restoring wood-engraving to the dignity of an original art. In 1919 he cut two of his most famous early prints, *Meeting House* and *Sleigh Ride,* which still hold their own in evocation of rural charm. Lankes had now settled in Gardenville, a suburb of Buffalo, and was working hard and hopefully. " I am cutting," he wrote late in 1921, " a *Cider Mill* in my rare odd moments. It looks as if it might turn out to be my best job thus far. It may be far enough cut by Sunday evening so that a proof can be pulled (Sunday is sacred to woodcutting and printing)." *Cider Mill* is still considered one of his best prints.

In 1922 he wrote: " I saw Burchfield's work Saturday. I am greatly impressed by it, and also by him. I am sure he will be one of the big artists of America. It seems to me that he has all the attributes neces-

sary to produce great work." This was the beginning of a long friend-
ship between the two artists. They went off together on sketching
trips. They collaborated on woodcuts. Burchfield would draw a de-
sign on the block and Lankes would engrave it. Seven in all were
made, of which *Carolina Village* and *Saturday Night* are the most
notable. " I heard from Burchfield the other day that the Metropoli-
tan Museum has purchased five of the B & L jobs. And on the heels
of that came the again pleasing news that the Cleveland Museum had
taken seven. They are not going to be outdone by no gosh darn met-
ropolitanmuseum. No sah. The more galleries get into that sort of
fight, the better I'll like it. Now it is up to the Albright Art Gallery to
show its mettle — to stand by its son (this is me). Like Hell it will."
Lankes and Burchfield once went on quite a sketching jaunt, swung
down to Woodstock and visited Bolton Brown (who gave them a
lesson in lithography) and George Bellows, and then up north to stay
with Robert Frost. " There was talk," the artist wrote, " supper, quoits
well into moonlight, more talk, Bert Williams records, a watermelon
feast in the wee sma' hours and to bed on the hay. Frost said next day,
that it was 3.00 a.m. when we retired. And you know how early in
the morning a calf begins to bawl for its ma! That's how much sleep
we got. It was our own notion to sleep in the barn." On another occa-
sion he reported: " Had a glorious visit with Robert Frost. We talked
the first night through, and wound up at 1.00 a.m. the second night
or morning rather. It was almost two full days of talk. The hills to-
ward Kent's place looked good from Frost's back porch."

In 1925 Lankes moved to Hilton Village, near Hampton Roads,
Virginia. It was a little mushroom town that had been left stranded
after the collapse of the shipbuilding industry following the war. He
was having a hard time making ends meet as an artist. Life would be
easier and living would be cheaper. It was a change of scene, pre-
cisely the contrast between lush South and austere New England
dramatized by Elinor Wylie in her memorable poem *Wild Peaches*.

184

PORTRAIT OF J. J. LANKES

PHOTOGRAPH BY CHEYNE

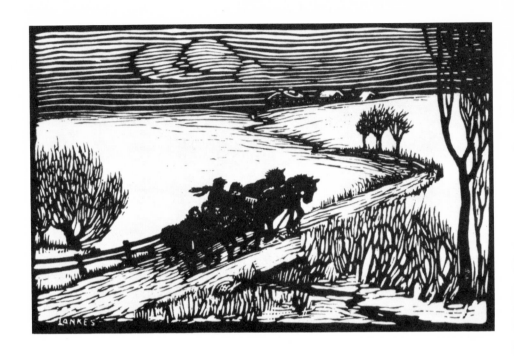

J. J. LANKES: SLEIGH RIDE

WOODCUT

4 x 6 INCHES

J. J. LANKES: SPRING COMES AGAIN

WOODCUT

7¾ x 11¼ INCHES

J. J. LANKES: HAYING

WOODCUT

7½ x 10¼ INCHES

What excited and stimulated him about the Chesapeake Bay region was not the stately mansion but the unpretentious and picturesque shack, the humble and intimate scene: *In Virginia, Farmyard, Cottage, Williamsburg.* Virginia brought new friends: Sherwood Anderson and H. L. Mencken. "Had a fine time with Sherwood," Lankes wrote; "he has been threatening to drop in here. He may, in the course of the next few days. He had to leave his farm — the spring dried up. They've had a real drought in that section." And again: "I am still battering at the woodcutting book manuscript. I suppose I'll keep it up until the book is set up. Mencken is interested in the introduction — so I am especially anxious to make it good. I told Mencken that a doc advised me to take a bottle of beer with my meals. Here is what he says: 'You are on the right track at last — that is therapeutically. Beer not only cures acidity, but also alkalinity. It is, in fact, a sovereign remedy for all the ailments of man.' I showed the letter to a friend on my way home from the post office. Last night he brought me ten bottles. A happy consequence. No, don't you send me any beer, but if you have *The Quest of the Print* by Weitenkampf, I should like to have it on approval."

In 1932 he wrote about his new job as visiting lecturer or artist in residence at Wells College in Aurora, New York. "I learn that I have a friend at Wells College, a poet to whom Frost says I really owe my appointment there. It seems the college authorities wrote to Frost concerning my experience as a teacher, and he was annoyed at the query. In effect he replied: Wot the hell, he's a performer in the arts, ain't he? 'Your book,' he says, 'should keep them from too great trepidation; that's teaching, I'm told, of the best kind, and there they have it in writing where they can examine it and re-examine it.' My own trepidation has worn off pretty well, if not entirely. . . . I've accepted the job. Pray for me. After October 1st, shall not be able to attend to old business — prints and greetings — except during holidays. So better holler for what you want ere the gates close on me. I

hope — perhaps foolishly — to do a bit of painting during my incarceration. I'll see you on my way up. At least we'll eat for another year." He spent eight college years at Wells. He enjoyed working with the students as far as there was creative work to do, but he did not fit very well into the academic routine. He had not been through the mill himself when he was young. His education had been more starkly realistic. He felt that the college atmosphere was stuffy and far removed from basic experience. "About five more weeks of this refined misery and I'm through. I'm thankful enough for the job — you understand — it is just that I get tired of the life. I am away from the family and nearly all the machinery of my trade, and I'm not a good mixer — lacking the fashionable attainments of golf, bridge, and dancing — or what passes for dancing. This clinching with one's sparring partner is O.K. too, if she happens to be shapely, etc., but what the hell about the reaction — when one has to be a respectable colletch perfesser? "

Thus Lankes has spent his life — and it's the life of most of the real artists in America — working most of his time at things he had no heart in. He never had an unrestricted chance to do the things he wanted to without a thought of bread and butter. As he said: " I spend all my time doing odd jobs, but not in Aht." There would be commercial work, illustration, book jackets, and the like. Regarding the work he really wants to do, he has his ups and downs. At times he is discouraged, he is sick and tired and done for, he can't produce a decent thing. The things he thinks are good don't sell. He is disgusted with fame and reputation; he would rather have the cash and let the credit go. But at other times he can shout: " My table is strewn with the tools of my trade — brushes, gravers, etching tools, plates, blocks, prints. Boy — I'm glad to be alive and to be an artist! " Not all his time has been spent making prints. He has written a book, *A Woodcut Manual*, one of the most delightful technical treatises ever written. It is so warm and human, so simple and practical, so full of

personality, that there is not a dull moment in reading it. It is his *beau geste* to all young students to spare them the heart-rending struggle he underwent to learn about woodcutting.

But above every other channel outside of print-making, his energies have flowed into letter-writing. He must have written thousands of letters, a truly lavish and spontaneous outpouring. "I look upon my letter-writing," he once said, "as how-de-dos, a moment's chat and away — and which entails no obligations on the visitee." I think that through his correspondence he lives a vicarious life, his own dream of a good life. He acquires a new and possibly his real personality. All his real and fancied handicaps fall away — his shyness, inarticulateness, his slowness of speech, the heavy-handed debilities of sickness and what not — and there emerges a new character, racy and witty, full of sparkling vitality, free and easy and the very life of the party. He tells stories; he sums up his successes and failures. He airs his opinions on all sorts of subjects with attitudes ranging from savage indignation to a kind of Mark Twainish humor. He recounts his pet peeves: formal dress, money-grubbers, club women, stuffed shirts. He expounds his philosophy — that of a simple, honest, independent, and warm-hearted man of the people.

"According to the *New Freeman*, the graphic artists in New York are not having any too gay a time. That used to be the case with the artists in Hilton Village. Now what am I doing? A fine occupation for a woodchopper — hoss-back riding, no less. Starving artists, my eye. Starving riding-school proprietoresses, I'd say. I am paying for this aristocratic pastime with prints. Now, the next thing will be to persuade the grocer and the landlord to accept my prints in preference to the atrocious art Uncle Sam passes out as legal tender. . . . The hunt started at daybreak. The hounds hit a hot trail almost immediately. For three hours that fox just ran the legs off the hounds, and then to show its contempt, it jumped up a tree to give us the laugh. My theory is that it had had a bottle of Pabst Blue Ribbon. I surmise

this because when I got home I had one and it made me feel swell. That fox, being so convenient to Hilton, will furnish sport until it goes to its Valhalla. The longer it eludes its hunters the more it will be appreciated.

"This is the noisiest small pretty village in all God's world. No poultry may be kept within its sacred precincts, but the dogs are the god-damnedest, the kids the shriekiest. The locomotives go by — I always pray that the beast tooting the whistle will go to hell before the day is out — Langley Field sends all its blasted planes over the house tops every day, fish-peddlers, melon-peddlers, icemen, etc., etc., etc. — Lexington Avenue in New York is oh so quiet.

"As I've said before, the whole notion of a protective tariff on imports stinks; I am perverse enough to want to put a tariff on exports. I would have it that the wealth of these great and noble states be kept right here — everything except congressmen. But them ain't wealth; them's liabilities. Anyway, why get het up? Who cares a hoot what the artist wants?

"Well, if someone had told me ten years ago that I'd live to participate in an argument concerning the elementary rights of man, or that I'd have to reason with a highly educated person against the business of bombing helpless men, women, and children, I would not have believed it. . . . It bears out my old belief that the human race is beyond redemption. As fast as one group of dictators are laid low another group develops. Between landowners and mind-owners what can be done?

"I am surprised sometimes at the prints that have been sold; perhaps they are the ones I should not put on the market; but having them, what else to do? If I were a rich guy there are few prints that I would let out — either to sell or to feed my vanity for notoriety. Being reasonably indigent and of a modest turn of mind, I have no scruples against turning all my sheep out in the pasture — or in the market place."

188

Lankes has made in the course of the last twenty-five years over a thousand woodcuts, good, bad, and indifferent. The best of them have a definite place in American graphic art. They are not particularly distinguished for technical or æsthetic reasons. "Technique," he says, "is a small part of art. I have no ambitions in that line." His prints do not possess the dynamic design or trenchant drawing that characterizes a Wanda Gág or an Adolf Dehn. His work can never be considered apart from the man and what he has to say. It has a simple, unobtrusive, folk-art quality. And it has the feel of the country and the seasons in it. Genevieve Taggard and Sherwood Anderson have written eloquently of this quality. Here is a bit from Anderson: "Lankes, the Virginia woodcut man, is really a gentle quiet man. He goes about looking for little slices of something significant and lovely in commonplace things. He has that rare, that charming faculty, so seldom found nowadays, of getting delight out of many little commonplace phases of our everyday life. You frame one of his little woodcuts and put it on the wall of your room; it is a group of trees on a windswept hillside, or a winter scene in a barnyard, or a Virginia village street. There it is. Why, you have yourself seen just such scenes a thousand times. They did not catch your attention, even seemed ugly to you, but now under the touch of this man's hand, see what they have become. . . . What I think of Lankes, what I really want to say of him is that he has got hold of something lost nowadays to most of us. He is a man who has sensed, who senses constantly, delicately, the reflected things in life. He is a man deeply concerned with life really, but it is his way to get at it through things. He feels always the reflected life in things, in barns, sheds back of barns, in little houses in which poor people live. He is always asserting something. 'Look,' he says. 'Look again. Don't you see it? Life is here in these inanimate things people have touched.'"

His work falls in several natural groups. There is the early and possibly best-known group of subject matter from New England and up-

per New York State. It is predominantly rural in feeling. It includes, in addition to those works already enumerated, several made on Rockwell Kent's farm, *Hired Man's House, Kent's Gate,* and those taken from Robert Frost's place, *Windy Hill Top, Frost's House, Calf Pasture Gate, Road to South Shaftsbury.* In the fifteen years he has lived in Virginia he has made a great number of Southern subjects, of which the following are perhaps the most notable: *In Virginia, The Lane, Farmyard, Sunday Afternoon, Haying, Spring Comes Again, Old Cape Henry Lighthouse.* He also made a few woodcuts around Aurora and, especially noteworthy, a group of Pennsylvania Dutch barns. Lankes has worked on this project off and on for many years. It was destined to be a book in collaboration with his friend, the well-known writer on architecture, C. H. Whitaker. The untimely death of the writer put an end to this enterprise. I cannot refrain, however, from quoting a characteristic passage from the artist's letters: " Got back yesterday from my second trip to Washington, from which place we made several sallies to the Dutch barn country. Whitaker will do the text and I the woodcuts of barns. We got some beauties. The text will have to do with debasement of society by the looters. We saw some country lovelier than a dream, way way far away from the big cities. Not a sign of progress — just narrow roads, rail fences, fields and trees — all clean-cut and undefiled. I had never hoped to see the like again; it was like turning back to childhood. But the evils of the day were in full evidence in most places. Some of the regions have suffered terribly since I had seen them before — thirteen years ago. A swell mill near Ephrata built *pro bono publico* in 1750 is now furnishing the power to operate a goddamned rayon factory."

Lankes has admonished both Sherwood Anderson and myself not to write about his life or character but only about his work. However, I really do not see how it can be done, for his work is so much a part of his life. I shall conclude with a recent characteristic outburst from

this gallant skeptical spirit: "The older I get, the less respect I develop for authority. There is a good deal of talk concerning the disregard artists have for such critters; just the same there is always a lingering respect for the people who write books on various subjects. Maybe it is a brain laziness to acquiesce in the ordinary conflicts with opinions — unless one develops early in life this skepticism of constituted authority. But comes a day when a feller knows everything is hooey. . . . The more I see of books, the more unnecessary they seem. Maybe 'tis a sign of approaching dissolution! Eventually a normal man must feel the necessity of throwing off extraneous goods, and take to heaven only that which is in his head. Possessions, possessions, possessions — all they do is possess one. I expect I won't have even a soul when I kick in — I'll give that to somebody, too." Answering that last statement, I should say that he has already given away his soul — in the form of his woodcuts — to the world at large.

HOWARD COOK

IN any evaluation of Howard Cook and his work one is led inevitably to a consideration of the relation between observed and observer. In the history of art there may be said to be two approaches to the problem, two lines of emphasis. One kind of artist seems to say: "Here is what I have seen and this is how *I* saw it," and the other: "Here is the essence set down for all to see." Of course such a sharp distinction between observation and observer does not exist in actual practice, but some estimate of relative emphasis can be made. On the whole Howard Cook belongs to the class which stresses the observation. He is objective rather than subjective in his approach. He is more interested in what he has to say than in the fact that he of all persons is saying it. He belongs among the impartial observers, the objective reporters, the recording angels.

Howard Cook is concerned with the visual world and tangible phenomena, with landscape in various regions, with churches and huts, dobe houses and skyscrapers, fields and factories, with people working and occupations, with character as it shines through the faces and gestures of people. Each rendering has its particular essence, its idiosyncrasy. His pictures of New England, New York City, the South-

HOWARD COOK: SELF PORTRAIT

WOOD-ENGRAVING

3¾ x 2⅞ INCHES

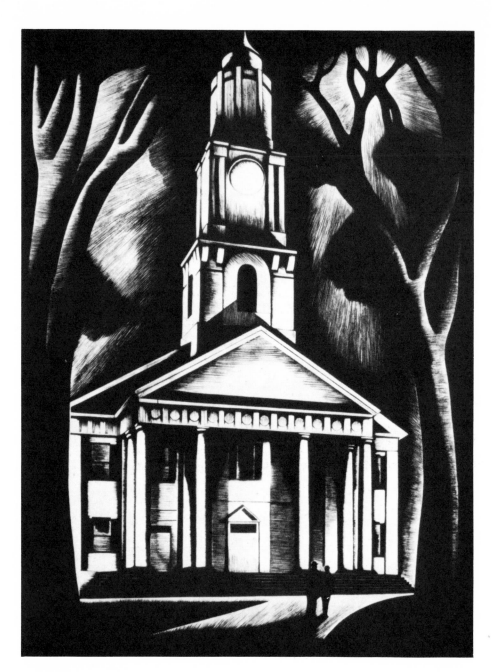

HOWARD COOK: NEW ENGLAND CHURCH

WOOD-ENGRAVING

11 ⅜ x 8½ INCHES

HOWARD COOK: EDISON PLANT

LITHOGRAPH

13⅜ x 9¾ INCHES

HOWARD COOK: SOUTHERN MOUNTAINEER

AQUATINT

12 X 9 INCHES

west, or Mexico have each a flavor of its own. This is not to imply that there is no animating unity behind all his production. The touch of the creator is there at all times. The artist's style is not obvious or flamboyant, and does not call attention to itself. It is the style of a trained observer and a skilled technician, of a reserved but alert intelligence. All his work is beautifully drawn and dynamically organized in three-dimensional design. He is one of the great designers.

He comes of old New England stock, and this may account for some of his personal reticence. His letters abound in observation of all kinds, sensitive and colorful descriptions of places and events, but there is not one revelation of the state of his soul. It is not that he is deliberately concealing anything; it just does not occur to him to speak of such things. He is a good-natured and jolly companion, with a zest for life and adventure, a staunch and reliable friend, but he just does not wear his heart on his sleeve. One may suspect that perhaps there are volcanic fires buried deep down in the mountain, but the peaks and ridges seem placid enough. He is a lone wolf, and, like most of the breed, of exceptionally strong character, honest to a fault, asking no favors, prepared always to make his own way. He is no joiner of societies. If he has name and fame it is because of his work; he has never depended upon diplomacy and log-rolling to become known. Very few people have seen him work; he prefers to work alone. In one of the few instances when he has spoken about himself he intimates this: " It has been a great blessing to have this remote ranch to work in. Instead of being bothered by the scores of art-curiosity-seekers who plague the life out of anyone living in town, I am left in peace because they cannot find their way to our place. So I have been able to work in a continuous stream without outside influences to break it. It is my make-up to get off like this by myself, for I have to stand on my own feet, sifting out my own problems, and I hope arriving at something that can fairly be called my own, good or bad. It has always been this way, with all the graphic arts proc-

193

esses at first, the drawing and painting in Mexico, intricacies of fresco, all of them produced by painful experimentation. But more than that, I love the serenity of this great plain, the getting down to essential earth-born things, or at times soaring wildly into the great arch of sky that is here."

Howard Cook was born at Springfield, Massachusetts, in 1901. He took the art courses through high school, and, having decided on art as a career, he prepared to go to the Art Students League. For about six months before going to New York he worked in a local photo-engraving shop, doing odd jobs of lettering and drawing over salt print photographs, which were washed out with some chemical, leaving only the drawing. He watched the engravers fixing up copper plates and learned something about reproduction in newspaper work. He studied all the books on Pennell and Whistler and on etching that he could find in the library, and tried a few copies from Lalanne's book on etching with the usual clothes-wringer. From 1919 to 1921 he studied at the League with Bridgman, Dasburg, Sterne, and Wallace Morgan. Meanwhile during one summer while painting outdoor billboards, he had great fun splashing out huge pictures of bread-eating babies and Hart-Schaffner-Marx stylish men. It is to be recalled that Pop Hart also served his turn at this occupation. Another summer he sought practical experience in a lithograph shop. He drew lions' heads on tomato cans and intricate lettering, but learned nothing about lithography.

After art-school days he made a haphazard living at illustration. He had always more or less paid his own way, borrowing at times and repaying when he had funds. There followed a period of wanderlust and travel which was one of the great educative forces in his life. In 1922 a sketching trip in England and France, in 1923 nine months at Panama, San Francisco, Japan, Hong Kong, and Canton; in 1925 two months at Constantinople and a few months at Paris. It was at Thomas Handforth's studio in Paris that he made his first real

etching. Late in 1925 he got a job as quartermaster for four months on a little coastwise steamer. He knew little enough about the job, but he could steer as well as any of the other Mexican quartermasters. He remembers being impressed with the Panama Canal: " The meeting-place of vessels from all over the world — the close view of the high walls of the canal cluttered with jungle growth, queer animals, lizards and the like. This job on the ship, in spite of some of its hardships and my awful greenness, was one of the most beautiful experiences of my life. Vivid pictures still remain — my standing at the wheel on the dark bridge during the early morning hours, as the quiet vessel rolled up over a smooth roller and down into a hollow, the magnificent open sky, the smell of the second mate's cigarette and the light of the steering compass. The great ocean seemed alive, too, as the black horizon would gather clouds and fling them over us and shut out the moon instantly; then we would be in the midst of a fierce rain squall. Then the lazy days, the dreamy sun. A coast line of flat sand and palms and a few scraggly straw huts, where we anchored a mile off shore and picked up bananas and mahogany. But I also remember sandpapering the top of the bridge all day in a ferocious sun in a port in Salvador, when the sun burned right through the shirt."

In Maine during the summer of 1926 he made his first important woodcuts, *Wind in the Elms, Boat Builders, Seabird.* They were broadly cut, impressionistic in treatment, and one of them in particular, *Railroad Sleeping,* still stands up well in mood and atmosphere. During these years he had been selling illustrations to magazines such as *Survey Graphic,* the *Century,* and the *Forum.* Late during the same year the *Forum* commissioned him to illustrate Willa Cather's *Death Comes for the Archbishop* and sent him to the Southwest for the purpose. He remained there for a year and a half with momentous results. In addition to the *Forum* illustrations he made about thirty woodcuts and etchings which are among the best prints ever made in the region (*Governor's Palace, Colorado River, Pueblo*

Moonlight, The Lobo, Talpa Furrows, Taos Plaza). In Taos, also, he met and married Barbara Latham, an artist originally from Connecticut. They were so attracted by the country there that after much intervening wandering, they eventually made it their permanent home.

The years 1928 to 1930 were productive and devoted to the discovery of New York, New England, and New Brunswick, with an interlude on a freighter to Europe and a sojourn in Paris. This was the period of the great skyscrapers in wood, *Canyons, Dictator, Chrysler Building, The New Yorker, Central Park South,* and particularly the monumental *Sky Scraper,* also the lithographs *Lower Manhattan, Edison Plant,* and *City Night.* Among the finest of the prints " down East " may be mentioned *Quoddy Bay, Herring Fisherman, The Valley, Country Shore,* and *Sunflowers* on copper, and *The Village, Fog in Eastport, Busy Harbor* on wood.

The award of a Guggenheim Fellowship in 1932 was one of the turning-points of his career. He went to Mexico and studied the technique of *buon fresco.* But more important than the unfolding of his powers from professional printmaker into all-around artist was his discovery of *Man.* Hitherto he had grappled with landscape and the rhythms of industry and metropolis, wherein figures were subordinate. Now he directed his research into humanity. He made many studies — beautiful, sensitive, powerful, tender — of Mexican men, women, and children. " We have seen," he writes, " the markets in some other pueblos, but none of them compare to the busy sight on Sunday in the Taxco plaza. The peons stream in from distant towns down over the myriad paths on the hillsides on Saturday afternoon, sleep in their places on the plaza, and then on Sunday it is all a vivid picture of white-clad peons with sombreros, gambling stalls, hat stands, bean-sellers, and little piles of vegetables. It is a grand excuse to draw these people if only because we pay them fifty centavos for half a day. But they never show up on an appointed day or rarely twice in succession. I am trying a dry-brush technique in color and

also drawing in black and red chalk, which suits their skin color." He also reveled in color after his long preoccupation with black and white: "Our garden has beautiful examples of canna and calla lilies, zinnias, geraniums, hibiscus, gladioli, sweet peas, poppies, elephant ears, bananas, acacia, peonies, lemons, oranges, limes, guayaba, frijoles, melons, corn, spinach — and what not, as Terry says. Also many brilliant large butterflies and beautiful humming-birds that are very tame. One of the latter flew over the flowers on our table one day and tried to drink honey out of some flowers painted on a Mexican platter. And the wild canaries play around all day in the sun." Out of this rich experience grew the wood-engraving *Cocoanut Palm*, the aquatints *Pedro, Guerrero Woman, Maria, Taxco Market*, and the etchings *Mexican Interior* and *Fiesta*, masterpieces technically as well as artistically.

Upon his return to the United States he began a series of mural commissions for Springfield, Pittsburgh, San Antonio, and Corpus Christi that have engaged most of his attention ever since. In the fresco medium his sense of monumental design, sure draftsmanship, and telling color are given free scope for successful achievement, and have placed him among the very few important mural painters in the country. However, the largeness of scope and conscientious preparation which wall painting entails have given him little opportunity for print-making.

Mural work was interrupted during 1935–6 by a year's journey through the South and Texas under a further grant from the Guggenheim Foundation. "It was my endeavor," he has said, "to search out the essential character of representative American individuals in relation to differing environmental influences. I was fascinated by the contrasts offered from one state to another: from the red earth of Virginia and its Negroes and white renters, to the rugged Cumberland Mountains, which lead back to a primitive pre-industrial era where self-reliant, fiercely independent mountaineers exist side by

side with poor whites whose spark of life is dimmed by accumulated misfortunes; contrasts again between a wild and remote Kentucky valley and the warm, sunny cotton fields of Alabama, its Negro rituals, agricultural exuberance, and hill-billies. And then across Louisiana to a far dot in La Salle Co., Texas, almost in Mexico, with cattlemen, physical giants, equaling in grandeur the vast country to which they belong as essentially as the mesquite and prickly pear that cover their desert." From this exploration and research has come a wealth of drawings and sketches but relatively few prints: *River Baptism, Southern Mountaineer, Old Timer, Fiddlers' Contest, Cumberland Girl, Chuck Wagon,* and *Texas Longhorns.*

In 1937 he was awarded the much coveted gold medal of the Architectural League for mural painting. The jury characterized his work as " distinguished by exceptional originality, free from derivative influences, and possessing a masterful organization and form." In connection with this award an amusing and rather illuminating incident occurred. The award was entirely unexpected, and there was a hectic scramble to get publicity data on the comparatively little-known recipient for release to the press. The firm which handled publicity for the Architectural League got in touch with Cook. The unpublicity-conscious artist naturally was completely unprepared. He had no photograph of himself, no clippings or list of awards and achievements, no life story neatly typed. The public-relations counsel was rather hurt and indignant at such dereliction. It was impolite and ungracious, almost pig-headed in fact, to be so uncooperative. The implication of this and other similar incidents is that every artist should have a dossier prepared for immortality. Otherwise the artist really is not playing the game. He should first spend much time and effort in building up his reputation, then perhaps he should knock off a few masterpieces to justify the build-up. This distortion of emphasis is more prevalent than one might suppose. I have seen such dossiers already prepared, nine tenths ballyhoo and one tenth achieve-

ment. Such people may succeed in selling themselves to the present, but never to the past or future. It is clearly a case of the tail wagging the dog.

In 1939 Cook wrote: " In our last two weeks in Ranchos, we succumbed to an urge that has been burning us for a long time, a house on the edge of the mesa. Only, it didn't burn us badly. All told, it cost us four hundred dollars, for which we receive two perfectly good adobe houses, a barn, an orchard (very tiny), a wheatfield, a Mexican oven, a well, lots of building stone, and the most magnificent view in all these parts. One house is very old with blackened vigas and rough cedar ceiling, the other is directly on the brow of the mesa leaning right against the western sun. The valley is ever fascinating in patchwork of cultivation, with great mountains beyond." This has been his permanent home ever since. His letters are filled with choice bits like this: " We have seen a Deer and a Buffalo Dance out at the Pueblo during this season, the best dances of our Indians. Just today was the Buffalo Dance, a beautiful affair of naked bodies painted with terracotta earth, white buckskin waist-cloths, and buffalo heads on top. It was solemn and deeply felt, with exquisite rhythm and singing." He writes also of work between mural commissions, drawings, free and patterned watercolors, promises of prints to come.

Howard Cook is one of the few artists who have not resorted to teaching to make a living. It is not that he has not had the opportunity, for he once was offered the headship of one of the most important art schools in the country. His living has sometimes been precarious, but he has always existed on his income as an artist, an income which a business man would consider a very meager return for the long training, the dedicated concentration, the tremendous mental and physical effort involved. He has not cared enough for money or fame to concentrate on them solely; he has valued his freedom and integrity, his artist's recording passion, the more. But there also have been compensations. If there have been hardships and wor-

ries, privations even, there also has been a life incredibly rich in experience and achievement, experience of beauty and adventure and human contacts, experience of creation, and achievement of works well and beautifully done. A great mural painter, he is also a great printmaker. The roster of his two hundred prints is impressive. Although by reason of the dynamic power of his design and the plastic organization of his composition he is usually classed with the modern artists, nevertheless he has won the respect of conservatives by his sound drawing and superb craftsmanship. The best of his work stands high in the annals of our time.

PORTRAIT OF MAHONRI YOUNG

PHOTOGRAPH BY SHIPLER

MAHONRI YOUNG: NAVAJO WATERING PLACE

ETCHING

5 X 10¼ INCHES

MAHONRI YOUNG: SNAKE DANCE

ETCHING

$12\frac{1}{2}$ x $9\frac{1}{4}$ INCHES

MAHONRI YOUNG: PONT NEUF

ETCHING

$9\frac{1}{2}$ X $11\frac{5}{8}$ INCHES

MAHONRI YOUNG

"*Nature has always been my continual delight for I am and always have been, as Gautier says of himself, 'one for whom the visible world exists.'*" In these words Mahonri Young gives a clue, I think, to the direction of his own career. The word "delight" is significant; likewise the words, "visible world," for, speaking as an artist, he assumes it to include not only nature but also the visual manifestations of art.

Mahonri Young is an instinctive or natural artist; he cannot remember the time when he did not want to be a sculptor. Expression came easily and naturally: it was no Herculean task, as with some artists, to master a new language. Not that he did not have to work hard to perfect his craft — every artist does — but there was no inner resistance between his actions and his desire; art was at all times the greater inclination.

In an autobiographical fragment he has given a glimpse of his early life: "I went through the public schools hating it all the way. There was one teacher to whom I owe a debt of gratitude — Miss Alta Wiggins. Miss Wiggins couldn't draw, and yet she gave me something I keep forgetting and have had to keep learning over again all my life:

201

'When you draw a straight line, look at the point where the line is going to end, not at the point of your pencil.' Nothing my world-famous teachers ever told me had anything like the value of this remark. . . . There came a time when there was a parting of the ways. I finally got through the eighth grade. I went to high school for one day. I remember the class in Latin, and liked it. I remember the algebra; whether I liked it or not I have forgotten. I have also forgotten why I didn't continue. That I have never regretted. If you know what you want to do, go straight and do it; don't go in for education and culture; life will give you both."

The creative impulse with Mahonri Young, one might almost say, is enjoyment. He creates out of his own delectation. The pleasurable impulse is twofold: when he is not creating art he is enjoying other works of art. Seldom have I seen in any creative artist a more sensitive and intelligent and whole-hearted appreciation of art, or indeed of the other good things of life — food, drink, literature, music, and the like. I have spent many a pleasant hour with him in New York at studio or gallery looking at and discussing art, or in Paris renewing acquaintance with old favorites at the Louvre, or enjoying the clowns and acrobats at the Cirque Medrano, or sipping apéritifs at a café and watching the streets and the people, his ever present sketch book constantly in use. His memory for pictures is as phenomenal as his fund of observations from nature. Out of both come illuminating generalizations and comparisons. For instance, a picture of a Navajo horse will start him discussing Indian customs or the different gaits of a horse, or a Degas drawing of a dancer will suggest to him some stimulating generalization about the practice of artists over the centuries. He is a rare talker, easy-going and above all intelligent: he is master of many arts, including the art of conversation. At times he will toss off an apt characterization of a person or by a flash of insight penetrate into the essence of an artist's way of working, or at times he will roll an epigram over his tongue, savoring it as he would a fine

wine or a whiff of good Havana. His favorite artists are those for whom, likewise, the visible world exists, especially the Renaissance Italians and the French from Daumier and Millet to Degas and Renoir. The moderns he appreciates, but not with so much gusto: " One thing I learned on the Italian journey was that, compared to the work of the Renaissance, modern art was too empty. Everywhere you looked in older pictures, there were things of interest — things to be seen."

Mahonri Young was born in Salt Lake City in 1877, a grandson of Brigham Young. He thus describes his boyhood: " I spent my first seven years in one of the most delightful places imaginable for a boy. We called it *The Factory* but its title was *The Deseret Woolen Mills.* Situated in the narrow valley which continued Parley's Canyon, between two branches of the stream, it was a place to dream of and regret. There were farmers and a farm; there were workmen and working women at the mill; there were animals and birds in and around the barn; and, in all directions, glorious landscapes. There was clay in the cut bank of the *Dugway.* Some of this I was early given to play with and I modeled birds and animals as any child would. The Jesuits say: *Let us have the child until he is seven years old and you may have him the rest of his life. . . ."*

Sculpture was his first love, but it was many years before he studied it seriously. Meanwhile he was occupied with drawing and illustration. He worked on the Salt Lake *Tribune* for five dollars a week and admired Charles Dana Gibson and A. B. Frost. He studied with J. T. Harwood, who had been in Paris. In 1899 he went to study at the Art Students League in New York. " I rode in a day coach from Salt Lake City to New York City with a break at Chicago. Chicago was the first big city I ever saw and it somewhat intimidated me. It has remained ever since my idea of a big town. Neither New York, London, Paris, nor Rome ever impressed me as Chicago did and still does. While there, I hurried to the Art Institute; that was the first

picture gallery I had ever seen. Things were hung differently there then. Two of Delacroix's finest animal studies, a lioness and a tiger, and another small picture of his were hung against the cornice. A superb Courbet mountain landscape occupied a similar position. These pictures were all beautifully displayed when I last saw them a year ago. The great Rembrandt *Girl at a Door* was there then, and on loan was Millet's little picture of a *Woman Bathing*. To me at that time it seemed a masterpiece of the first water — it still does. I have seen it every time I passed through Chicago, and it still remains as good as when I first saw it. When I reached New York, I couldn't wait to see the Metropolitan; though it was raining as hard as it can rain in New York, I started out."

In 1901 he went to Paris to study at Julien's and elsewhere, painting and drawing incessantly, and eventually modeling in clay as well. He traveled to London and Italy to see pictures and to sketch. "A number of friends were going to Italy on the three-week trip, run every year for the Italians to go home for Easter. I went along. I started drawing almost as soon as we left Paris. My experience was similar to Corot's when he first went to Rome. He sketched in the streets, but when he got back to his room, he found he had only parts of figures — a part of a head here, an arm or leg there, but nothing complete. He took stock of himself and came to the conclusion that he wouldn't come home the next day until he had drawn a whole figure. He found very quickly that to do this, he had to draw first the leading lines, the main proportions, and the big areas of light and dark, leaving details for later." Some Jongkinds he saw in a shop window inspired him to make watercolors. Millet likewise was an inspiration: "Since those early days, when Millet discovered for me form, space, light, and movement, I have never ceased to love and admire his work, and the more I have studied it and the more I have seen of it, the greater and more profound it has become. Though I studied him, I did not try to imitate him. He sent me to nature. I un-

derstood that, though I must get my material from nature, it was my job as an artist to make of it an ordered, composed work of art no matter in what medium I worked."

He also started etching in Paris. He had made one etching as early as 1898, but it was not until 1902 that he really set about mastering the medium. That year he made about a dozen, including such plates as *The Roman Beggar, The Forge: Rue St. Jacques,* and *Pont des Arts,* as good as any by the Americans then etching in Europe. Several years after his return to the United States he made about ten etchings, chiefly of Utah subjects: *Ben Eldridge Farm, Noon, Cottage in Salt Lake.* The treatment, particularly in composition, is still somewhat halting; but it is interesting to see how in the print *In Salt Lake Valley* with its excellently observed horses in pasture and in the two zinc plates, *Excavating Capitol Hill,* he anticipated subject matter that he was to make peculiarly his own. It was not until 1913 that he really found his stride in a group of drypoints, chiefly of workers: *Gas Mains, The Sand Pit, Excavating with Steam Drill.* They are powerfully and vividly drawn, and are among the earliest and finest examples of industrial subject matter, a vein that was later exploited by many other artists. Pennell and Pearson were also celebrating the Wonder of Work at the time, but their emphasis was largely architectural, whereas Young's was on the human side. In that and succeeding years he made other masterly drypoints, such as the delightful *Fort Washington Point* with the kids at the swimming-hole, *The Watering Trough,* the best of his Utah subjects, and the superb re-creation of an Indian village, *Tewa,* which for draftsmanship and economy of line, and suggestion of atmosphere and mood, is as fine as any drypoint made in the twentieth century whether in America or England.

In 1912 he had made his first trip to Arizona and the Indian country. He was in the Southwest intermittently for the next dozen years, gathering material for his monumental Navajo and Apache groups at

the American Museum of Natural History. From some of the many drawings and studies of that period he made drypoints and etchings, about twenty-five during the years 1915–19 and eight notable etchings in 1932–3. They are among the most distinguished prints ever made of the Southwest, and they rank high in quality among the artist's own works. Mahonri Young, as I have said, creates out of his own delight in living; and living means, for him, participation in nature and all the life around him. This is admirably reflected in his prints of the Southwest. There is something so simple and natural about them. They evoke the scene without the seeming obtrusion of personality: it is as if we were looking at it with our own eyes, so complete is the artist's identification with it. The artist finds enjoyment in the good things of life, nature and natural activities; and he shares his pleasure with us. It is a rare hedonism that communicates its delight to others. We see the land drenched in still sunshine in *Navajo Watering Place, Walpi in Sunlight,* or *Tewa;* we feel the stirring breeze in *Burro and Juniper Tree* or *Navajo Shepherdess;* we sense the hush of dusk in *Mexican Freighters* or *Towards Evening.* We participate in B*aling Hay at Ganado* or *Husking Corn at Ganado.* There is no trace of posing or self-consciousness in Young's figures; they go about their ways simply and naturally. His Indians are authentic. The artist neither idealizes nor condescends: he presents them in their natural setting as part of the land where they have always lived. And with distinction, too — monumentally in the two *Hopi Snake Dances* or with a kind of singing melody in *Navajo Pastoral.*

Much of Young's work has been a " Song for Occupations." It is possible that this happy interest in work of all kinds is part of his Mormon heritage. Industry was and is a keynote to the Mormon character, and the beehive a potent symbol among the Latter-Day Saints. Work is a natural activity of man, and something to take delight in. With Mahonri Young it is always work out of doors and col-

ored by the seasons: *Spring in Fort Lee, The Suburbanite, Husking Corn at Ganado, Winter Evening*. Architecture has interested him less, although in *Pont Neuf* he has shown that he can render beautifully the houses of Paris. Yet even there the interest is primarily in the hurrying throngs that cross the bridge. The plate has an added interest in that it contains a delightful self-portrait of the artist sketching on the spot. Of course he has been engrossed in other things besides people at work. He knows his horses and other animals, goats, sheep, chickens, hawks, and the like. He has made many drawings, several sculptures, and one notable print (*Beat Him to the Punch*) of boxers and boxing.

Mahonri Young is a middle-of-the-road artist, neither conservative nor modern. He is never academic: he is firmly grounded in the classics, but he manages to endow tradition with his own sense of life. He goes his own way — always with delight and pleasure. And in his delight we ourselves take pleasure.

Index

i

INDEX

INDEX

iii

INDEX

INDEX

v

INDEX